stark bewölkt

flüchtige Erscheinungen des Himmels

clouds up high *fleeting figures in the sky*

Appelt Siegrun
B. Ona
Bachler Hildegund
Baldasti Gerhard
Bechtold Astrid
Bergler Fritz
Blaskovic Aimée
Choung-Fux Eva
Cmelka Helga
Dreux Béatrice
Eberl Irma
Ecker Gottfried
Engelhardt Khy
Fodor Gyula
Gappmayr Heinz
Gottfried Markus Maria
Grossmann Silvia
Heindl Ursula
Hikade Karl
Hirschmann Werner Paul
Hollegha Wolfgang
Höllwarth Gottfried
Huber Lisa
Hutar Gerhard
Jaschke Gerhard
Jöchl Hans
Kampfer August
Kempinger Herwig
Klinkan Alfred
Klučarić Claudia
Lang Kurt
Lehmden Anton
Lindinger Heinz
Maier Norman
Meierhofer Christine
Mejchar Elfriede
Menhardt Moje
Monaco Julie
Nitzl Iris
Pfaffenbichler Hubert
Pisk Michael
Prelog Drago Julius
Rataitz Peter
Rind Trude
Roithner Hubert
Schellander Meina
Schlegel Eva
Schwaiger Josef
Sielecki Hubert
Spiegel Michaela
Sturm Gabriele
Swoboda Helmut
Szigethy Ida
Titz Lea
Traar Jochen
Trinkl Werner
Wachsmuth Simon
Wacik Franz
Walde Martin
Weigand Hans
Weissenbacher Sebastian
Wisniewski Jana
Zeppel-Sperl Robert
Ziegelman David

stark bewölkt

flüchtige Erscheinungen des Himmels

clouds up high *fleeting figures in the sky*

Herausgegeben von Edited by
Berthold Ecker, Johannes Karel, Timm Starl
für die Kulturabteilung der Stadt Wien
for the Department for Cultural Affairs of the City of Vienna
(MA 7)

Mit Beiträgen von With contributions by
Aigner Silvie
Baur Simon
Breicha Otto
Ecker Berthold
Faber Monika
Fink Roland
Frischmuth Barbara
Fritz Elisabeth
Fuchs Rainer
Gansert Ulrich
Griesser-Stermscheg Martina
Huber Sonja
Jurkovic Harald
Karel Johannes
Matzer Ulrike
Matzner Alexandra
Micheler Elisabeth
Nagl Michaela
Reichhardt Michaela
Schlegel Franz-Xaver
Schmidt Burghart
Schön Markus
Spiegl Andreas
Starl Timm
Steininger Florian
Uhrmann Erwin

SpringerWienNewYork

Impressum Imprint

Katalog Catalogue

stark bewölkt
flüchtige Erscheinungen des Himmels
clouds up high
fleeting figures in the sky

Herausgeber für die Kulturabteilung der Stadt Wien (MA 7) Editors for the Department for Cultural Affairs of the City of Vienna: Berthold Ecker, Johannes Karel, Timm Starl
Katalogredaktion Catalogue editor: Johannes Karel
Texte Texts: Silvie Aigner, Simon Baur, Otto Breicha, Berthold Ecker, Monika Faber, Roland Fink, Barbara Frischmuth, Elisabeth Fritz, Rainer Fuchs, Ulrich Gansert, Martina Griesser-Stermscheg, Sonja Huber, Harald Jurkovic, Johannes Karel, Ulrike Matzer, Alexandra Matzner, Elisabeth Micheler, Michaela Nagl, Michaela Reichhardt, Franz-Xaver Schlegel, Burghart Schmidt, Markus Schön, Andreas Spiegl, Timm Starl, Florian Steininger, Erwin Uhrmann
Lektorat Proof: Fanny Esterhazy (Dt. Germ.)
Übersetzung Translation: Wolfgang Astelbauer, Rebecca Law
Grafik Graphic: Marianne Friedl
Lithografie Lithography: Pixelstorm, Kostal & Schindler OEG
Druck Print: A. Holzhausen, Druck & Medien GmbH

Ausstellung Exhibition

stark bewölkt
flüchtige Erscheinungen des Himmels
clouds up high
fleeting figures in the sky

27.02. – 30.05.2009

MUSA Museum auf Abruf
Felderstraße 6-8, 1010 Wien
www.musa.at

Ein Projekt der Kulturabteilung der Stadt Wien (MA 7)
A project of the Department for Cultural Affairs of the City of Vienna
Für den Inhalt verantwortlich Responsible editor: Bernhard Denscher
MUSA Museum auf Abruf-Leitung MUSA Museum on Demand-Director: Berthold Ecker
Kuratoren Curators: Berthold Ecker, Johannes Karel, Timm Starl
Projektleitung Project management: Johannes Karel
Mitarbeit Assistance: Gunda Achleitner, Roland Fink, Andrea Höller, Karin Krammer, Peter Schauer, Táňa Šedová, Gabriele Strommer, Heimo Watzlik, Michael Wolschlager
Katalogredaktion Catalogue editor: Johannes Karel
Kunstvermittlung Communication: Astrid Rypar
Öffentlichkeitsarbeit PR: Veronika Gross, Martin Lengauer (die jungs kommunikation)
RestauratorInnen Conservators: Peter Hanzer, Barbara Kühnen
Ausstellungsaufbau Exhibition construction: Christian Hirschhofer

© 2009 Springer-Verlag/Wien
Printed in Austria
SpringerWienNewYork is a part of
Springer Science + Business Media
springer.at

Gedruckt auf säurefreiem, chlorfrei gebleichtem Papier – TCF Printed on acid-free and chlorine-free bleached paper

SPIN: 12551606
Mit zahlreichen farbigen Abbildungen
With numerous coloured figures

Bibliografische Information der Deutschen Nationalbibliothek Die Deutsche Nationalbibliothek verzeichnet diese Publikation in der Deutschen Nationalbibliografie; detaillierte bibliografische Daten sind im Internet über http://dnb.d-nb.de abrufbar.

ISBN 978-3-211-89113-1 SpringerWienNewYork

Cover, Vor- und Nachsatz frontleaf and endleaf
Ausschnitt aus detail from: Siegrun Appelt, Clouds, 1996

Inhalt Content

Berthold Ecker

stark bewölkt

Zu den faszinierendsten Erlebnissen am Beginn meiner Auseinandersetzung mit Kunst zählte die Begegnung mit den Wolkenskizzen von Adalbert Stifter. Sie erzeugten in mir, so wie Detailabbildungen aus den Gemälden von Velázquez, eine Ahnung von Malerei als einer Beschäftigung mit dem Medium selbst, ähnlich wie die selbstreferentielle Malerei, die später zum Terminus für eine eigene Annäherung an das Medium werden sollte. Seither verfolgt mich die Idee, der Wolke eine Ausstellung zu widmen, und dies wurde durch zwei bedeutende Vorgängerprojekte, *Die Entdeckung des Himmels*[1] in Hamburg und Berlin sowie *Die Erfindung des Himmels*[2] in Aarau, noch bestärkt.

Wien ist zudem seit langem ein guter Boden für Wolken: Nicht nur hat Stifter hier seine Studien betrieben, mit der Abhaltung des ersten internationalen Meteorologenkongresses 1873 im Rahmen der Wiener Weltausstellung wurden auch bedeutende Fortschritte auf wissenschaftlicher Ebene erzielt.

Und nun also eine Wiener Wolkenausstellung: Damit sollen, nach den Ausstellungsprojekten der „Entdeckung" und der „Erfindung" des Himmels, die das Phänomen der Wolke in natur- und geisteswissenschaftlicher Hinsicht vorbildlich untersucht haben, die Werke der Wiener KünstlerInnen in die Überlegungen zum Thema eingebracht werden. Thematische Untersuchungen sind meist vor dem Hintergrund vertrauter künstlerischer Positionen ange-siedelt. Dies führt dazu, dass immer wieder die gleichen Künstlerpersönlich-keiten als Zeugen und Beispiele herangezogen werden. Einen anderen Zugang bietet der lokale Hintergrund der jeweiligen KuratorInnen, der maßgebliches Material liefern kann. Ebensolches möchten wir mit unserer Zusammenstellung *stark bewölkt* anbieten und damit den Diskurs zur Wolke um viele interessante, wenn auch flüchtige Erscheinungen des Himmels bereichern.

Eine Sichtung der Sammlung des MUSA Museum auf Abruf hat „Wolken-stücke" in vielfältigen Annäherungen an das Phänomen zutage gefördert. Dieser umfangreiche Bestand an Werken,[3] denen Wolken ihr Gepräge verleihen, beinhaltet allerdings auch eine Menge Arbeiten, die sich allgemein mit dem Himmel auseinandersetzen und folglich eben auch Wolken zu bieten haben. Unser kuratorisches Bemühen konzentrierte sich dagegen auf „die Wolke an sich", nicht ihr „Eben-auch-Existieren" am Himmel; es ist das Phänomen in seiner reinen Form bzw. als solitäres Element, das im Zentrum unserer Betrachtung stand. Das bedeutet, dass das Gebilde völlig aus seinem Umfeld losgelöst als amorphes schwebendes Etwas vor das Auge tritt und nicht als Accessoire bildnerischer Intention. Dadurch wird der räumliche Konnex des Gebildes zurückgedrängt oder gar eliminiert. Natürlich bleibt immer wieder ein Rest an örtlichen Bezügen, wodurch unmittelbar eine Anbindung an das Beständige, eine Information zu geografischen Koor-dinaten entsteht. Die unangefochtene Hauptrolle sollte aber in jedem Fall die Wolke als Phänomen spielen; als Beiwerk anderer landschaftlicher oder innergestalterischer Zusammenhänge ist sie aus dieser Sicht weniger interessant.

1 *Wolkenbilder. Die Entdeckung des Himmels*, Ausstellung und Katalog von Bärbel Hedinger, Inés Richter-Musso und Ortrud Westheider, Ausstellungskatalog Altonaer Museum, München: Hirmer, 2004.

2 *Wolkenbilder. Die Erfindung des Himmels*, hrsg. von Stephan Kunz, Johannes Stückelberger, Beat Wismer, Ausstellungs-katalog Aargauer Kunsthaus, Aarau, München: Hirmer, 2005.

3 In der Erstauswahl waren über 200 Werke enthalten.

Berthold Ecker

clouds up high

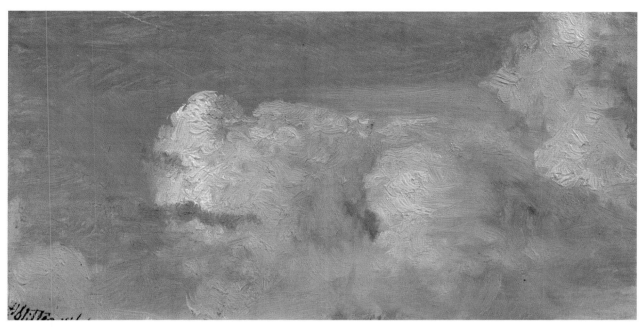

Adalbert Stifter, Wolkenstudie Cloud Study, 1861
Öl auf Leinwand oil on canvas, 9 x 17,2 cm
Adalbert-Stifter-Gesellschaft, Abdruck mit freundlicher
Genehmigung des Wien Museums Reproduced with the
kind permission of the Wien Museum

One of my most fascinating experiences when first dealing with art was when I came across Adalbert Stifter's cloud sketches. Just like individual details from Velázquez' paintings, they evoked in me a notion of painting as an exploration of the medium as such, similar to self-referential painting, which later was to become a term signifying a distinctive approach to the artistic medium. Since then I have been entertaining the idea of devoting an exhibition to clouds, which was further encouraged by two significant prequels: *Die Entdeckung des Himmels*[1] *(The Discovery of the Sky)* in Hamburg and Berlin and *Die Erfindung des Himmels*[2] *(The Invention of the Sky)* in Aarau.

Moreover, Vienna has long been a fertile ground for clouds: not only did Stifter pursue his studies here; in 1873, when the first International Congress of Meteorology was held in the context of the Vienna World Fair, considerable progress was also achieved on a scientific level.

At last there is a cloud exhibition in Vienna: following the exhibition projects dedicated to the "discovery" and the "invention" of the sky, which were excellent examinations of the phenomenon of the cloud from the perspectives of the natural sciences and the liberal arts, works by Viennese artists are to be introduced into previous considerations on the subject. Thematic investigations are usually conducted on the basis of familiar artistic positions, implicating that works by the same artists are referred to as testimonies and examples over and over again. Curators with local backgrounds offer different approaches that can supply relevant materials. This is exactly what we would like to accomplish with our compilation *clouds up high,* thus enriching the discourse on clouds by a score of interesting, if ephemeral, occurrences in the sky.

1 *Wolkenbilder. Die Entdeckung des Himmels,* curated and edited by Bärbel Hedinger, Inés Richter-Musso, and Ortrud Westheider, exhibition catalogue, Altonaer Museum, Munich: Hirmer, 2004.

2 *Wolkenbilder. Die Erfindung des Himmels,* edited by Stephan Kunz, Johannes Stückelberger, and Beat Wismer, exhibition catalogue, Aargauer Kunsthaus, Aarau, Munich: Hirmer, 2005.

Am Beginn der Geschichte der Wolken als eigenständiges naturwissenschaftliches Phänomen stand ein Vortrag mit dem Titel *Über die Modifikationen der Wolken*, den Luke Howard 1802 in London hielt. Von ihm stammt die Klassifikation der Wolken in Cirrus, Cumulus und Stratus, die bis heute in Grundzügen die Lehre bestimmt. Aber schon lange vorher beschäftigten sich Künstler mit dem Himmelsphänomen. Besonders Filippo Brunelleschis perspektivische Malerei vom Baptisterium in Florenz, entstanden am Beginn des 15. Jahrhunderts, erscheint aufschlussreich in Hinblick auf die damalige Haltung zu den Wolken. Während ihm mit der räumlichen Wiedergabe der Architektur und des Platzes dank der Zentralperspektive ein Bravourstück gelang, kapitulierte er vor der räumlichen Darstellung des Himmels. Dort, wo mathematische Größen und berechenbare Verhältnisse gegeben waren, vermochte er die Illusion der Räumlichkeit zu erzeugen, scheiterte aber an der Dimensions- und Raumlosigkeit des Himmels und behalf sich mit dem Einsatz eines Spiegels, der den wirklichen Himmel an der vorgesehenen Stelle in das Bild übertrug. Geometrie und Wolken hatten sich als inkompatibel erwiesen und die Himmelserscheinungen als eine besondere Herausforderung in der bildnerischen Erfassung herausgestellt. Und das blieben sie auch in den folgenden Jahrhunderten. Schon in den Anfängen der Landschaftsmalerei, etwa bei Konrad Witz' „Der wunderbare Fischzug" von 1444, dienen sie nicht nur als konstruktives Element im Bildgefüge, sondern erlauben dem Maler seine Meisterschaft an den Spiegelungen im Wasser zu demonstrieren bzw. mit dem wolkenverhangenen Berggipfel im Hintergrund ein narratives Moment einzuführen.

Einen herausragenden Höhepunkt erreichte die Darstellung von Wolken im späten 18. und beginnenden 19. Jahrhundert, als ihre Bedeutung für die Stimmung und das Zeitgefüge der Landschaft erkannt wurde.[4] Diesbezügliche Werke von Caspar Wolf, Johann Christian Dahl, Carl Blechen oder William Turner zählen zu den Ikonen der Wolkenmalerei und wurden wohl nur durch das Genie Caspar David Friedrichs übertroffen. In ihm gipfelt die inhaltliche Aufladung der Landschaft als Spiegel der Seele gemäß der romantischen Naturphilosophie, und auch hier spielen Wolken die Hauptrolle auf der Klaviatur der Emotionen. Für die österreichische Kunstgeschichte dieser Zeit sind Heinrich Reinhold und Adalbert Stifter zu nennen.

John Constable malte in den Jahren 1821 und 1822 immer am selben Ort (Hampstead) eine Serie von Wolkenstudien („cloud studies") und wurde dadurch zum Pionier einer forschenden Beschäftigung mit dem Phänomen der Wolken mittels ihrer Verbildlichung. Er verfertigte auch „inscriptions", indem er die meteorologischen Bedingungen vor Ort auf die Rückseite der Bilder notierte. Darüber hinaus erlegte er sich zum Malen einen strengen zeitlichen Rahmen auf, um die Vergleichbarkeit der Phänomene zu gewährleisten.[5] Dieser wissenschaftliche Ansatz korrespondiert mit der damals einsetzenden Wolkenforschung und findet sich auch noch in zeitgenössischen Arbeiten, etwa in der Installation von Gabriele Sturm.

Längst haben sich Termini wie „die Unschärfe", „das Mannigfaltige", „das Chaos" und „die Polyvalenz" zu Schlüsselbegriffen zeitgenössischer Denkansätze auf dem Weg zum Verständnis ungeheuer komplexer Zusammenhänge mikroskopischer wie universeller Welten etabliert. Die Wolke als früher Ausgangspunkt und Sinnbild dieser Problemfelder hat bis heute nichts von

4 Inés Richter-Musso, „Die Wolke als Lehrmeisterin der Malerei", in: *Wolkenbilder* (Anm. 1), S. 48 ff.

5 Ramón Reichert, „‚Forming the formless'. John Constable's Cloud Studies", in: *Archiv für Mediengeschichte – Wolken*, hrsg. von Lorenz Engell, Bernhard Siegert, Joseph Vogl, Weimar: Verlag der Bauhaus-Universität, 2005, S. 57–67.

Sifting through the collection of the MUSA Museum on Demand has unearthed cloudscapes addressing the phenomenon in question in various ways. These ample holdings of works whose special character is owing to clouds[3] also include numerous examples dealing with the sky in general, thus offering clouds as a sidelight. However, our curatorial efforts focused on "clouds as such" and not on their "incidental existence" in the sky; it is the phenomenon in its pure form – as a solitary element – that is in the center of our considerations. This implies that the eye is confronted with a structure completely detached from its surroundings, with an amorphous, floating object, and not with an accessory of pictorial intention. In this way, the structure's spatial context is repressed or even eliminated. Certainly there always remains a vestige of local references offering a direct link to what is permanent – some information about geographic coordinates. However, in any case the phenomenon of the cloud is meant to be the uncontested protagonist; from this perspective, we thought clouds to be less interesting as additional elements of other landscape or compositional contexts.

At the beginning of the history of clouds as a scientific natural phenomenon in its own right was a lecture entitled *On the Modification of Clouds*, presented by Luke Howard in London in 1802. He devised the classification of clouds into cirrus, cumulus, and stratus, on which research is still basically grounded. On the other hand, artists had been dealing with this celestial phenomenon long before. Filippo Brunelleschi's perspectival rendering of the baptistery in Florence, painted in the fifteenth century, seems to be particularly revealing with regard to the attitude toward clouds prevalent in those days. While thanks to central perspective he succeeded in accomplishing a tour de force in the three-dimensional depiction of the architectural structure and the square, he gave up when it came to a spatial representation of the sky. As long as he could rely on mathematical quantities and calculable proportions, he was capable of creating a spatial illusion; but he failed to do so in the face of the absence of dimensional and spatial reference points in the sky, using a mirror in order to transfer the real sky into the picture in the relevant place. Geometry and clouds had thus turned out to be incompatible, and, as celestial phenomena to be depicted, clouds proved to pose a particular challenge. This is what they continued to do in the centuries to come. Even in the early beginnings of landscape painting, for instance in Konrad Witz's „Miraculous Draft of Fishes" dating from 1444, clouds not only serve as a constructive element of the composition, but also allow the painter to demonstrate his great skills – such as in the reflection of clouds in the water – and introduce a narrative moment – such as with the mountain peaks in the background wreathed in clouds.

Depictions of clouds experienced an extraordinary heyday in the late eighteenth and early nineteenth centuries, when their significance for the atmosphere of a painting and for the temporal fabric of a landscape was recognized.[4] Relevant works by Caspar Wolf, Johann Christian Dahl, Carl Blechen, and William Turner number among the icons of cloud painting and were probably only surpassed by the genius of Caspar David Friedrich. In the latter's art, the landscape's being charged with the function of a mirror of the soul according to Romanticist natural philosophy reaches a climax, with clouds playing the main role on the claviature of emotions. As for Austrian art history, relevant artists during the period in question were Heinrich Reinhold and Adalbert Stifter.

3 The first selection comprised more than 200 works.

4 Inés Richter-Musso, "Die Wolke als Lehrmeisterin der Malerei," in: *Wolkenbilder,* see n. 1, pp. 48 ff.

ihrer Faszination verloren und dient als Emblem und Verbildlichung vielen KünstlerInnen als Anregung. Besonders im Bereich medienreflexiver künstlerischer Arbeit wird die Wolke aus verschiedenen Blickwinkeln und oft in seriellen Abläufen beleuchtet.

Wolkenmotive haben bei aller möglichen Opulenz die Tendenz zur formalen Reduktion, obwohl sie das vollständige Repertoire der formalen Möglichkeiten in sich tragen. Der Begriff Reduktion zielt hier vor allem auf ihre Verortbarkeit, da sie durch das Fehlen von Bezugspunkten zur Topografie oft wie losgelöst von dieser Welt vor dem Himmel schweben, lasten oder ziehen.[6] Größe, Stellung am Himmel, Blickwinkel zum/r Betrachter/in, all dies ist in solchen Fällen ausgeklammert. Dadurch erhalten Wolken mitunter etwas Absolutes, oder anders herum – indem die Relation fehlt – etwas absolut Relatives.

So wie die Wolken ihr Spiel in einem Zwischenreich, zwischen Himmel und Erde treiben, ist auch ihr Wesen durch dieses „Dazwischen" definiert. Sie sind nicht der Unendlichkeit des Raumes zugeordnet, aber auch nicht dem Koordinatensystem der terrestrischen Topografie, und es ist nicht einmal so selbstverständlich, ob sie der Welt des Dinglichen oder der des Phänomenalen zuzuordnen sind. „Wahrscheinlich muss man die Wolke zu jenen seltsamen, bizarren Objekten rechnen, die sich durch Unterscheidungen charakterisieren, die alle Unterscheidungen erschweren, unterlaufen oder überbrücken. Sie ist sogar der paradigmatische Fall eines solchen Halbdings."[7] Gerade diese Zwitterstellung zwischen Gegenstand und optischem Phänomen, zwischen eigengesetzlichem Wesen und fremdbestimmter feuchter Luft, zwischen Sein und Scheinen hat viele KünstlerInnen zu ihren Arbeiten motiviert.

Ein weiteres Charakteristikum der Wolke ist ihre Flüchtigkeit. Durch permanente Mutation und die Funktion als Fond für verschiedenste Lichtphänomene, aus denen meteorologische Vorgänge abgelesen werden, erscheint sie wie eine Verkörperung der Zeit. Kein Wunder folglich, dass gerade Stifter, der Großmeister der literarischen Slow Motion, sich mit den Wolken in etlichen Studien und Gemälden auseinandersetzte. Das Fließen der Zeit war ihm auch eine wesentliche gestalterische Herausforderung. So versucht in Stifters *Nachkommenschaften* der Maler Friedrich Roderer „die wirkliche Wirklichkeit und dazu die wirkliche Darstellung derselben" beim Malen einer Moorlandschaft unter einen Hut zu bringen, scheitert aber an der beschränkten Möglichkeit der Ölmalerei, etwas „wirklich" darzustellen, und muss erkennen, dass die unmittelbare menschliche Wahrnehmung dem medialen Ergebnis weit überlegen ist. Auch die Mittel der Perspektive und der illusionistischen Malerei versagen angesichts amorpher Naturformen, und darüber hinaus stellt der Zeitfluss der „wirklichen Wirklichkeit" eine nicht zu bewältigende Herausforderung für die „wirkliche Darstellung" mittels der Malerei dar.[8]

In der künstlerischen Praxis wurden den Wolken verschiedenste Rollen zugewiesen. Sie fungieren als diffuses Stimmungsbild, Symbol, Hintergrundfolie mit und ohne emotionalen Gehalt oder sind von beliebigen Motiven so weit abstrahiert, dass sie wie Gewölk wirken. Auch die Gegenstandslose Malerei vermittelt mitunter Assoziationen zu Wolken. Das bewusste „Nicht-Darstellen" als rein medieninterner Vorgang kann die vermeintliche Wahrnehmung der metamorphotischen Gestalt bzw. Nicht-Gestalt der Wolke erzielen.

6 Timm Starl bezeichnet diese Ortlosigkeit als „räumliches Nirgendwo".

7 *Archiv für Mediengeschichte – Wolken*, hrsg. von Lorenz Engell, Bernhard Siegert, Joseph Vogl, Weimar: Verlag der Bauhaus-Universität, 2005, S. 5.

8 Herta Wolf, „Optische Kammern und visuelle/virtuelle Räume", in: *Der Entzug der Bilder*, hrsg. von Michael Wetzel, Herta Wolf, München: Fink 1994, S. 79–102.

Auguste Kronheim, Durch die Wüste Through the Desert,
1980
Holzschnitt auf Bütten woodcut on hand-made-paper, 30,5 x 24,3 cm
Sammlung der Kulturabteilung der Stadt Wien MUSA Collection
of the Department for Cultural Affairs of the City of Vienna MUSA

Between 1821 an 1822, John Constable painted a series of cloud studies from the same spot (Hampstead), thus becoming a pioneer in the explorative observation of clouds by means of their visualization. He also added inscriptions, noting down the respective meteorological conditions on the reverse side of the pictures. Moreover, when doing these paintings, he imposed on himself a strict time schedule in order to guarantee the comparability of the phenomena observed.[5] This scientific approach corresponds with the then-incipient research into clouds and still manifests itself in contemporary works, such as in the installation by Gabriele Sturm.

Terms like "vagueness", "plurality", "chaos" and "polyvalency" have long become established keywords in contemporary thinking in an effort to understand the tremendously complex relationships within both the microscopic and universal worlds. The cloud as an early starting point and symbol for such discourse has lost nothing of its fascination and, as an emblem and metaphor, still inspires numerous artists. Particularly in the field of media-reflexive works, clouds are explored from various perspectives and frequently within serial processes.

In spite of their potential opulence, cloud motifs show a tendency toward reduction, although they carry the full repertory of formal possibilities. In this context, the term "reduction" refers primarily to the localizability of clouds, for because of the lack of topographical reference points, they frequently seem to be removed from this world, floating and resting in or moving across the sky.[6] Their size, their position in the sky, and the spectator's vantage point are all ignored in such cases. In this way clouds are sometimes imbued with something absolute, or conversely, because they are not related to anything else, with something absolutely relative.

Just as the play of clouds takes place in the intermediary realm between sky and earth, their nature is defined by an "in-between" quality. Clouds can be neither assigned to the infinity of the universe nor to the coordinate system of terrestrial topography; it is not even self-evident whether they belong to the world of things or to the world of phenomena. "Clouds must probably be numbered among those bizarre objects that are characterized by distinctive features complicating, undermining, or bypassing any distinction. They may even be considered the most paradigmatic case of such a semi-thing."[7] It is this very hybrid quality oscillating between object and optical phenomenon, between reality and appearance, between the self-governing nature of clouds and their dependence on humid air that has inspired artists in their work.

A further characteristic of clouds is their fleetingness. Due to permanent mutation and because of their function as a foil for various light phenomena from which meteorological processes can be read, they seem to be an embodiment of time. It is thus no wonder that Stifter, the great master of literary slow motion, dealt with clouds in numerous studies and paintings. The flow of time also was a great challenge to his creativity. In Stifter's *Nachkommenschaften (Descendants),* the painter Friedrich Roderer attempts to reconcile "reality as it really exists" and its "realistic depiction" when painting a moor, but because of the limited possibilities of oil painting fails to depict things as they really are; he is forced to recognize that immediate human perception is far superior to the result produced in an artistic medium. Even the tools of perspective and illusionism turn out to be futile when it comes to capturing amorphous natural forms; moreover, the flow of time in "reality as it really exists" is a challenge that cannot be tackled by the means offered by painting.[8]

5 Ramón Reichert, "'Forming the Formless'. John Constable's Cloud Studies," in: *Archiv für Mediengeschichte – Wolken*, edited by Lorenz Engell, Bernhard Siegert, and Joseph Vogl, Weimar: Verlag der Bauhaus-Universität, 2005, pp. 57–67.

6 Timm Starl refers to this unlocalizability as "spatial nowhere."

7 *Archiv für Mediengeschichte – Wolken*, edited by Lorenz Engell, Bernhard Siegert, and Joseph Vogl, Weimar: Verlag der Bauhaus-Universität, 2005, p. 5.

8 Herta Wolf, "Optische Kammern und visuelle/virtuelle Räume," in: *Der Entzug der Bilder*, edited by Michael Wetzel and Herta Wolf, Munich: Fink, 1994, pp. 79–102.

Die Frage nach der Bedeutung und Inhaltlichkeit der Wolke lässt sich nicht nur in eine Richtung beantworten. Ob sie positiv oder negativ besetzt wird, hängt vom kulturellen Hintergrund und Erfahrungsschatz der Interpretin/des Interpreten ab. Eine dunkle Wolke kann bedrohlich oder verheißungsvoll sein, sie kann verwüsten, aber auch das ersehnte Wasser bringen. Sie kann gnädig verhüllen oder sich ungebeten zwischen den Menschen und den Himmel stellen, sie ist das Gefährt der Götter, vielfach auch der Ort des christlichen Gottes, folglich ein Ort des Heils, wenngleich von ebendort auch die Blitze des Zeus geflogen kommen. Wolken sind die Mimik der Landschaft. Sie verhelfen ihr zu höchster Heiterkeit genauso, wie sie die Szenerie in tiefste Melancholie tauchen können.

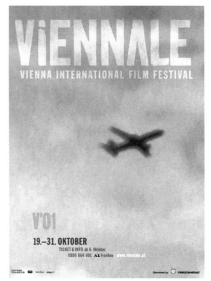

In Gilles Deleuzes Interpretation von Samuel Becketts Fernsehspiel ... *nur noch Gewölk* ... werden die Worte: „... nur noch Gewölk in den Höh'n ... bald kein Horizont mehr ... müdes Vogelgestöhn ..." zu einem zentralen Bild der Erschöpfung, die wiederum das Ende des Möglichen birgt.[9] Das sich Auflösende, Stofflose steht hier für einen Endpunkt, es ist ein dunkles Bild der Schwermut – eine zeitgenössische Allegorie der Melancholie, deren Erscheinungsformen sich im vergangenen Jahrhundert grundlegend gewandelt haben. Und doch wird die Wolke, deren Auflösung ins Nichts eine besonders zarte „Todesgestalt" evoziert, nur selten herangezogen, um die Schattenseiten des Lebens im Allgemeinen zu verbildlichen. Erschöpfung respektive das Melancholische als Hauptaussage bildnerischer Wolkenarbeiten finden sich nur in Ausnahmefällen.

In angewandten Bereichen wie Werbung, Film und diversen Printmedien überwiegen positive Konnotationen zu Wolken, die in diesen Zusammenhängen wohlgesittet in kleinen Gruppen, nicht zu groß und meist blütenweiß auftreten. Wird allerdings in Betracht gezogen, was in einer Wolke an Stofflichkeit enthalten sein kann, dann eröffnet sich mit der Gift-, Schadstoff-, Industrie- und Atomwolke ein weiteres Feld, in dem KünstlerInnen meist stärker inhaltlich orientiert agieren als bei den weniger belasteten „Naturwolken".

Die Ausstellung *stark bewölkt* umfasst Werke von über 50 KünstlerInnen aus den vergangenen 60 Jahren und vermittelt dank der vielen in Wien vorhandenen künstlerischen Zugänge zur Wolke einen reich bestückten Himmel. Fast alle Arbeiten stammen aus der Sammlung des MUSA, einige wenige, wie die fein strukturierten Wolken von Helga Cmelka oder das Modell der „Stufenwolke" von Gottfried Höllwarth, hat die Künstlerin/der Künstler dankenswerterweise als Leihgabe zur Verfügung gestellt. Von beiden befinden sich einige Arbeiten aus anderen Werkphasen im Bestand des MUSA.

Da die Wolke als Gebilde aus feuchter Luft nicht greifbar und auch gedanklich nur sehr komplex definierbar ist, erwiesen sich allzu strenge Kategorien als ihrem Wesen fremd und als für ein kuratorisches Konzept kontraproduktiv.

Zuvorderst ist der Umgang mit dem Motiv bei allen KünstlerInnen durch das eigene künstlerische Herangehen geprägt, die „Handschrift" tritt angesichts des wandelbaren Motivs, das selbst kaum über eigenen Charakter verfügt, in den Vordergrund. Beispielhaft zeigt sich diese Tendenz bei Alfred Stieglitz, der über seine Wolkenserie „Equivalents" sagt: „Durch die Wolken wollte ich meine Lebensphilosophie darstellen – zeigen, dass meine Fotografien ihre

9 Samuel Beckett, „... nur noch Gewölk ...", in: Samuel Beckett, *Quadrat. Stücke für das Fernsehen*. Mit einem Essay „Erschöpft" von Gilles Deleuze, Frankfurt/Main: Suhrkamp 1996, S. 40 und S. 51 f.

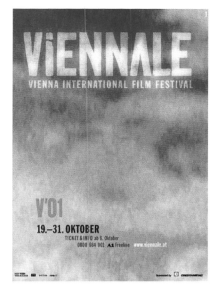

**Plakat der VIENNALE 2001
(nach September 2001)** Poster of the
VIENNALE 2001 (after September 2001)
© VIENNALE-Vienna International Film
Festival, Abdruck mit freundlicher
Genehmigung der VIENNALE Reproduced
with the kind permission of the VIENNALE

In artistic practice, clouds have been assigned various roles. They function as a
means to create a diffuse atmosphere, as a symbol, or as a backdrop with or
without emotional content; any chosen motif may be abstracted to such an extent
that it appears to be a mass of clouds. Occasionally, non-objective painting can be
associated with clouds as well. The deliberate intention to produce something that
does not represent anything – a process purely focusing on the medium – may
result in a metamorphotic configuration or non-configuration that appears to be a
cloud.

Investigations into the meaning and substance of clouds can lead in many
directions. Whether clouds are connoted positively or negatively depends on the
interpreter's cultural background and experience. A dark cloud can make a
threatening or a promising impression; it can be devastating or deliver the water
that has long been desired. It can conceal graciously or move between man and
the sky uninvited. It may be the vehicle of deities and frequently also the abode of
the Christian God and thus a place of salvation, even if Zeus casts down his
thunderbolts from there. Clouds lend expressiveness to a landscape. They can
make the scenery appear utterly serene or immerse it in deep melancholy.

In Gilles Deleuze's interpretation of Samuel Beckett's television play *… but the
clouds …*, the words "Seem but the clouds of the sky / When the horizon fades; /
Or a bird's sleepy cry" become a central image of exhaustion, which embraces the
end of what might be possible.[9] Here the dissolving, immaterial quality defines an
ultimate point – it is a dark image of gloom, a contemporary allegory of melancholy,
whose manifestations have changed profoundly during the past century. And yet
the cloud, whose disintegration into nothingness evokes a particularly frail "image
of death," is only rarely referred to in order to represent the dark sides of life in
general. In the visual arts, cloudscapes expressing exhaustion or melancholy are an
exception.

When the image of a cloud is applied in advertising, film, and various printed
media, positive connotations prevail. In such contexts, clouds appear in small
groups in an orderly fashion, not too big and usually sparkling white. Considering,
however, all the substances a cloud may contain, an entirely new field opens up:
toxic clouds, nuclear clouds, and clouds produced by exhaust fumes or industrial
emissions rather provoke artists to act in a more thematically focused fashion than
with the less negatively tainted "natural" clouds.

The exhibition *clouds up high* comprises works by more than 50 artists from the
past 60 years and – thanks to Vienna's great diversity of artistic approaches toward
clouds – conveys a lively populated firmament. Almost all of the works on display
come from the MUSA's own collection, except for a few that have generously
been lent by their authors – such as the subtly structured clouds by Helga Cmelka
and the model "Stufenwolke" (Layered Cloud) by Gottfried Höllwarth. Both artists,
though, figure in the MUSA's collection with works from other periods.

Since clouds consist of humid air, they are intangible, and grasping them
intellectually is quite a complex process. An overly strict classification into
categories is thus alien to their nature and has turned out to be counterproductive
for a curatorial concept.

For all of these artists it can be said that their handling of the motif in question is
first and foremost defined by their individual approaches; and due to the
changeability of the motif, which hardly has a character of its own, their personal

9 Gilles Deleuze, "L'Épuisé," in: Samuel Beckett, *Quad et autres
pièces pour la télévision,* Paris: Éditions de Minuit, 1992, pp. 57–106.

Präsenz nicht dem Bildgegenstande verdankten – nicht besonderen Bäumen oder Gesichtern oder Interieurs, keinen besonderen Privilegien, denn die Wolken waren für alle gratis – noch wurde keine Steuer auf sie erhoben".[10]

Der Grund für die schwere Fassbarkeit liegt nicht zuletzt in der ständigen Verwandlung und Bewegung dieser Dunstgebilde in sich und in ihrem Umfeld. Durch dieses fließende Sein gelten sie auch als Äquivalent der Zeit. Es lag also nahe, die große Diaprojektion „Clouds" von Siegrun Appelt ins Zentrum der Schau zu stellen, da sie nicht nur die kaum merkliche Veränderung der Wolken ins Bild rückt, sondern darüber hinaus durch die technisierte Bildgebung, mit der auch akustische Signale verbunden sind, den Vorgang der Wahrnehmung an sich thematisiert.

Um dieses bewusste, verstehende „Wolkensehen" herum sind die anderen Werke angeordnet, wobei keine strikten Gruppierungen nach Medien oder konzeptuellen Ansätzen erstellt wurden, da hier die Übergänge wie Wolken ineinander fließen.

Zunächst fällt eine relativ umfangreiche Gruppe ins Auge, der ein konventioneller Zugang mit den Mitteln der Malerei und Grafik eigen ist. Die Wolken von Franz Wacik zeigen noch ein sehr konservatives Verhältnis zum Motiv, das auf die Tradition des 19. Jahrhunderts zurückverweist. Das Blatt stammt aus den 1930er Jahren und ist damit die älteste Wolke der Ausstellung. Auch die Beispiele von der Hand August Kampfers und Hans Jöchls sind ganz auf die Wiedergabe des Naturphänomens ausgerichtet, beide betrachten die Wolke als zeichnerische Herausforderung, wobei der eine stärker auf deren Plastizität, der andere eher auf ihre Transluzidität konzentriert ist.

Die Abstraktion in der Malerei hat bekanntlich verschiedene Wurzeln, eine davon ist die Natur beziehungsweise der Gegenstand. Im Prozess des Auseinanderlösens von Form und Bedeutung entfernt sich das bildnerische Ergebnis schrittweise vom ursprünglichen Motiv, bis der anfängliche Zusammenhang im rationalen Sehvorgang nicht mehr feststellbar ist. Einer der Protagonisten dieser figurativen Abstraktion war Sam Francis. Seine „Formen auf der Leinwand erinnern an Wolken, die in dichter Ballung einen Himmelsausschnitt füllen oder die zu Fetzen zerrissen über das Sehfeld jagen".[11] Ab Mitte der 1950er Jahre entwickelt er seinen Stil zu einer Malerei in Farbwolken, die fallweise wirkt, als wäre eine Aufsicht auf die Erde durch die Wolken hindurch zu sehen. Etwa zu dieser Zeit setzt auch das Werk von Wolfgang Hollegha ein. In Affinität zu Francis geht er gleichfalls von Elementen der Natur aus, deren formale Bedeutsamkeit er in großen Formaten hinter sich lässt, sodass in der Umsetzung eine reine Malerei aus farbintensiven Wolken entsteht, die nur noch im Titel auf den Ursprung verweist. Hollegha ist einer der Gründungsväter dieser Auffassung von Malerei in Österreich und hat eine große Anzahl von jüngeren KünstlerInnen beeinflusst.

Natürlich hat jede der Malereien in dieser Gruppe ihre besondere Eigenart. So vermittelt Karl Hikade mit seinen subtilen Farbabstufungen gleichermaßen die Duftigkeit der Wolken, forciert die Unschärfe als Stimmungsträger und erzeugt räumliche Tiefe. Ona B. dagegen ist mit „Nordlicht" mehr an der Wiedergabe des physikalischen Phänomens interessiert, wobei das Gemälde nicht gesehen werden sollte, ohne ihre installativ-performative Grundhaltung zu reflektieren. Bei Ursula Heindl steht die Beschäftigung mit der Farbe im

10 Alfred Stieglitz, Wie ich dazu kam, Wolken zu fotografieren, in: Wolkenbilder. Die Entdeckung des Himmels, München 2004, S. 87.

11 Franz Meyer, Kunsthalle Bern 1960, zitiert nach: Oliver Wick, „Über den Wolken und wolkiges Nichts", in: Wolkenbilder (Anm. 1), S. 129.

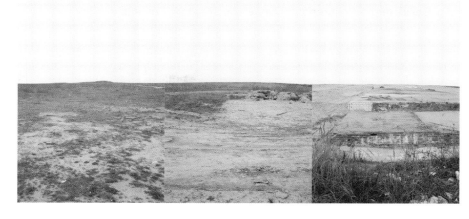

Nina Dick, Brache_3 (12 Brachen in Berlin)
Waste Land_3 (12 waste lands in Berlin), **2004**
Silbergelatineprint auf Aluminium
gelatin silverprint on aluminum, **94 x 171 cm**
Sammlung der Kulturabteilung der Stadt Wien MUSA Collection of
the Department for Cultural Affairs of the City of Vienna MUSA

styles come to the fore. This tendency exemplarily manifests itself in the works of
Alfred Stieglitz, who said about his cloud series "Equivalents": "Through clouds
[I wanted] to put down my philosophy of life – to show that my photographs were
not due to subject matter – not to special trees, or faces, or interiors – to special
privileges – clouds were there for everyone – no tax as yet on them – free."[10]

The reason for their being so difficult to grasp lies in the constant metamorphosis
and movement of these hazy structures within themselves and in their surroundings.
Due to this flowing existence, they are also considered an equivalent of time.
It therefore suggested itself to make the large slide projection "Clouds" by Siegrun
Appelt the center of the show, as it not only focuses on the hardly noticeable
transformations of clouds, but also addresses perception as such through the
engineered imaging process that also encompasses acoustic signals.

The other works are arranged around this conscious and comprehending
observation of clouds, without their being strictly grouped according to medium
or concept; transitions are flowing, comparable to the clouds themselves.

What catches the eye at the very beginning of the exhibition is a relatively large
group of works that rely on conventional approaches using the traditional means of
painting and the graphic arts: Franz Wacik's clouds are still informed by a rather
conservative treatment of the motif, pointing to the tradition of the nineteenth
century. The sheet dates from the 1930s and is thus the oldest cloudscape in the
exhibition. Examples by the hands of August Kampfer and Hans Jöchl are
completely directed at the rendering of a natural phenomenon; both of them regard
the motif of the cloud as a challenge to draftsmanship, with one concentrating on
its volume and the other focusing on its translucency.

As it is well known, abstraction in painting can have several origins, one of them
being nature or objects as such. In the process of separating form from content,
the painted result is gradually removed from the original motif, until the initial
connection can no longer be perceived rationally. Sam Francis was among the
protagonists of this kind of figurative abstraction. His "forms on canvas are
reminiscent of clouds which, densely accumulating, fill up a section of the sky or,
torn into shreds, race across the field of vision."[11] Starting in the mid-1950s, his
painting evolved into a style of colored clouds, occasionally suggesting a bird's eye
view of the earth shining through. This was about the time when Wolfgang

10 Alfred Stieglitz, "How I Came to Photograph Clouds," in:
Amateur Photographer and Photography, vol. 56, no. 1819, 1923,
p. 255.

11 Franz Meyer, Kunsthalle Bern, 1960, quoted from: Oliver Wick,
"Über den Wolken und wolkiges Nichts," in: *Wolkenbilder,* see n. 1,
p. 129.

Zentrum, die sie besonders in den roten „Wolkenbildern" zu einer unglaub-
lichen sinnlichen Wirkung zu steigern vermag. Die unmittelbare Beschäftigung
mit der Farbe und dem Malvorgang ohne vorgegebenes Motiv führt auch bei
Gerhard Baldasti zu beeindruckenden Wolkenformationen von hoher emotio-
naler Wirkkraft. Andere Wolkenmalereien, die gleichfalls an der Grenze
zwischen Phänomen und Abstraktion stehen, verdanken sich der Auseinan-
dersetzung mit konkreten topografischen Gegebenheiten (Moje Menhardt,
Helmut Swoboda) oder der Fragmentierung des Himmels zu Ausschnitten,
wodurch sich erst in der Serie der Bedeutungsgehalt wieder erschließt (Fritz
Bergler). Hubert Roithner schafft mit seinen großformatigen abstrakten
Bildern Eindrücke voller Assoziationsmöglichkeiten, die im gezeigten Werk
„Air" mehr auf ein Gefühl des Himmels als auf seine konkrete Darstellung
hinzielen, und Josef Schwaiger betreibt streng konzeptionelle, wissenschaf-
tlich systematische Bildschöpfung – als Malerei lässt sich dieser Vorgang fast
nicht mehr beschreiben – und kommt mit dieser Prozedur ebenfalls zu
wolkigen Ergebnissen. Andere Malereien haben stärker konstruktive bzw.
auch narrative Elemente (Drago Prelog, Peter Rataitz), während bei Irma Eberl
strukturelle Überlegungen bei der Beschreibung des Phänomens wesentlich
werden und die Zwitterstellung der Wolke zwischen Dinghaftigkeit und
Abstraktion ansprechen.

Vor sehr persönlich gefärbten Hintergründen bedient sich schließlich eine
Reihe von MalerInnen auf erzählerische Weise des Themas der Wolke. In
mythologischen, religiösen oder auch märchenhaften Zusammenhängen
tauchen sie an prominenten Stellen auf, tragen oder verbergen Götter und
lassen durch surreal verdrehte Größenverhältnisse magische Stimmungen
entstehen. Phantastische Himmelskörper zwischen Wolken finden sich auch
bei Anton Lehmden und Werner Trinkl, während in der „Sache mit den vier
Schornsteinen vor meinem Fenster" von Heinz Lindinger die Wolken zu
mysteriösen Akteuren werden, denen nicht so leicht auf die Spur zu kommen
ist. Geheimnisvoll, wenn auch wesentlich ironischer schweben auch die
Lämmchen von Sebastian Weissenbacher schwarzgesichtig vor undefinier-
tem Grau. Paul Hirschmann lässt seine nackte Rückenfigur in ostentative
Parallele zur Sehnsuchtsfigur der Romantik treten, ohne dass geklärt wäre,
ob eine ironische Auffassung dahinter steht. Fast entgegengesetzt, jedenfalls
dezidiert anti-narrativ arbeitet Martin Walde, dessen Wolke als mehr oder
weniger beliebiges Bildelement fungiert.

Modelle von Wolken in grafischen Vereinfachungen, die sich der arche-
typischen Wolke fast im Sinne eines Piktogramms annähern oder auch in der
Festlegung des an sich nicht festlegbaren transitorischen Moments in der
Statik einer skulpturalen oder grafischen Lösung, finden sich bei Simon
Wachsmuth, Hubert Pfaffenbichler, Markus Maria Gottfried und Gottfried
Höllwarth.

KünstlerInnen, die (ausschließlich) mit Fotografie arbeiten, bilden naturge-
mäß eine starke Wolkenschicht aus, ist doch die Wolkenfotografie schon seit
dem 19. Jahrhundert fast als eigenständiges Genre ausgeprägt.[12] In einer
frühen Serie (1962) beschäftigt sich Elfriede Mejchar mit dem Thema,
verwendet darin unterschiedliche Ausschnitte, auch solche, in denen die
Landschaft als Basis für das Wolkenspektakel dient, doch gelingt es ihr, durch
ein spezielles Tönungsverfahren die Konzentration der Rezipientin/des

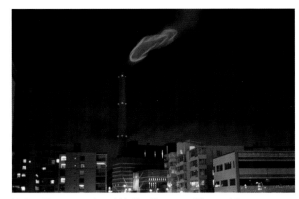

Helen Evans und and Heiko Hansen, Nuage Vert,
Helsinki, 2008
© bei den KünstlerInnen by the artists, Abdruck mit freundlicher
Genehmigung der KünstlerInnen reproduced with the kind
permission of the artists

Hollegha's career began. Showing an affinity to Francis, he started out from elements of nature as well, overcoming their formal signification with his pure painting of brightly colored clouds in large formats, with only the titles supplying clues as to the motifs' origins. Hollegha was one of the pioneers of this approach to painting in Austria and exercised a considerable influence on younger artists.

It goes without saying that each of the painting styles in this group has its own idiosyncrasies. For example, Karl Hikade's subtly nuanced colors likewise evoke the fluffiness of clouds; the artist relies on blurring for atmosphere and attempts to create an illusion of depth. In "Nordlicht" (Northern Lights), on the other hand, Ona B. is more interested in capturing a physical phenomenon; looking at her painting, one should bear in mind her penchant for installation and performance. In Ursula Heindl's work, the focus is on color, which she manages to heighten to such an extent that an extraordinarily sensual effect is achieved; this applies particularly to her red "Wolkenbilder" (Cloud Pictures). In Gerhard Baldasti's art as well, an intuitive preoccupation with color and painting freed from given motifs leads to impressive cloud formations of great emotional impact. Further cloudscapes also oscillating between phenomenon and abstraction rely on the exploration of concrete topographic situations (Moje Menhardt, Helmut Swoboda) or on the fragmentation of the sky into individual sections, with the meaning of the work only revealing itself as a series (Fritz Bergler). With his large abstract pictures, Hubert Roithner creates impressions allowing a host of associations and in his work "Air" aims at evoking rather a feeling of the sky than a concrete depiction of it. Josef Schwaiger draws upon strictly scientific and systematic concepts for the creation of his work, which can practically no longer be described as painting, although the artist's method likewise produces cloudy results. Other approaches concentrate more intensively on constructive and narrative elements (Drago Prelog, Peter Rataitz), whereas structural considerations become relevant in Irma Eberl's description of the phenomenon, which also addresses the cloud's hybrid nature that lies between reality and abstraction.

Starting out from highly personally tinged backgrounds, a number of artists relate to the subject of the cloud in a markedly narrative manner. Clouds appear in prominent places in the context of myths, legends, and fairy tales. They support or conceal deities or create a magical atmosphere through surreally reversed proportions. In Anton Lehmden's and Werner Trinkl's art, clouds appear amidst fantastic celestial bodies; in Heinz Lindinger's work "Die Sache mit den vier Schornsteinen vor meinem Fenster" (The Thing about the Four Chimneys in Front of My Window), clouds appear as mysterious protagonists that are difficult to track down. Just as mysteriously, if much more ironically, Sebastian Weissenbacher's black-faced lambkins float across a field of indefinable gray. Paul Hirschmann, with his back view of a nude figure, draws an ostentatious parallel to Romanticism's embodiment of yearning, without revealing, however, whether there is an ironic attitude behind it. On the other hand, Martin Walde, whose cloud functions as a more or less arbitrarily chosen pictorial element, moves into a diametrically opposed, or at least anti-narrative, direction.

Graphically simplified models of clouds approximating their archetype almost in the sense of a pictogram or adopting the static form of a sculptural or graphic solution in an attempt to define the cloud's virtually indefinable transitoriness occur in the art of Simon Wachsmuth, Hubert Pfaffenbichler, Markus Maria Gottfried, and Gottfried Höllwarth.

Rezipienten auf die Dramaturgie des Himmels zu richten. 20 Jahre später entstand mit den Polaroids von Trude Rind eine weitere sehr umfangreiche Wolkenserie, mit der sie die Atmosphäre des Augenblicks von einem gleichbleibenden Standpunkt aus festhielt und damit eine Art bildliches Tagebuch erstellte. Eine Geschichte, deren Stimmung durch die Beigabe einer Wolke bestimmt ist, erzählt auch Jana Wisniewski in ihrem „Fotomärchenbuch". Als Einzelstücke, die nahezu den Anspruch eines Gemäldes erheben, wirken die Aufnahmen von Norman Maier. Er versteht es, mit der Kamera eine starke malerische Wirkung zu erzielen, während Gyula Fodors nicht weniger beeindruckende Arbeit eher den physikalischen Phänomenen des Himmels nachspürt und Silvia Grossmann auf ihrer Reise mit einem Frachter über den Atlantik im Gegeneinander der strengen Geometrie der Container und der Unendlichkeit des Wolkenhimmels über dem Meer zu elementaren Bildfindungen gelangt.

In der gesamten Wiener Szene gibt es wohl kaum KünstlerInnen, die so sehr mit dem Thema der Wolke im Zusammenhang gebracht werden, wie Eva Schlegel und Herwig Kempinger; unabhängig voneinander schaffen sie auf Basis der Fotografie in mehreren Verbindungs- und Verfremdungsschritten markante Wolkenwerke, die über die „wirkliche Wirklichkeit" weit hinausgehen. Die Arbeit von Julie Monaco schließlich lässt die sinnlich wahrgenommene Welt hinter sich und bleibt doch bei ihr, indem ihre äußere Erscheinung vollständig virtuell errechnet wird. Auch im Werk von Hildegund Bachler, Christine Meierhofer, Iris Nitzl, Jochen Traar und Hans Weigand ist das „natürliche" Motiv lediglich Ausgangspunkt der künstlerischen Intention, welche die Wolken in völlig neue Deutungszusammenhänge stellt.

Schließlich finden wir eine stark divergierende Gruppe von Kunstwolken, für die das Phänomen lediglich als Rohstoff verwendet und im Sinne der jeweiligen künstlerischen Intention auf vielfältigen Wegen verwertet wurde.

Eine Wolke auf einem Bild kann dann als Wolke durchgehen, wenn sie wie eine Wolke ausschaut, das heißt, vieles kann eine Wolke spielen, ausgeschlossen sind eigentlich nur geometrische Formen. Bei Philipp Preuss alias David Ziegelman kommt es zur Wolkenbildung durch Bleichen auf blauem Stoff. Aber kann ein Eliminierungsvorgang eine Wolke bilden?

Durch Phasenverschiebung (Astrid Bechtold), Einkopieren des fliegenden Selbstporträts (Aimée Blaskovic), performative Elemente (Lea Titz) oder die Konfrontation der Wolken mit Text (Michaela Spiegel, Claudia Klučarić) werden Irritationen erzeugt, die uns die eigene Wahrnehmung hinterfragen lassen. Ähnlich agiert Khy Engelhardt. Mit der Verunsicherung des Sehens arbeiten auch Kurt Lang und Michael Pisk, wobei der eine durch zerknülltes Zeitungspapier hinter trübem Plexiglas und der andere durch Krakelee, das er in einem speziellen Materialschwundverfahren erreicht, das Auge dazu verführt, Wolkenformen wahrzunehmen.

Heinz Gappmayr und Gerhard Jaschke gehen konzeptuell vor und verschränken die Bildfindung mit sprachlichen Elementen.

Im Werk von Gottfried Ecker finden sich Wolken über mehrere Phasen und in verschiedenen Medien. Die Idee zur Malerei nach einer fiktiven Skulptur einer Wolke entspricht einem seiner Prinzipien in den 1990er Jahren, Figuren als Skulpturen in ihr „natürliches" Umfeld zu stellen, wodurch die Ambivalenz

12 Siehe den Beitrag von Timm Starl.

Artists working (exclusively) with photography have naturally developed into an impressive formation, given that cloud photography has been a more or less autonomous genre since the nineteenth century.[12] Elfriede Mejchar dealt with the subject in an early series (1962), using various fields of view – including such in which the landscape provides a basis for the spectacle of clouds above. Nevertheless, thanks to a special tinting process, she succeeds in directing the spectator's attention to the dramaturgy of the sky. Trude Rind's extensive cloud series was made 20 years later; in her Polaroid prints she captured the atmosphere of specific moments from the same vantage point, thus compiling a kind of visual diary. In her "Fotomärchenbuch" (Photographic Storybook), Jana Wisniewski relates a tale whose atmosphere strongly depends on a cloud. The photographs of Norman Maier, who succeeds in accomplishing a powerful painterly effect with his camera, make the impression of unique specimens that almost pretend to be paintings. On the other hand, Gyula Fodor's works, which are by no means less impressive, rather explore physical phenomena in the sky. During a journey on a cargo ship across the Atlantic, Silvia Grossmann arrived at elementary pictorial inventions by juxtaposing the containers' austere geometry with the infinity of the clouded sky above the sea.

In the entire Viennese art scene there are hardly any other artists who can be so closely associated with the subject of clouds as Eva Schlegel and Herwig Kempinger. Independently from each other and using photography as a basis, they create striking cloudscapes going far beyond "reality as it really exists" through multiple steps of combination and distortion. Julie Monaco leaves the sensually perceived world behind and yet remains faithful to it by making a completely virtual calculation of its outer appearance. In the works by Hildegund Bachler, Christine Meierhofer, Iris Nitzl, Jochen Traar, and Hans Weigand, the "natural" motif also serves merely as a starting point for artistic volition, with clouds being used in entirely new contexts and interpretations.

Finally, we encounter a strongly diverging group of artificial clouds in which the phenomenon of the cloud is purely employed as a raw material to be used in manifold ways and according to different artistic intentions.

A cloud in a picture may be taken for a cloud if it looks like one; i.e., many things can play the role of a cloud, so that in fact only geometric forms are excluded. In the art of Philipp Preuss alias David Ziegelman, the formation of clouds is brought about by bleaching blue fabric. But can clouds really be built with the aid of an elimination process?

Irritations urging us to question our own perception are achieved through phase shifting (Astrid Bechtold), the integration of a floating self-portrait (Aimée Blaskovic), performative elements (Lea Titz), or the confrontation of clouds with text (Michaela Spiegel, Claudia Klučarić). Khy Engelhardt experiments with a similar approach. Kurt Lang and Michael Pisk likewise attempt to unsettle the sense of vision, either by putting crumpled newsprint behind clouded Plexiglas or by beguiling the eye into perceiving cloud formations in craquelure produced in a special material reduction process.

Heinz Gappmayr and Gerhard Jaschke employ a conceptual approach, combining their images with language elements.

Clouds in different media run through several periods of Gottfried Ecker's work. His idea of doing a painting after the fictitious sculpture of a cloud corresponds

12 See the contribution by Timm Starl.

des Abbildens hervortritt. Mit den „Wolkenkalotten" steht er in einer spielerischen Nachbarschaft zu Joseph Beuys, der im Aquarell „Was birgt die Wolke?" 1981 ebenfalls den Schädel unterlegt und damit auf das positive Entwicklungspotential des Menschen hinweist.

Gabriele Sturms Wolkenmalerei und ihre Bemühungen, die Spezifik der Wolken direkt vor Ort festzuhalten, erinnern ein wenig an die Fotoserien, die der führende Meteorologe Albert Riggenbach um 1900 auf dem Säntis (CH) gemacht hatte. In ihrem Streben nach dichter Beschreibung, das ihr gesamtes bisheriges Schaffen auszeichnet, erweitert sie ihre Studien um Aquarelle, die in der Geschwindigkeit der Produktion mit der fließenden Veränderung des Motivs Schritt halten können. Aber auch in diesen Blättern trägt Sturm der permanenten Mutation Rechnung und vereinfacht den Darstellungs-„Gegenstand" zu schlicht vorgetragenen Farbangaben, die den Moment der Aufnahme charakterisieren. Ein Video erweitert schließlich die Beobachtung um den Faktor Zeit. Als Basis für diese Beobachtung in unterschiedlichen Medien unterlegt sie eine frei gestaltete und den ganzen Raum erfassende meteorologische Karte, vor der die Forschungsergebnisse in einem gedachten Rastersystem platziert werden, das wiederum auf die Systematik des künstlerischen Blicks verweist. In dieser Verortung in ein geometrisches System besteht letztlich eine Affinität zu den Wolkenserien Gerhard Richters, der seine Wolken gleichfalls in ein Hängungssystem fügt und damit den Eindruck eines Fensterdurchblicks hervorruft. Die „wirkliche Wirklichkeit" und die „wirkliche Darstellung" kommen sich in diesen Arbeiten näher.[13]

13 Vergleiche dazu: *Wolkenbilder* (Anm. 1), S. 167–177.

Alle Personenbezeichnungen, die in diesem Text sprachlich in der männlichen Form verwendet werden, gelten sinngemäß auch in der weiblichen Form.

with one of his principles of the 1990s, which was to place figures in their "natural" environment in the form of sculptures, thus underscoring the ambivalence of making a reproduction. His "Wolkenkalotten" (Cloud Calottes) are a playful reference to Joseph Beuys, whose watercolor "Was birgt the Wolke?" (What Does the Cloud Hold?) from 1981 is likewise based on the human skull and thus points to man's positive potential for development.

Gabriele Sturm's cloud paintings and her efforts to capture the specific qualities of clouds on the spot are somehow reminiscent of the series of photographs taken by Albert Riggenbach, a leading meteorologist, on Mount Säntis (CH) around 1900. In her ambition to produce a concise description – a feature characterizing her entire œuvre – she further extends her studies by watercolors whose swiftness in execution can keep pace with the flowing transformation of her motif. But in these works as well, Sturm takes into account the aspect of permanent mutation, reducing her "object" to plain color statements identifying the moment of the sheets' making. In a video she eventually adds the factor of time. For her observations in different media, she uses a freely conceived meteorological map filling the entire space as a basis from which the findings are transferred to an imaginary grid, which in turn underlines the systematic nature of her artistic eye. As for this inscription into a geometric system, there is an affinity to the cloud series by Gerhard Richter, who also integrates his clouds within a hanging system, thus creating the impression of a view through a window. In these works, "reality as it really exists" and its "realistic depiction" do converge.[13]

13 Comp. *Wolkenbilder,* see n. 1, pp. 167–177.

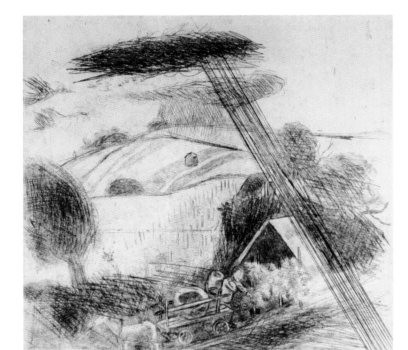

Leopold Birstinger, Weinernte Vintage, um c. **1934**
Radierung auf Papier etching on paper, **25,2 x 25,1 cm**
Privatbesitz private ownership

Timm Starl

Eine kleine Geschichte der Wolkenfotografie

> „[...] die wunderbaren Gebilde des Ungreifbaren." Charles Baudelaire, vor 1867[1]
>
> „Clouds are especially good subject matter for the photographer." Alvin Langdon Coburn, 1966[2]
>
> „dass sie ohne uns auskommen, / die Wolken, aber nicht umgekehrt" Hans Magnus Enzensberger, 2003[3]

1821 und 1822 hält der englische Maler John Constable (1776–1837) von seinem Garten aus in zwölf Ölskizzen den bewölkten Himmel fest und notiert Datum und Stunde. An denselben Tagen 173 Jahre später nimmt der deutsche Künstler Gerhard Lang (geb. 1963) vom gleichen Standort in Hampstead Heath aus die Wolkengebilde fotografisch auf.[4] Die zwei Künstler arbeiten mit verschiedenen Medien, wobei Constable die bald aufkommende Fotografie anklingen lässt, wenn er zu jedem Bild den genauen Zeitpunkt seiner Entstehung festhält. Damit kategorisiert er das Werk als Momentbild, auch wenn im gemalten Augenblick im Gegensatz zum fotografischen mehrere aufeinander folgende Erscheinungen zusammengefasst sind.

Die nachstehenden Ausführungen umfassen in etwa den Zeitraum von Constable bis Lang und sollen einen Überblick darüber geben, mit welchen Fragestellungen sich Fotografen und Fotografinnen, Künstler und Künstlerinnen,[5] die mit Fotografie arbeiten, dem Phänomen Wolken genähert haben. Dabei steht im Hintergrund, dass mit der Kamera Erscheinungen festgehalten werden, deren Gestalt und Volumen sich ständig ändern, also bewegen. Das verwendete Medium ist für die Darstellung eigentlich nicht prädestiniert, zumal es nur den Stillstand kennt, in den es sämtliche Erscheinungen versetzt. Um meine „kleine Geschichte" entsprechend kurz zu halten, habe ich einige markante Positionen ausgewählt und die wissenschaftlichen Vermessungen mittels Fotografie und Fotogrammetrie sowie deren kulturgeschichtliche Dimension ausgeklammert, nachdem Herta Wolf in mehreren prägnanten Beiträgen darauf eingegangen ist.[6]

Le Gray, 1856

Die frühen Propagandisten der neuen Kunst lassen sich bei ihren Voraussagen nicht davon beirren, dass manche Aufnahmen noch gar nicht möglich sind. Der Physiker und Leiter der Pariser Sternwarte Dominique François Arago (1786–1853) versichert am 4. Januar 1841 in einem Bericht an die Académie des sciences, man werde künftig mittels der Fotografie „in Bewegung befindliche Objekte wie Bäume im Wind, fließende Gewässer, einen Meeressturm, ein Schiff unter Segeln, Wolken oder das Gewühl einer Menschenmenge" festhalten können.[7] Dass er Wasser, Schiffe und Wolken erwähnt, mag unter anderem daran gelegen haben, dass es sich um gängige Motive der romantischen Landschaftsmalerei handelte, die auch in Frankreich einigen Zuspruch erfuhren. Als Freund des Erfinders Louis Jacques Mandé Daguerre (1787–1851) weiß der Astronom von den verhältnismäßig langen Belichtungszeiten – bei Landschaftsaufnahmen mehrere Minuten –, die notwendig sind, um scharfe Bilder zu erhalten. Bewegte Gegenstände

1 Charles Baudelaire, „La soupe et les nuages / Die Suppe und die Wolken", in: ders., *Le Spleen de Paris. Gedichte in Prosa* [1869], Übersetzung von Friedhelm Kemp, München, Wien: Carl Hanser, 1985 (*Sämtliche Werke/Briefe*, hrsg. von Friedhelm Kemp und Claude Pichois in Zusammenarbeit mit Wilhelm Drost, Bd. 8), S. 280–281, hier S. 281.
2 *Alvin Langdon Coburn. Photographer. An Autobiography with over 70 Reproductions of his works*, ed. by Helmut and Alison Gernsheim, New York: Dover Publications, 1978, S. 46.
3 Hans Magnus Enzensberger, „Die Geschichte der Wolken", in: ders., *Die Geschichte der Wolken. 99 Meditationen*, Frankfurt am Main: Suhrkamp, 2003, S. 133–143, hier S. 137.
4 Zur Datierung vgl. Ramón Reichert, „‚Forming the formless'. John Constable's *Cloud studies*", in: *Archiv für Mediengeschichte – Wolken*, hrsg. von Lorenz Engell, Bernhard Siegert, Joseph Vogl, Weimar: Verlag der Bauhaus-Universität, 2005, S. 57–67; zu Gerhard Lang vgl. Lucius Burckhardt, „Skying. John Constable's Clouds are still passing", in: *Luft*, Köln: Wienand, 2003 (Kunst- und Ausstellungshalle der Bundesrepublik Deutschland, Schriftenreihe Forum, Bd. 12, Elemente des Naturhaushalts IV), S. 133–136.
5 Die weibliche Form unterschlage ich im Folgenden, zumal sich nahezu ausschließlich männliche Bildautoren des Themas angenommen haben.
6 Herta Wolf, „Wolken, Spiegel und Uhren. Eine Lektüre meteorologischer Fotografien", in: *Fotogeschichte*, Heft 48, 13. Jg., 1993, S. 3–18; Herta Wolf, „Fixieren – Vermessen: Zur Funktion fotografischer Registratur in der Moderne", in: *Riskante Bilder. Kunst, Literatur Medien*, hrsg. von Norbert Bolz, Cordula Meier, Birgit Richard und Susanne Holschbach, München: Wilhelm Fink, 1997, S. 239–261; Herta Wolf, „Wie man Wolken beobachtet", in: *Wolkenbilder. Die Erfindung des Himmels*, hrsg. von Stephan Kunz, Johannes Stückelberger, Beat Wismer, Ausstellungskatalog Aargauer Kunsthaus, Aarau, München: Hirmer, 2005, S. 75—83.
7 *Comptes rendus de l'Académie des science*s, 1841, Bd. 12, [Sitzung vom 4. Januar], S. 23.

Timm Starl

A Brief History of Cloud Photography

"[…] the marvelous constructions of the impalpable." Charles Baudelaire, before 1867[1]

"Clouds are especially good subject matter for the photographer." Alvin Langdon Coburn, 1966[2]

"that clouds can do without us,/ but not vice versa" Hans Magnus Enzensberger, 2003[3]

Die Vignette entspricht der Illustration auf dem Umschlag des Buches von The vignette is identical to the illustration on the cover of the book by **Ludwig David, *Ratgeber im Photographieren. Leicht faßliches Lehrbuch für Amatörphotographen*, 87. bis 91. neu bearbeitete Auflage** 87th–91st rev. eds. Halle a. S.: Wilhelm Knapp, 1916.

In 1821 and 1822, the English painter John Constable (1776–1837) made twelve oil sketches of the clouded sky from his garden, noting down the respective dates and times of day. On the very same days 173 years later, the German artist Gerhard Lang (born in 1963) took photographs of cloud formations from the same spot on Hampstead Heath.[4] The two artists were working in different media, with Constable anticipating photography, the advent of which was imminent, by keeping records of the exact time each picture was executed. He thus categorized these works as momentary impressions, even if the painted moment, contrary to the photographed one, subsumes a succession of several occurrences.

The following comments cover approximately the period between Constable and Lang and are meant to provide an overview of the perspectives from which photographers and artists working with photography approached the phenomenon of clouds. What has to be considered here is that the camera captures objects whose forms and volumes are constantly changing, i.e., moving. In fact, the medium used for representing these objects is not ideally suited, for it only knows immobility, freezing each and every phenomenon in that state. In order to make my "brief history" appropriately concise, I have selected several crucial positions. I have excluded scientific photographic and photogrammetric surveys, as well as their cultural and historical dimensions, for they have been extensively dealt with by Herta Wolf in a number of succinct contributions.[5]

Le Gray, 1856

In their predictions, early propagandists of the new art form did not let themselves be distracted by the fact that some photographic methods did not yet exist. On January 4, 1841, the physicist and director of the Paris observatory Dominique François Arago (1786–1853) asserted in a report to the Académie des sciences that it would be possible in the future to capture "such moving objects as wind-blown trees, bodies of flowing water, a tempest at sea, a ship under sail, clouds, or a milling crowd" by means of photography.[6] His mentioning water, ships, and clouds may be accounted for by the frequent use of these motifs in Romanticist landscape painting, which also enjoyed considerable popularity in France. Being a friend of the inventor Louis Jacques Mandé Daguerre (1787–1851), the astronomer was well aware of the relatively long exposure times – several minutes in the case of landscapes – necessary to produce sharp pictures. Moving objects mostly turned out blurred or were not reflected onto the plate at all.

1 Charles Baudelaire, "La soupe et les nuages [The Soup and The Clouds]," in: idem, *Le Spleen de Paris [Paris Spleen]* [1869], translated by Cat Nilan, http://www.piranesia.net, 1999 (accessed November 30, 2008).
2 *Alvin Langdon Coburn, Photographer. An Autobiography with Over 70 Reproductions of His Works*, ed. by Helmut and Alison Gernsheim, New York: Dover Publications, 1978, p. 46.
3 Hans Magnus Enzensberger, "Die Geschichte der Wolken," in: idem, *Die Geschichte der Wolken. 99 Meditationen*, Frankfurt am Main: Suhrkamp, 2003, pp. 133–43, p. 137.
4 For the dating, cf. Ramón Reichert, "'Forming the Formless'. John Constable's *Cloud Studies*," in: *Archiv für Mediengeschichte – Wolken*, ed. by Lorenz Engell, Bernhard Siegert, and Joseph Vogl, Weimar: Verlag der Bauhaus-Universität, 2005, pp. 57–67; on Gerhard Lang, cf. Lucius Burckhardt, "Skying. John Constable's Clouds Are Still Passing," in: *Luft*, Cologne: Wienand, 2003 (Kunst- und Ausstellungshalle der Bundesrepublik Deutschland, *Schriftenreihe Forum*, vol. 12, *Elemente des Naturhaushalts* IV), pp. 133–36.
5 Herta Wolf, "Wolken, Spiegel und Uhren. Eine Lektüre meteorologischer Fotografien," in: *Fotogeschichte* 48, 13th year, 1993, pp. 3–18; Herta Wolf, "Fixieren – Vermessen: Zur Funktion fotografischer Registratur in der Moderne," in: *Riskante Bilder. Kunst, Literatur, Medien*, ed. by Norbert Bolz, Cordula Meier, Birgit Richard, and Susanne Holschbach, Munich: Wilhelm Fink, 1997, pp. 239–61; Herta Wolf, "Wie man Wolken beobachtet," in: *Wolkenbilder. Die Erfindung des Himmels*, ed. by Stephan Kunz, Johannes Stückelberger, and Beat Wismer, exhibition catalogue, Aargauer Kunsthaus, Aarau, Munich: Hirmer, 2005, pp. 75–83.
6 *Comptes rendus de l'Académie des sciences*, 1841, vol. 12 [session of January 4], p. 23.

erscheinen zumeist schemenhaft oder finden überhaupt keinen Niederschlag auf der Platte.

Nicht bekannt ist Arago jedoch, dass auch die Farbe eine Rolle spielt. Die fotosensible Schicht war nicht sehr lichtempfindlich, aber überempfindlich gegenüber Blau – was bei einer Darstellung des Himmels mit entsprechend kurz bemessener Belichtungszeit zur Folge hatte, dass sich vom Vordergrund nicht mehr als eine Silhouette abbildete. Die für die Frühzeit des Mediums seltene Wolkenstudie der Bostoner Daguerreotypisten Albert Sands Southworth (1811–1894) und Josiah Johnson Hawes (1808–1901) aus der zweiten Hälfte der 1840er Jahre offenbart diesen Effekt.

Der Pariser Lichtbildner Gustave Le Gray (1820–1884) weiß sich zu helfen, als er Mitte der 1850er Jahre daran geht, in den Häfen und an der Küste der Normandie zu fotografieren. Angeregt hatten ihn vermutlich die Seestücke und Marinebilder bekannter Maler, die er als ehemaliger Schüler von Paul Delaroche (1797–1856) gekannt haben muss.[8] Geläufig war ihm sicher auch eine Serie von Marineaufnahmen aus Le Havre von Louis Cyrus Macaire (1807–1871), mit der dieser 1851 reüssiert hatte, sowie dessen weiteren, in der Folge hergestellten einschlägigen Arbeiten. Le Gray nimmt erstmals 1855 oder 1856 den Wolkenhimmel und vom selben Standpunkt mit anderer Belichtungsdauer das Meer und den Küstenstreifen auf und kombiniert die beiden Negative an der Horizontlinie. Die in zwei Schritten gefertigten Abzüge auf Papier gehören zu den frühesten Fotomontagen, von denen Beispiele erhalten sind.[9] Im Übrigen entspricht die Machart der in jenen Jahren stark zunehmenden arbeitsteiligen Produktionsweise, die darin besteht, in aufeinander folgenden Vorgängen einzelne Teile herzustellen und anschließend zusammenzufügen.

Die Kombinationsbilder Le Grays werden neben traditionell hergestellten fotografischen Arbeiten auf Ausstellungen gezeigt und erregen einiges Aufsehen: „Schiffe unter vollen Segeln, das wogende Meer, am Himmel dahineilende Wolkenfetzen, die Sonne in ihrem Strahlenkranz werden in ein und demselben Augenblick ohne alle Zauberei fotografisch gebannt und wiedergegeben", heißt es in der *Revue photographique* vom 5. Februar 1857.[10] Dass es zweier Augenblicke bedurfte, konnte sich der Rezensent einfach nicht vorstellen.

Eine Passage in „Le Confiteor de l'Artiste" von Charles Baudelaire (1821–1867) liest sich – abgesehen von den vielen weiteren Konnotationen[11] –, als wäre der Text im Anblick der Studien von Le Gray, die er 1857 und danach an den Küsten des Mittelmeers und der Bretagne fortgeführt hat, entstanden: „Welche Wonne, seinen Blick in die Unermeßlichkeit von Himmel und Meer zu tauchen! Einsamkeit, Schweigen, unvergleichliche Keuschheit des Azur! Ein kleines bebendes Segel am Horizont, das, durch seine Kleinheit und Vereinzeltheit, mein unheilbares Dasein nachahmt, die eintönige Weise der Brandung, all diese Dinge denken durch mich, oder ich denke durch sie (denn in der Weite der Träumerei löst das *Ich* sich rasch auf!)"[12] Wie der Fotograf vereint der Dichter so Himmel und Meer in gleicher Farbigkeit, und wie der Betrachter einer Fotografie muss er ein leicht bewegtes Segel und das leise Rauschen der Brandung imaginieren: Bewegungen und Geräusche, die ihm ein stummes Medium, das alles Bewegte erstarren lässt, vorenthält.

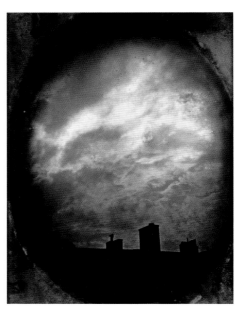

Southworth & Hawes, A Cloud Study, um c. 1845/50
Daguerreotypie, ganze Platte (21,6 x 16,5 cm) daguerreotype, whole plate (21.6 x 16.5 cm) (aus from: *Young America. The Daguerreotype of Southworth & Hawes,* ed. by Grant B. Romer and Brian Wallis, Ausstellungskatalog George Eastman House und International Museum of Photography, Rochester: George Eastman House, New York: International Museum of Photography, Göttingen: Steidl, 2005, S. p. 217, Nr. no. 1821)

8 Zu den bekanntesten gehörten Camille Corot (1796–1875), Jean Antoine Théodore Gudin (1802–1880) und Louis Gabriel Eugène Isabey (1803–1886). Zur Wolkenmalerei im 19. Jahrhundert vgl. *Wolkenbilder. Die Entdeckung des Himmels*, Ausstellung und Katalog von Bärbel Hedinger, Inés Richter-Musso und Ortrud Westheider, Ausstellungskatalog Altonaer Museum, München: Hirmer, 2004, dort auch Abbildungen mehrerer Arbeiten von Corot und Gudin.
9 Etwa zur gleichen Zeit experimentiert Oscar Gustave Rejlander (1813–1875) mit der Negativmontage und entwirft Genreszenen aus bis zu 35 Einzelaufnahmen; vgl. Helmut Gernsheim, *Geschichte der Photographie. Die ersten hundert Jahre*, Frankfurt am Main, Berlin, Wien: Propyläen, 1983 (Propyläen Kunstgeschichte, Sonderband III), S. 295–297. Bereits 1848 meldet F. C. Vogel in Frankfurt am Main ein Patent an, „bestehend in der Zusammenfügung mehrerer negativer Lichtbilder und deren Übertragung auf ein vereinigtes positives". Zit. nach: Eberhard Mayer-Wegelin, *Frühe Fotografie in Frankfurt am Main 1839–1870*, Ausstellungskatalog Historisches Museum Frankfurt, München: Schirmer-Mosel, 1982, S. 29. Vermutlich hat er solche Montagen aus Kalotypien hergestellt, jedoch haben sich keine Belegstücke erhalten.
10 Zit. nach: *Neue Geschichte der Fotografie*, hrsg. von Michel Frizot, Köln: Könemann, 1998, S. 100.
11 Vgl. beispielsweise Karin Westerwelle, „Zeit und Schock. Charles Baudelaires ‚Confiteor des Artisten'", in: *Merkur*, Heft 8, 47. Jg., August 1993, S. 667–682.
12 Charles Baudelaire, „Le Confiteor de l'Artiste / Das Confiteor des Künstlers", in: ders., (Anm. 1), S. 122–123, hier S. 123.

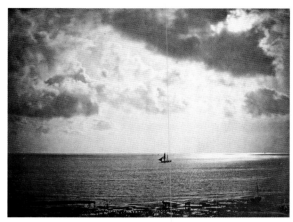

Gustave Le Gray, „Le Brick", 1856
Albuminabzug von zwei Glasnegativen albumen print from two
glass negatives (aus from: *Gustave Le Gray. 1820–1884*, sous la
direction de curated by Sylvie Aubenas, Ausstellungs-katalog
exhibition catalogue, Paris: Bibliothèque nationale de France /
Gallimard, 2002, S. p.108)

However, Arago did not know that color played a role as well. The photosensitive layer was not extremely receptive to light, but was oversensitive to blue; taking a picture of the sky at an appropriately fast shutter speed thus resulted in pictures in which the foreground appeared merely as a silhouette. This effect is revealed by a cloudscape dating from the second half of the 1840s by the Boston daguerreotypists Albert Sands Southworth (1811–1894) and Josiah Johnson Hawes (1808–1901) – a rare example from the early days of the medium.

The Parisian photographer Gustave Le Gray (1820–1884) was quite resourceful when he began taking pictures in the seaports and on the coast of Normandy in the mid-1850s. He had probably been inspired by the seascapes and marines by well-known painters that must have been familiar to him as a former student of Paul Delaroche (1797–1856).[7] Most certainly he was also familiar with a successful series of marine photographs of Le Havre by Louis Cyrus Macaire (1807–1871) from 1851, as well as with the latter's subsequent works in this field. In 1855 or 1856 Le Gray was the first to photograph the clouded sky and – from the same vantage point, but with a different exposure time – the sea and the coastline, combining the two negatives at the horizon line. The prints on paper thus produced in two steps number among the earliest photomontages to have survived.[8] Incidentally, this procedure corresponds to production processes based on work division as they became increasingly common in those years, envisaging the successive production of individual parts and their subsequent combination.

When Le Gray's composite pictures were displayed in exhibitions next to traditionally produced photographs, they caused quite a stir: "Ships under full sail, the surging sea, shreds of clouds rushing across the sky, the sun surrounded by its corona – all of them have been captured and rendered photographically at one and the same instant, without any magic at all," one could read in the *Revue photographique* of February 5, 1857.[9] The commentator could simply not imagine that two shots had been necessary.

Aside from its numerous other connotations,[10] a passage from "Le Confiteor de l'Artiste" by Charles Baudelaire (1821–1867) reads as if the text had been written under the direct impression of Le Gray's studies, which he had continued in 1857 and afterwards on the Mediterranean coasts and in Brittany: "What a great delight to drown one's gaze in the immensity of the sky and the sea! Solitude, silence, incomparable chastity of azure! A little sail shivering on the horizon, and which, in its tininess and its isolation, imitates my irremediable existence, monotonous melody of the swell of the waves, all of these things think through me, or I think through them (for in the vastness of reverie, the I quickly loses itself!)."[11] Like the photographer, the poet combined the identically colored motifs of sky and sea, and like the viewer of a photograph, he had to imagine perforce a tenderly billowing sail and the soft murmur of the surge: movements and sounds withheld from him by a silent medium freezing each and every stir.

Le Gray introduced movement and color in a different fashion: he assembled two shots to form an image, translating all the shades and hues into the deep brown of albumen prints, occasionally enhancing them through golden toning. Thus, space and time are wondrously annihilated in these creations. Simultaneously, these photographs, due to their colored abstraction, break away from the Romanticist understanding of nature as an eternal cycle between earth and sky, as well as from the common modes of representation of previous decades. In that regard they point to the modernity of a future that lay far ahead: during the second half of the

7 Among the most renowned painters were Camille Corot (1796–1875), Jean Antoine Théodore Gudin (1802–1880), and Louis Gabriel Eugène Isabey (1803–1886). On 19th-century cloud painting, cf. *Wolkenbilder. Die Entdeckung des Himmels*, ed. by Bärbel Hedinger, Inés Richter-Musso, and Ortrud Westheider, exhibition catalogue, Altonaer Museum, Munich: Hirmer, 2004, with reproductions of several works by Corot and Gudin.
8 At about the same time, Oscar Gustave Rejlander (1813–1875) was experimenting with negative montage, designing genre scenes composed of up to 35 individual exposures; cf. Helmut Gernsheim, *Geschichte der Photographie. Die ersten hundert Jahre*, Frankfurt am Main, Berlin, Vienna: Propyläen, 1983 (*Propyläen Kunstgeschichte*, special vol. III), pp. 295–97. As early as 1848, F. C. Vogel filed a patent in Frankfurt am Main, "bestehend in der Zusammenfügung mehrerer negativer Lichtbilder und deren Übertragung auf ein vereinigtes positives" ["consisting of an assemblage of several negative photographs transferred onto a positive one"]; quoted from Eberhard Mayer-Wegelin, *Frühe Fotografie in Frankfurt am Main 1839–1870*, exhibition catalogue, Historisches Museum Frankfurt, Munich: Schirmer-Mosel, 1982, p. 29. He probably used calotypes for such montages, but no examples have survived.
9 "Schiffe unter vollen Segeln, das wogende Meer, am Himmel dahineilende Wolkenfetzen, die Sonne in ihrem Strahlenkranz werden in ein und demselben Augenblick ohne alle Zauberei fotografisch gebannt und wiedergegeben"; quoted from: *Neue Geschichte der Fotografie*, ed. by Michel Frizot, Cologne: Könemann, 1998, p. 100.
10 Cf., for example, Karin Westerwelle, "Zeit und Schock. Charles Baudelaires 'Confiteor des Artisten,'" in: *Merkur*, 8/47, August 1993, pp. 667–82.
11 Charles Baudelaire, "Le Confiteor de l'Artiste [The Artist's 'Confiteor']," in: idem, *Le Spleen de Paris [Paris Spleen]* [1869], translated by Cat Nilan, http://www.piranesia.net, 1999 (accessed November 30, 2008).

Le Gray bringt auf andere Weise Bewegung und Farbigkeit ins Spiel: Er fügt zwei Augenblicke zu einem Bild zusammen und übersetzt alle Farben und Töne in das satte Braun der Albuminabzüge, gelegentlich noch mit einer Goldtonung verstärkt. So sind in diesen Kreationen Raum und Zeit auf besondere Weise aufgehoben. Zugleich setzen sich die Fotografien mit ihrer farblichen Abstraktion von dem romantischen Naturverständnis eines ewigen Kreislaufes zwischen Himmel und Erde sowie den gängigen Darstellungs-formen der davorliegenden Jahrzehnte ab. Insofern weisen sie auf die Modernität einer fernen Zukunft: In der zweiten Hälfte des 20. Jahrhunderts werden Künstler die selben Sujets – wenn auch mit anderen Intentionen – aufgreifen und sich analoger Mittel – bis zu beinahe monochromen Ausfertigungen – bedienen.[13]

Muybridge, um 1869

Die aus mehreren Aufnahmen zusammengesetzten Fotografien werden im 19. Jahrhundert Kombinations- oder Kompositbilder genannt. Der in Tunbridge Wells lebende Henry Peach Robinson (1830–1901), Verfechter einer an der Malerei sich orientierenden piktorialistischen Fotografie, stellt 1869 fest: Die „Methode, Photographien von zwei oder mehr Negativen zu combiniren, ist jetzt so allgemein geworden, dass es kaum einen Photo-graphen geben wird, der gute Bilder zu erzeugen trachtet und der nicht mehr oder weniger von dieser Methode Gebrauch macht. Der Landschafts-photograph wird fast immer zu jenen Bildern, die er der Ausstellung werth hält, einen Himmel hinzufügen."[14] Auch der in San Francisco tätige Eadweard Muybridge (1830–1904) arbeitet mit zwei Negativen, als er Ende der 1860er Jahre Ansichten des Yosemite Valley und anderer Gegenden fotografiert. Zudem konstruiert er einen Vorsatz zum Objektiv, der verhindert, dass das blaue Licht in vollem Ausmaß die Platte erreicht.[15]

In diesen Jahren entstehen auch Wolkenstudien, die nicht für Kombinations-bilder gedacht waren. Jedenfalls sind keine Abzüge überliefert, in denen dieselben Motive aufscheinen, und auch der Aufnahmewinkel spricht zumeist gegen eine solche Absicht. Da die Kamera ausschließlich gegen den Himmel gerichtet ist, können die Aufnahmen überall und an jedem Tag und zu jeder Stunde entstanden sein. Ihre Besonderheit liegt also auch darin, dass der Standort des Fotografen nicht rekonstruiert werden kann, sich keine Gerade vom Objekt zum Autor denken lässt. Erst die Ansicht im Stereobetrachter, die ja vom Fotografen geplant gewesen ist, lässt den Himmel im Hintergrund und die Wolken davor erscheinen und führt so zu einer räumlichen Konstruktion. Damit eröffnet sich eine Tiefenstruktur, die den Blick anzieht. Der Betrachter tritt sozusagen ins Bild, der Blick findet eine Richtung, und es ist nicht mehr von Bedeutung, *wo* die Kamera gestanden hat. Erst im stereofotografischen Schauraum findet der Blick Halt durch die Richtung, die ihm vorgetäuscht wird und die den fehlenden Horizont ersetzt.

Eadweard Muybridge, „A Study of Clouds",
um c. 1869
Hälfte einer Stereoaufnahme, Albuminabzüge half of
a stereo photograph, albumen print (aus from: Naomi
Rosenblum, *A World History of Photography*, New York,
London, Paris: Abbeville Press, [3]1997, S. p. 133)

13 Vgl. die entsprechenden Arbeiten von Gerhard Richter, Joseph Beuys und Markus Raetz, abgebildet in: *Wolkenbilder. Die Erfindung des Himmels*, hrsg. von Stephan Kunz, Johannes Stückelberger, Beat Wismer, Ausstellungskatalog Aargauer Kunsthaus, Aarau, München: Hirmer, 2005, S. 98, 142 und 177.
14 H. P. Robinson, „Combinirte Photographien", in: ders., *Der malerische Effect in der Photographie als Anleitung zur Composition und Behandlung des Lichtes in Photographien*, frei nach dem Englischen von C. Schiendl, Halle a/S.: Wilhelm Knapp, 1886, S. 167–168, hier S. 167. Zu Robinsons zusammengesetzten Genrebildern und die mit Partnern oder allein hergestellten „Seascapes" vgl. Margaret F. Harker, *Henry Peach Robinson. Master of Photographic Art, 1830–1901*, Oxford, New York: Basil Blackwell, 1988, insbesondere S. 34–38, 53 und Tafelteil.
15 Vgl. Naomi Rosenblum, *A World History of Photography*, New York, London, Paris: Abbeville Press, [3]1997, S. 132 f., die jedoch nähere Angaben zur Funktion schuldig bleibt. Vermutlich handelt es sich um einen Klappverschluss, der die Himmelpartie früher abdeckt als den darunterliegenden Teil.

Eadweard Muybridge, „A Study of Clouds",
um c. 1869
Hälfte einer Stereoaufnahme, Albuminabzüge half of
a stereo photograph, albumen print (aus from: Naomi
Rosenblum, *A World History of Photography*, New York,
London, Paris: Abbeville Press, ³1997, S. p. 133)

20th century, artists were to address the same subject matter – if with different intentions – employing analog means, including the development of almost monochrome impressions.[12]

Muybridge, c. 1869

In the 19th century, pictures composed of several shots were referred to as composite photographs or combination prints. Henry Peach Robinson (1830–1901), who lived in Tunbridge Wells, was an advocate of pictorial photography governed by the principles of painting. In 1869 he stated that the method of combining photographs from two or more negatives had become so common that there was hardly an ambitious photographer who did not make use of this method to some extent: landscape photographers would almost always print a sky into those pictures they considered worth exhibiting.[13] Eadweard Muybridge (1830–1904), active in San Francisco, likewise worked with two negatives when photographing the Yosemite Valley and other regions in the late 1860s. He also constructed an auxiliary device to be mounted in front of the lens that was to prevent blue light from fully hitting the plate.[14]

In those years, artists also made cloud studies that were not meant for composite pictures. In any case, no such prints have survived in which the respective motifs appear, and in most cases the camera angle also speaks against such an intention. Since the camera was directed exclusively toward the sky, the pictures could have been shot any day, at any time, and anywhere. What also makes them special is that the photographer's vantage point cannot be reconstructed, and no straight line can be imagined between object and author. Only looking at the picture through a stereo viewer – which the photographer had in fact envisaged – will make the clouds stand out from the sky in the background, thus resulting in a spatial construction. This opens up a three-dimensional structure that attracts the gaze. The spectator enters the picture, so to speak, the gaze is directed, and it is no longer important *where* the camera was positioned. Only in the illusionary space of stereo photography is the gaze stabilized through the pretense of a certain direction that replaces the lacking horizon.

Beck, 1903
Coburn, 1912

In 1873, the German photochemist Hermann Wilhelm Vogel (1834–1898) succeeded in making the negative layers receptive to blue also sensitive to green and yellow light by adding dyes. Following further improvements achieved by him and others, orthochromatic plates that largely rendered the tonal values correctly came onto the market in 1884. Nevertheless, composite pictures continued to be made, because – as Vogel stated in 1891 – "one rarely finds a beautiful and suitable sky above a landscape. In case of such lack one cannot but wait for an appropriately tuned sky, photograph it separately, and copy it into the picture [...]."[15] Even if such and similar recommendations appeared in manuals until well into the 1930s, they probably were not followed extensively, for the manipulations required were not exactly simple.[16]

12 Cf. the relevant works by Gerhard Richter, Joseph Beuys, and Markus Raetz reproduced in: *Wolkenbilder. Die Erfindung des Himmels,* ed. by Stephan Kunz, Johannes Stückelberger, and Beat Wismer, exhibition catalogue, Aargauer Kunsthaus, Aarau, Munich: Hirmer, 2005, pp. 98, 142, and 177.
13 H. P. Robinson, "Combination Printing," in: *Pictorial Effect in Photography. Being Hints on Composition and Chiaroscuro for Photographers,* London: Piper & Carter, 1869. On Robinson's composite genre pictures and the seascapes produced alone or with other artists, cf. Margaret F. Harker, *Henry Peach Robinson. Master of Photographic Art, 1830–1901,* Oxford, New York: Basil Blackwell, 1988, particularly pp. 34–38, 53, and plate section.
14 Cf. Naomi Rosenblum, *A World History of Photography,* New York, London, Paris: Abbeville Press, ³1997, pp. 132–33, who, however, does not point out its function. It was probably a kind of capping shutter that covers the section of the sky earlier than the part below.
15 H. W. Vogel, *Photographische Kunstlehre oder die künstlerischen Grundsätze der Lichtbildnerei. Für Fachmänner und Liebhaber,* Berlin: Robert Oppenheim, 1891, p. 193.
16 Cf. the extensive comments on clouds in landscapes by A. Horsley Hinton in: idem, *Practical Pictorial Photography,* London: Hazell, Watson & Viney, 1902, pp. 27–36.

Beck, 1903
Coburn, 1912

1873 gelingt es dem deutschen Fotochemiker Hermann Wilhelm Vogel (1834–1898), die blauempfindlichen Negativschichten durch Zusatz von Farbstoffen auch für die grünen und gelben Lichtstrahlen sensibel zu machen. Nach weiteren Verbesserungen durch ihn und andere kommen 1884 ortho-chromatische Platten mit weitgehend farbwertrichtigen Eigenschaften auf den Markt. Allerdings werden weiterhin Kombinationsbilder hergestellt, denn – wie Vogel 1891 vermerkt – „[s]elten findet man einen schönen und passenden Himmel über einer Landschaft. Bei Mangel eines solchen aber bleibt nichts übrig, als einen passend gestimmten Himmel abzuwarten und separat aufzunehmen und einzukopieren [...]."[16] Auch wenn ähnliche Ratschläge noch bis in die 1930er Jahre in den Anleitungsbüchern auftauchen, wurde davon vermutlich nicht allzu viel Gebrauch gemacht, waren doch die dafür notwendigen Manipulationen nicht gerade einfach.[17]

Insbesondere den künstlerisch ambitionierten Amateuren der 1890er Jahre und der folgenden beiden Jahrzehnte geht es weniger um genaue Darstellungen von Wolken und Landschaft und deren Zusammenspiel, sondern in erster Linie um stimmungsvolle Bilder. Diese Vertreter einer künstlerischen Fotografie, meist Angehörige wohlhabender Schichten und des Bildungsbürgertums, orientieren sich an der Malerei früherer Perioden und entwerfen – im Nachklang des Impressionismus – vielfach unscharfe und häufig eingefärbte Ansichten. Damit gehen sie auf Distanz zu einer Berufs-fotografie, die erkennbare Sujets und genaue Wiedergabe verlangt, auf Aktualität besteht und ihre Geschäfte zunehmend mit der Belieferung von Presse und Postkartenverlagen betreibt. Zugleich bedeutet diese Rück-wendung in ästhetischen Belangen ein – wenn auch nicht erklärtes – Abwenden von den politischen und sozialen Entwicklungen einer zu Ende gehenden Epoche. So bringt Heinrich Beck (1874–1960), ab 1903 erster Vorsitzender der Freien Vereinigung von Amateurphotographen in Hamburg, im selben Jahr mehrere blaugraue Gummidrucke heraus, die sich mit ihren dramatisch anmutenden Wolkenformationen über dem Meer nur wenig von den gemalten und fotografischen Schöpfungen der Jahrhundertmitte und davor unterscheiden.

Unter den Vertretern dieser Richtung, die das kunstfotografische Terrain jener Jahre beherrschen, suchen einige wenige nach neuen Formen, die mehr die allgemein herrschende Unsicherheit über die angängigen Entwicklungen zum Ausdruck bringen. Zu ihnen zählt der in London lebende Amerikaner Alvin Langdon Coburn (1882–1966), der zwar wie seine Kollegen in der üblichen Manier unscharfe Edeldrucke in diversen Farbtönen fabriziert, aber immer wieder nach neuen Motiven Ausschau hält, steile Perspektiven von erhöhten Standpunkten wählt und auf diese Weise manche Erscheinungen ins Abstrakte überführt. Damit zeigt er neue Sehweisen auf, die sich in den 1920er Jahren avantgardistische Fotokünstler zu eigen machen werden.

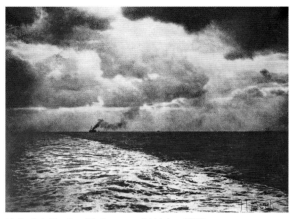

Heinrich Beck, „Kielwasser" *Wake,* 1903
Gummidruck, 44,1 x 60,5 cm gum bichromate print, 44.1 x 60.5 cm (aus from: *Kunstphotographie um 1900. Die Sammlung Ernst Juhl,* Ausstellungskatalog exhibition catalogue, Museum für Kunst und Gewerbe, Hamburg 1989 [Dokumente der Photographie 3], S. p. 73)

16 H. W. Vogel, *Photographische Kunstlehre oder die künstle-rischen Grundsätze der Lichtbildnerei. Für Fachmänner und Liebhaber,* Berlin: Robert Oppenheim, 1891, S. 193.
17 Vgl. die umfangreichen Ausführungen zu „Wolken in der Landschaft" von A. Horsley Hinton in: ders.: *Künstlerische Land-schafts-Photographie in Studium und Praxis,* Berlin: Gustav Schmidt, ³1903, S. 87–98.

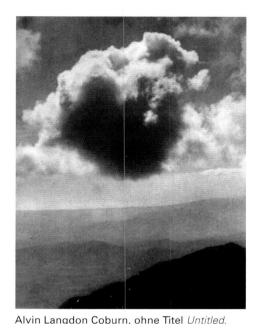

Alvin Langdon Coburn, ohne Titel *Untitled,*
veröffentlicht als Tafel 3 in dem Buch
published as plate 3 in the book
The Cloud von by Percy Bysshe Shelley, 1912
Platindruck, 6,5 x 5 inch platinum print, 16.5 x 12.7 cm
(aus: from: John Szarkowski, *Looking at
Photographs. 100 Pictures from the Collection of
The Museum of Modern Art*, Paris: Idea Books
International, 1976, S. p. 64)

In the 1890s and the following two decades, it was particularly amateurs with artistic aspirations who were not so much interested in accurate depictions of clouds and landscapes and their interplay, but first and foremost in atmospheric pictures. These practitioners of artistic photography, mostly members of the wealthy classes and the intellectual bourgeoisie, oriented themselves toward painting styles of earlier periods, designing images – reminiscences of Impressionism – that were commonly blurred and frequently colored. In doing so, they disassociated themselves from professional photography, which demanded the precise representation of recognizable subjects, insisted on topicality, and increasingly supplied the press and postcard publishers. At the same time, this retrogression in aesthetic matters meant a neglect of the political and social developments of a dying epoch, even if not explicitly declared. In 1903, Heinrich Beck (1874–1960), for example, who that same year became the first chairman of the Free Association of Amateur Photographers in Hamburg, published several bluish-grey gum bichromate prints whose dramatic cloud formations above the sea differed only slightly from painted and photographed creations from the middle of the previous century and earlier periods.

Only few among the exponents of this movement dominating the terrain of artistic photography during those years were seeking new forms that rather expressed the general uncertainty as to upcoming developments. Among them was Alvin Langdon Coburn (1882–1966), a London-based American who – like his colleagues – fabricated refined blurred prints in various shades, but who was constantly looking for new motifs and often chose steep perspectives from elevated vantage points, thus translating many a view into the language of abstraction. In this way he introduced new visual approaches that were to be adopted by photographic artists of the avantgarde in the 1920s.

Coburn took more than 100 pictures of clouds, such as those from a journey in 1911 to the Grand Canyon, capturing, among other subjects, low shreds of clouds amidst rock formations. His studies offer a poetic view of things,[17] occasionally giving the impression of an irritated gaze looking for certainties in nature that everyday life could not offer.

Stieglitz, 1922–1935

In the course of his life, the American photographer, publisher, and gallery owner Alfred Stieglitz (1864–1946) took some 400 pictures of clouds, most of which date from the 1920s and '30s. Starting around 1980, authors in the USA and Europe dealt with these works time and again. Rosalind Krauss and Philippe Dubois, as well as Herta Wolf, following in their wake, have pointed out the group's autoreferential moments, detaching themselves both from the author and the spectator in terms of motif, frame, and perspective, "eventually knowing no other subject than photography as such"[18] and aiming at the structural factors of the photographic process. Stieglitz chose various titles for these pictures: some of them he called *Equivalents*, whereas others were merely named after the places where they had been taken; others he referred to as *Poplars*, provided that the image included some; a series dating from 1922 he entitled *Music – A Sequence of Ten Cloud Photographs*.[19]

17 Cf. the comment on the reproduced cloudscape from 1912 in: John Szarkowski, *Looking at Photographs. 100 Pictures from the Collection of The Museum of Modern Art*, Paris: Idea Books, 1976, p. 62. A large selection of images and several cloud pictures can be found in: *Alvin Langdon Coburn. Fotografien 1900–1924*, ed. by Karl Steinorth, exhibition catalogue, Römisch-Germanisches Museum, Cologne, Zurich, New York: Edition Stemmle, 1998.
18 Philippe Dubois, *Der fotografische Akt. Versuch über ein theoretisches Dispositiv [L'Acte Photographique*, 1990], translated from the French by Dieter Hornig, ed. by Herta Wolf, Amsterdam, Dresden: Verlag der Kunst, 1998 (*Schriftenreihe zur Geschichte und Theorie der Fotografie*, vol. 1), on the *Equivalents*, pp. 199–213, p. 200. Also comp. Rosalind Krauss, "Stieglitz/Equivalents," in: idem, *Le Photographique. Pour une théorie des écarts*, translated by Marc Bloch and Jean Kempf, Paris: Macula, 1990, pp. 126–37 (previously published in English in *October*, 11, winter issue, 1979, pp. 129–40), as well as the texts by Herta Wolf (see note 5).
19 Cf. Sarah Greenough, *Alfred Stieglitz. The Key Set. The Alfred Stieglitz Collection of Photographs*, vol. 1: *1886–1922*, vol. 2: *1923–1937*, Washington. National Gallery of Art, New York: Harry N. Abrams, 2002, pp. 470–887.

Coburn fertigt mehr als 100 Wolkenaufnahmen, beispielsweise auf einer Reise von 1911 zum Grand Canyon, wobei er unter anderem tieffliegende Wolkenfetzen zwischen den Bergmassiven festhält. Seine Studien zeigen ebenso eine poetische Sicht der Dinge,[18] wie sie gelegentlich den Eindruck vermitteln, als suche ein irritierter Blick in der Natur nach Gewissheiten, die der Alltag nicht zu bieten vermag.

Stieglitz, 1922–1935

Der amerikanische Fotograf, Publizist und Galeriebetreiber Alfred Stieglitz (1864–1946) hat im Laufe seines Lebens um die 400 Wolkenaufnahmen gemacht, die meisten in den 1920er und 1930er Jahren. Seit etwa 1980 haben sich Autorinnen und Autoren in den USA und Europa immer wieder mit diesen Arbeiten beschäftigt. Rosalind Krauss und Philippe Dubois sowie in deren Gefolge Herta Wolf betonen die autoreferenziellen Momente der Werkfolge, die sich über Motiv, Ausschnitt und Perspektivität ebenso vom Autor wie von den Betrachtern lösen, „letztlich kein anderes Sujet haben als die Fotografie selbst"[19] und auf die strukturellen Gegebenheiten des Fotografischen abzielen. Stieglitz hat den Aufnahmen diverse Titel gegeben: Einen Teil hat er „Equivalents" genannt, einige ausschließlich mit Ortsnamen versehen oder als „Poplars" bezeichnet, wenn Pappeln mit ins Bild gekommen sind; eine Folge von 1922 betitelte er mit „Music – A Sequence of Ten Cloud Photographs".[20]

In einem Beitrag für die Zeitschrift *Amateur Photographer and Photography* von 1923 äußert sich Stieglitz zu seiner Obsession: „Wie ich dazu kam, Wolken zu fotografieren". Bereits „[v]or fünfunddreißig oder mehr Jahren" interessierten ihn „Wolken und ihre Beziehung zur Umgebung und Wolken als solche und Wolken, die schwierig zu fotografieren waren". Es gelte, „herauszufinden, was ich in 40 Jahren über die Fotografie gelernt hatte. Durch die Wolken wollte ich meine Lebensphilosophie darstellen." Das Ergebnis sollten „reine Fotografien" sein, sie würden der Absicht entsprechen, „Fotografien so sehr wie Fotografien aussehen zu lassen, daß sie, wenn man Augen hat und sieht, unsichtbar bleiben".[21] Tatsächlich hat der Fotograf ab 1888 immer wieder Wolken aufgenommen und auch Wolkenbilder anderer Fotokünstler in den von ihm herausgegebenen Fachjournalen veröffentlicht.[22]

Seine Aufnahmen lassen sich in drei Gruppen einteilen: Wolken mit Horizont, Wolken mit Baumkronen und Wolken allein, die im Folgenden als ‚reine Wolken' bezeichnet werden. Die vom Autor gewählten Titel sagen nichts über das jeweilige Motiv aus, gleichwohl wurden in den vergangenen Jahrzehnten nahezu ausschließlich die ‚reinen Wolken' publiziert, und hier wiederum nur solche, die mit „Equivalent" untertitelt worden waren. Auch die erwähnten theoretischen Ausführungen sind mit diesen Aufnahmen illustriert und werden mit Hinweis auf sie begründet. Dies erweckt den Anschein, als hätte Stieglitz ausschließlich die ‚reinen Wolken' als die einzig „reinen Fotografien" angesehen, obgleich sich bis 1935 die Motive ständig abwechseln und die letzte bekannt gewordene Aufnahme, die mit „Equivalent Series 27c" identifiziert ist, eine Pappelkrone vor einem Wolkenhimmel zeigt.[23]

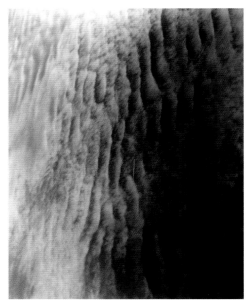

Alfred Stieglitz, „Equivalent", 1930
je 11,2 x 8,9 cm each 11.2 x 8.9 cm (aus from: Sarah Greenough, *Alfred Stieglitz. The Key Set. The Alfred Stieglitz Collection of Photographs*, Vol. 2: *1923–1937*, Washington, National Gallery of Art, New York: Harry N. Abrams, 2002, S. p. 766, Nr. no. 1333, und and S. p. 771, Nr. no. 1334 [richtig: 1344])

18 Vgl. den Kommentar zu der abgebildeten Wolkenaufnahme von 1912 in: John Szarkowski, *Looking at Photographs. 100 Pictures from the Collection of The Museum of Modern Art*, Paris: Idea Books, 1976, S. 62. Umfangreiches Bildmaterial und mehrere Wolkenaufnahmen finden sich in: *Alvin Langdon Coburn. Fotografien 1900–1924*, hrsg. von Karl Steinorth, Ausstellungskatalog Römisch-Germanisches Museum Köln, Zürich, New York: Edition Stemmle, 1998.
19 Philippe Dubois, *Der fotografische Akt. Versuch über ein theoretisches Dispositiv* [*Le Photographique. Pour une Théorie des Écarts*, 1990], aus dem Französischen von Dieter Hornig, hrsg. von Herta Wolf, Amsterdam, Dresden: Verlag der Kunst, 1998 (Schriftenreihe zur Geschichte und Theorie der Fotografie, Bd. 1), zu den „Equivalents" S. 199–213, hier S. 200. Vgl. auch Rosalind Krauss, „Stieglitz' Äquivalente" [Stieglitz/Equivalents, 1979], übersetzt von Henning Schmidgen, in: dies., *Das Photographische. Eine Theorie der Abstände*, München: Wilhelm Fink, 1998 (Bild und Text, hrsg. von Gottfried Böhm, Karlheinz Stierle), S. 127–137, sowie die Texte von Herta Wolf (Anm. 6).
20 Vgl. Sarah Greenough, *Alfred Stieglitz. The Key Set. The Alfred Stieglitz Collection of Photographs*, Vol. 1: *1886–1922*, Vol. 2: *1923–1937*, Washington. National Gallery of Art, New York: Harry N. Abrams, 2002, S. 470–887.

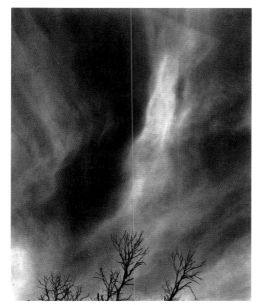

Alfred Stieglitz, „Equivalent", 1930
je 11,2 x 8,9 cm each 11.2 x 8.9 cm (aus from: Sarah
Greenough, *Alfred Stieglitz. The Key Set. The Alfred
Stieglitz Collection of Photographs,* Vol. 2: *1923–1937,*
Washington, National Gallery of Art, New York: Harry
N. Abrams, 2002, S. p. 766, Nr. no. 1333, und and
S. p. 771, Nr. no. 1334 [richtig: 1344])

20 Alfred Stieglitz, "How I Came to Photograph Clouds," in:
Amateur Photographer and Photography, vol. 56, no. 1819, 1923, p.
255.
21 Such as in 1899 and 1903, by Juan C. Abel, A. Horsley Hinton,
and Adolphe A. Stoiber, in *Camera Notes,* as well as in 1906, by
Eduard J. Steichen, in: *Camera Work;* cf. Christian A. Peterson,
Alfred Stieglitz's Camera Notes, exhibition catalogue, The
Minneapolis Institute of Arts, New York, London 1993, pp. 67, 113,
and 149, as well as *Alfred Stieglitz. Camera Work. A Pictorial Guide,*
ed. by Marianne Fulton Margolis, New York: Dover Publications,
1978, p. 44.
22 Reproduced in: Dorothy Norman, *Alfred Stieglitz. An American
Seer,* An Aperture Book, New York: Random House, 1973, p. 224.
Also compare the chapter "The Equivalents," pp. 143–62, and the
cloud study *From Lake Como* dating from 1888, p. 144.
23 Dubois, 1998, note 18, p. 213.

In "How I Came to Photograph Clouds," written in 1923 for the periodical *Amateur Photographer and Photography,* Stieglitz commented upon his obsession: "Thirty-five or more years ago […] clouds and their relationship to the rest of the world, and clouds for themselves, interested me, and clouds which were difficult to photograph […]. I wanted to photograph clouds to find out what I had learned in 40 years about photography." The result should be "straight photographs," which would comply with his aim "to make my photographs look as much like photographs that unless one has eyes and sees, they won't be seen."[20] Starting in 1888, the photographer had indeed taken pictures of clouds over and over again, and he also published images of clouds by other fine art photographers in his professional journals.[21]

His pictures can be divided into three groups: clouds with horizons, clouds with treetops, and clouds by themselves, the latter in the following referred to as "pure clouds." Although the titles chosen by the author do not tell anything about the respective motifs, the pictures published in the past decades show almost exclusively "pure clouds," and from among those, only examples entitled *Equivalent* have been chosen. These pictures have also been used to illustrate the theoretical comments mentioned above, which are explained in reference to these images. This gives the impression that Stieglitz had only regarded the "pure clouds" as truly "straight photographs," although the motifs kept changing until 1935 and the last picture that has become known, identified as *Equivalent Series 27c,* shows the top of a poplar against a clouded sky.[22]

Contrary to that, I would assume that Stieglitz did not want to make a final pictorial statement, but that he was trying to solve his issues mainly within the perspectival differences among the various cloud studies. One could also say that the problem reveals itself in the shift in perspective between the traditionally composed motifs – promising orientation because it is possible for the spectator to adopt the photographer's position – and those cloudscapes that do not allow any conclusions as to the angle from which they were viewed. It is necessary to compare two differently configured pictures in order to perceive the disparities between them.

From Stieglitz' complex œuvre, Krauss, Dubois, and Wolf have chosen just one type of picture from which to draw their conclusions. Such a procedure does not yet disqualify the theses developed from it, even if, in some respects, these theses are subordinated to the self-referentiality assigned to the subject and are only brought forward with regard to the imagery of a single mode of representation.

Regardless of all theoretical pondering, those cloud pictures showing neither horizon nor trees are fascinating because of the spatial nowhere to which the spectator is exposed. Unlike the cloud studies by Eadweard Muybridge, who introduced a pictorial axis by means of a stereographic construction, Stieglitz's "pure clouds" offer no clues that would reveal the photographer's vantage point or allow one's gaze to follow a certain direction. There is neither top nor bottom; the spectator loses his footing; the gaze falls back on itself, and the photograph is left to exist for its own sake. "When looking at these pictures closely, they create […] in us this extraordinary feeling of instability, of a loss of balance, so that we literally start tumbling. Images ever circling and twirling. Floating, detached, airy images. Images that fly."[23]

Demgegenüber möchte ich annehmen, dass Stieglitz gar kein abschließendes bildliches Statement angestrebt, sondern seine Fragen vor allem in den perspektivischen Differenzen der unterschiedlichen Wolkenstudien gesucht hat. Man könnte auch sagen, die Problematik eröffne sich im Wechsel des Blicks von den traditionell gestalteten Motiven, die Orientierung verheißen, indem der Betrachter die Möglichkeit hat, sich in die Position des Fotografen zu denken, und jenen hin zum Himmel und den Wolkengebilden, die keinen Rückschluss lassen, in welchem Winkel sie gesehen worden sind. Es bedarf der Nebeneinanderstellung zweier unterschiedlich ausgelegter Aufnahmen, um den dabei sich auftuenden Abstand zu erfassen.

Krauss, Dubois und Wolf haben aus einem komplexen Œuvre einen Typus Bild gewählt und leiten von diesem ihre Folgerungen ab. Eine solche Vorgehensweise disqualifiziert noch nicht die daraus entwickelten Thesen, auch wenn sie sich in gewisser Hinsicht der ihrem Gegenstand zugewiesenen Selbstbezüglichkeit unterordnen und nur mehr innerhalb der bildsprachlichen Gegebenheiten eines einzigen Darstellungsmodus argumentieren.

Von allen theoretischen Erwägungen unbenommen fasziniert an jenen Wolkenbildern, die weder Horizont noch Bäume zeigen, das räumliche Nirgendwo, in das der Betrachter versetzt wird. Anders als bei den Wolkenstudien von Eadweard Muybridge, der mittels der stereografischen Konstruktion eine Bildachse ins Spiel gebracht hat, liefert Stieglitz in den ‚reinen Wolken' keine Anhaltspunkte, die zum Standort des Bildautors führen oder irgendeine Richtung verfolgen lassen. Es gibt kein Oben und Unten, dem Betrachter wird der Boden entzogen, der Blick fällt auf sich selbst zurück, die Fotografie bleibt für sich. Diese Bilder „erzeugen [...], wenn man sich in sie vertieft, in uns dieses außerordentliche Gefühl der Instabilität, des Verlusts des Gleichgewichts, daß wir buchstäblich zu taumeln beginnen. Bilder, die kreisen, kreisen und wirbeln. Schwebende, losgebundene, luftige Bilder. Bilder, die fliegen."[24]

Wolff, 1937

In den Jahren nach dem Ersten Weltkrieg geht man in Deutschland daran, verlorenes Terrain auf industriellem Sektor zurückzugewinnen, quasi technisch und ökonomisch wieder aufzurüsten. Die national gestimmten Parolen finden ihren bildlichen Ausdruck in zahlreichen Veröffentlichungen, die das „Hohelied der Arbeit" singen.[25] Es erscheinen Bildbände, bestückt mit Darstellungen insbesondere der Schwerindustrie, die den „Wiederaufstieg Deutschlands" beschwören, wie es eine Veröffentlichung von 1930 auf der Titelseite ankündigt.[26] In Fachpublikationen für Fotografen ist über eineinhalb Jahrzehnte regelmäßig zu lesen, wie eindrucksvolle Industrieaufnahmen zu gestalten seien.

Als Schauplatz wählen die Lichtbildner vornehmlich Stahlwerke und Kokereien, Fabriken und Hüttenanlagen, Werften und Bahnanschlüsse. Dort finden sie ihre Motive: Hochöfen und Schlote, Kühltürme, Schiffe und Eisenbahnzüge, Rauch ausstoßend und Dampf ablassend. Diese künstlichen Wolken in den Aufnahmen bezeugen, dass etwas in Bewegung sei, dass produziert oder transportiert werde, dass Mensch und Maschine tätig seien. „[E]ine Dampflokomotive [...] lebt, arbeitet, keucht", heißt es in einem

21 Alfred Stieglitz, „Wie ich dazu kam, Wolken zu fotografieren" [„How I came to photograph clouds", 1923], Übersetzung: Max Wechsler, in: Wolkenbilder. Die Erfindung des Himmels, hrsg. von Stephan Kunz, Johannes Stückelberger, Beat Wismer, Ausstellungskatalog Aargauer Kunsthaus, Aarau, München: Hirmer, 2005, S. 85–89.
22 Unter anderem in den Jahren 1899 und 1903 von Juan C. Abel, A. Horsley Hinton und Adolphe A. Stoiber in Camera Notes sowie 1906 von Eduard J. Steichen in Camera Work; vgl. Christian A. Peterson, Alfred Stieglitz's Camera Notes, Ausstellungskatalog The Minneapolis Institute of Arts, New York, London 1993, S. 67, 113 und 149, sowie Alfred Stieglitz. Camera Work. A pictorial Guide, ed. by Marianne Fulton Margolis, New York: Dover Publications, 1978, S. 44.
23 Abgebildet in: Dorothy Norman, Alfred Stieglitz. An American Seer, An Aperture Book, New York: Random House, 1973, S. 224. Vgl. auch das Kapitel „The Equivalents", S. 143-162 und darin die Wolkenstudie „From Lake Como" von 1888, S. 144.

24 Dubois, (Anm. 19), S. 213.
25 Unser Oberschlesien. Das Hohelied deutscher Arbeit. Eine Sammlung von Heimatbildern nach Aufnahmen von Bruno Zwiener, Gleiwitz: Heimatverlag Oberschlesien, o.J.
26 Deutsche Arbeit. Bilder vom Wiederaufstieg Deutschlands, 92 Aufnahmen von O.E. Hoppé, Berlin: Ullstein, 1930.

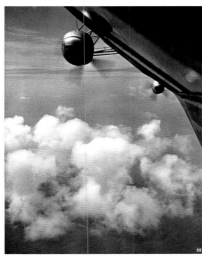

Paul Wolff, Lokomotive, Zeppelin „Hindenburg",
um c. 1937
(aus from: Paul Wolff, *Arbeit!*, Berlin: Volk und Reich Verlag,
Frankfurt am Main: H. Bechhold Verlagsbuchhandlung, 1937,
S. pp. 162 and und 55)

24 *Unser Oberschlesien. Das Hohelied deutscher Arbeit. Eine
Sammlung von Heimatbildern nach Aufnahmen von Bruno Zwiener*,
Gleiwitz: Heimatverlag Oberschlesien, n.d.
25 *Deutsche Arbeit. Bilder vom Wiederaufstieg Deutschlands,
92 Aufnahmen von O. E. Hoppé*, Berlin: Ullstein, 1930.
26 Alexander Niklitschek, *Kunstphotographie der Technik*, Berlin:
Photokino-Verlag, 1933, p. 70.
27 Cf., for example, Wolf H. Döring, *Wolken ins Foto!*, Halle a. S.:
Wilhelm Knapp, 1936 (*Der Fotorat*, 30).
28 Paul Wolff, *Arbeit!*, Berlin: Volk und Reich Verlag, Frankfurt am
Main: H. Bechhold Verlagsbuchhandlung, 1937; Heinrich Hauser, *Im
Kraftfeld von Rüsselsheim, mit 80 Farbphotos von Dr. Paul Wolff*,
Munich: Knorr und Hirth, 1940.

Wolff, 1937

During the years following World War I, Germany set about recovering lost terrain in the industrial sector, trying to catch up technologically and economically. Nationalist-tinged slogans found their visual expression in numerous publications speaking in praise of labor.[24] Countless books appeared, illustrated above all with pictures of the heavy industries meant to attest to "Germany's comeback," as it was announced on the cover of a publication in 1930.[25] Over a period of one and a half decades, publications for professional photographers regularly contained instructions on how to create impressive industrial photographs.

Photographers mostly chose such sites as steelworks, coking plants, factories, metallurgical plants, dockyards, and railroad installations, depicting motifs like furnaces, chimneys, cooling towers, ships, and trains emitting smoke and letting off steam. These artificial clouds were proof that things were being kept in motion, that something was being produced or shipped, that manpower and machinery were performing their work. "A steam engine [...] is alive, works, pants," said a manual that appeared in 1933.[26] Frequently, cloud formations are looming above these factories and vehicles, as if the dynamics of industrial and working life were continued in the sky. Piled clouds were meant to be a powerful demonstration of ongoing developments. In order to create strong contrasts between light and dark objects, between the atmosphere and soot-blackened buildings, as well as between white steam and grayish-black fumes, photographers relied on high-speed lenses, highly sensitive films, and all kinds of filters, including graduated yellow ones.[27]

The subject matter in question was dealt with both by professional photographers engaged by factory owners, shipping companies, publishing houses, and newspaper editors, and amateurs inspired by the recommendations of photo clubs or the patriotic slogans of political parties. In 1933, the National Socialists readily adopted the primacy of patriotic photography over all other genres, as it was proclaimed by amateur clubs. This also comprised the *mise-en-scène* of the performance of industry and the working population, complying with the National Socialists' aim to demonstrate Germany's strength to the world. The manner of representation was largely left to the photographers, who usually relied on traditional compositional approaches and favored overall views of their objects. Only now and then did steep or oblique perspectives and extreme fields of view, which were preferred by the advocates of a "new vision" in photography, find their way into the pictorial world of industrial work and production.

Paul Wolff (1887–1951) numbers among those photographers who adapted their compositional means to the respective requirements. Initially, he held fast to pictorial tendencies, creating townscapes whose narrow lanes and old houses he endowed with a romantic air through blurring and brown toning. In the mid-1920s, he received more and more industrial assignments for advertisements and publications issued on the occasion of company anniversaries; he switched from the plate camera to the 35-mm camera and excelled in the fields of both press coverage and technically oriented documentation. Wolff was one of the most successful German photographers during the interwar years; he also owes his popularity to two books: *Arbeit*, published in 1937, and *Im Kraftfeld von Rüsselsheim*, published in 1940.[28]

Ratgeber von 1933.[27] Und über den Fabrikationsstätten und Fahrzeugen stehen häufig dräuende Wolkenformationen, als würde sich die Dynamik der Industrie- und Arbeitswelt am Himmel fortsetzen. Die Haufenwolke soll kraftvoll demonstrieren, welche Entwicklung unter ihr vonstatten geht. Damit sich die hellen und dunklen Objekte, die Atmosphäre und die rußgeschwärzten Gebäude, der weiße Dampf und der grauschwarze Rauch kontrastreich voneinander abheben, kommen lichtstarke Objektive, hochempfindliches Filmmaterial und allerlei Filter bis hin zu verlaufenden Gelbscheiben zur Anwendung.[28]

Dem Thema widmen sich ebenso Berufsfotografen, die im Auftrag von Fabrikbesitzern oder Verkehrsbetrieben, von Verlagen oder Zeitungs-redaktionen tätig sind, wie Amateure, die den Anregungen der Vereine oder auch den patriotischen Sprüchen der politischen Kräfte folgen. Insbesondere das von den Amateurverbänden hochgehaltene Primat der Heimatfotografie gegenüber allen anderen Genres und die dazu zählende Inszenierung der Leistungen von Industrie und arbeitender Bevölkerung werden 1933 von den Nationalsozialisten gerne übernommen, passt es doch zu deren Ziel, Deutschlands Stärke gegenüber der Welt zu demonstrieren. Die Art der Darstellung überlässt man weitgehend den Fotografen, die sich zumeist auf tradierte Formen stützen und Gesamtansichten ihrer Objekte bevorzugen. Nur dann und wann finden Steil- und Schrägsichten, extreme An- und Ausschnitte, derer sich die Jünger des Neuen Sehens mit Vorliebe bedienen, Eingang in die Bildwelt der industriellen Arbeit und Fertigung.

Paul Wolff (1887–1951) gehört zu den Fotografen, die ihre kompositorischen Mittel nach den jeweiligen Anforderungen wählen. Zunächst hängt er pikto-rialistischen Tendenzen an und schafft Stadtporträts, bei denen er die engen Gassen und alten Häuser mit den romantisierenden Zügen der Unschärfe und Brauntonung ausstattet. Mitte der 1920er Jahre erhält er zunehmend Industrieaufträge für Anzeigenvorlagen und Firmenfestschriften, wechselt von der Platten- zu einer Kleinbildkamera und beherrscht ebenso das Metier der Berichterstattung wie der sachlich angelegten Dokumentation. Wolff ist einer der meistbeschäftigten deutschen Bildautoren zwischen den Weltkriegen, seine Bekanntheit verdankt er nicht zuletzt den beiden Buchveröffent-lichungen *Arbeit* von 1937 und *Im Kraftfeld von Rüsselsheim* von 1940.[29]

Hildegard U., „Über dem Atlantik", Reise in die USA
Above the Atlantic, journey into the USA, 26. September 1951 September 26, 1951
Bild 6,9 x 6,7 cm, Abzug 8,3 x 7,9 cm image area 6.9 x 6.7 cm, print 8.3 x 7.9 cm (Fotomuseum im Münchner Stadtmuseum, Album K 208/7)

Anonym, 1950er Jahre

Nimmt man ein privates Fotoalbum der 1950er oder 1960er Jahre zur Hand, in dem eine Reise nachgezeichnet ist, enthält es gelegentlich eine Wolkenauf-nahme.[30] Insbesondere wenn ein Tourist das erste Mal mit dem Flugzeug an den Urlaubsort gebracht wird, hält er gerne die ersten Stationen fest: manchmal die Abflughalle, die wartende Maschine auf dem Rollfeld, häufig die Familie auf der Gangway.[31] In der Kabine wird für gewöhnlich erst fotografiert, wenn das Flugzeug seine Reisehöhe erreicht hat. Das Dröhnen der Motoren hat nachgelassen, die Schräglage ist in eine horizontale übergegangen, man holt die Kamera aus dem Handgepäck. Die Sonne scheint, doch die Sicht nach unten ist verdeckt. Einem Gebirge gleich türmen sich die Wolken – das muss fotografiert werden. Manchmal ragt noch ein silbrig glänzender Flügel in die weiße Landschaft, oder ein Teil des Fensters begrenzt das Bild auf einer Seite.

27 Alexander Niklitschek, *Kunstphotographie der Technik*, Berlin: Photokino-Verlag, 1933, S. 70.
28 Vgl. beispielsweise Wolf H. Döring, *Wolken ins Foto!* Halle (S): Wilhelm Knapp, 1936 (Der Fotorat, 30).
29 Paul Wolff, *Arbeit!*, Berlin: Volk und Reich Verlag, Frankfurt am Main: H. Bechhold Verlagsbuchhandlung, 1937; Heinrich Hauser, *Im Kraftfeld von Rüsselsheim*, mit 80 Farbphotos von Dr. Paul Wolff, München: Knorr und Hirth, 1940.
30 Bei der Recherche sowie der Beschaffung der hier abgebildeten Knipseraufnahmen haben mich Bernhard Cella, Ulrike Matzer, Ulrich Pohlmann, Joachim Schmid und Friedrich Tietjen unterstützt, wofür ich ihnen herzlich danke.
31 Vgl. die Zusammenstellung von Joachim Schmid, „Fluggäste am Flugzeug. 50er bis 70er Jahre", in: *„Knipsen". Private Fotografie in Deutschland von 1900 bis heute*, Ausstellungskatalog Institut für Auslandsbeziehungen, o.O. [Stuttgart] 1997, S. 58/59.

Anonymer Knipser Anonymous snapshooter,
ohne Titel *Untitled,* Juni June **1989**
9 x 12,5 cm 9 x 12.5 cm (Sammlung Joachim Schmid, Berlin)

Anonymous, 1950s

Looking at a private photo album from the 1950s or '60s documenting a journey, one may occasionally come across a cloudscape.[29] Particularly tourists traveling to their vacation resort by air for the first time love taking pictures of the place of departure: sometimes of the terminal or the plane waiting on the airfield, and frequently of the family climbing the gangway.[30] Once in the cabin, the first pictures are usually taken when the aircraft has reached the required cruising altitude. When the roar of the engines has subsided and the slope has passed into a horizontal position, the camera is taken out of the hand baggage. The sun is shining, but the view downward is obstructed. Clouds are piling up like mountains – a picture simply has to be taken. Sometimes a shining silvery wing protrudes into the white landscape, or one side of the picture is bordered by a part of the window frame.

Such pictures can be found among souvenir photos dating from the early days of mass tourism and package tours. When the vacation was over, they were pasted into an album with all the other prints (or stored away in a box with the other slides), usually without any further description. Occasionally, merely the date is inscribed, since these photographs do not depict any sights in the usual sense, and no fellow travelers appear in them; neither is it possible to name the location, for people either ignored the captain's announcement or did not remember it. They were nowhere – somewhere between sky and earth. The only thing they could hold on to was a phenomenon that is known to be merely capable of steadying the gaze. Their eyes trusted nature, whereas their bodies were at the mercy of technology.

But just because orientation was impossible, the traveler felt for the first time that he had left everything behind: tedious routines, problems on the job, the ever-recurring alternation of work and spare time, profession and family. Nor can one see from these pictures that the traveler was confined to a narrow seat, surrounded by unknown fellow passengers and exposed to the aircrew's impersonal politeness. Upon arrival, vacationers hoped for an entire world of novelties, days without constraint, leisure without end. Nobody thought of the regulations involved in half- or full-board accommodation or the excursions announced in the itinerary. People looked at the clouds piling up high and sensed unbridled freedom – at least for a moment. These moments of carefreeness and oblivion have been preserved in the cloudscapes of air passengers.

29 I thank Bernhard Cella, Ulrike Matzer, Ulrich Pohlmann, Joachim Schmid, and Friedrich Tietjen for their help in investigating the issue of snapshot photography and securing the examples reproduced here.
30 See the compilation by Joachim Schmid, "Fluggäste am Flugzeug. 50er bis 70er Jahre," in: *"Knipsen." Private Fotografie in Deutschland von 1900 bis heute,* exhibition catalogue, Institut für Auslandsbeziehungen, n.p. [Stuttgart] 1997, pp. 58–59.

Solche Aufnahmen gehören zu den Erinnerungsbildern der frühen Zeit des Massen- und Pauschaltourismus sowie vieler erster Flugreisen. Sie werden mit allen anderen Abzügen nach dem Urlaub ins Album geklebt (oder mit den übrigen Dias in einer Kassette aufbewahrt), jedoch wird gewöhnlich auf eine Identifizierung verzichtet und nur das Datum gelegentlich verzeichnet. Es handelt sich ja nicht um eine Sehenswürdigkeit im üblichen Sinn, kein Mitreisender ist abgebildet; eine Ortsangabe ist ebenso unmöglich, die Durchsage des Kapitäns hat man überhört oder sich nicht gemerkt. Man befindet sich im Nirgendwo zwischen Himmel und Erde. Den einzigen Halt bildet eine Erscheinung, von der man weiß, dass sich nur der Blick an ihr festzumachen vermag. Die Augen vertrauen der Natur, während der Körper der Technik ausgeliefert ist.

Doch gerade weil keine Orientierung möglich ist, überkommt den Reisenden zum ersten Mal das Gefühl, alles hinter sich gelassen zu haben. Die Mühen des Alltags, die Widrigkeiten in der Firma, der immer gleiche Wechsel von Arbeit und Freizeit, von Beruf und Familie sind vergessen. Präsent ist auch nicht, dass man an einen engen Sitz gebunden, von unbekannten Passagieren umgeben und der unpersönlichen Freundlichkeit des Personals ausgesetzt ist. Nach der Ankunft erhofft man sich eine Welt voller Neuigkeiten, Tage ohne Zwänge, unbegrenzte Muße. An die Reglementierungen bei der Unter-bringung in Halb- oder Vollpension und der im Prospekt angekündigten Ausflüge denkt keiner. Man schaut auf die Wolkenberge und empfindet – für einen Augenblick zumindest – grenzenlose Freiheit. Diese Momente der Unbeschwertheit und des Vergessens sind in den Wolkenbildern der Flugreisenden aufgehoben.

Graham, 1994
Lichtsteiner, 1996

Die Fotografen wie die Künstler, die mit Fotografie arbeiten, nähern sich ab den 1960er Jahren in der Mehrzahl den Wolken, indem sie deren Opazität und Flüchtigkeit gegen die Zeit stellen, die ständige Metamorphose gegen den Augenblick. Eine sich unablässig wandelnde Erscheinung der Natur wird gewissermaßen an ein Jetzt gebunden, das ihr fremd ist. Denn die Daseins-form der Wolke ist die stete Bewegung in der Atmosphäre wie in sich selbst, das Drehen, Sich-Auf-bäumen, Zerreißen im Wind wie das Zusammenballen, Ineinanderschieben, Zusammendrängen. Nichts ist dem Wesen der Wolken ferner als der Schnitt durch die Zeit, der sie anhält und erstarren lässt. Die Vielfalt der Formen wird ins Momentan-Skulpturale gewendet oder im Dunsthaften verborgen. Als ob sich das Plötzliche des Auftretens zügeln ließe, wenn es mit dem Etikett des Moments, eines Datums, einer Uhrzeit ausgestattet wird.

Dies unterscheidet die fotografierten Wolken von den gemalten und gezeichneten, deren Schöpfer ihrem Sujet hinterhereilen und doch jeden Augenblick zu spät kommen, so eigentlich den Zufall nicht kennen, wenn er nicht ihrer Phantasie als Idee entspringt. Die Fotokünstler und Kunst-fotografen hingegen erfinden den Augenblick, indem sie den Zufall der Geschwindigkeit der Apparatur überantworten, die eine Ansicht liefert, die niemals von jemandem so gesehen worden ist. Beide Medien stehen in einer

Rudolf Lichtsteiner, „Reisen außerhalb, No. 3",
1982/1996
60 x 50 cm (aus from: *Kunstform International*,
Bd. vol. 136: *Ästhetik des Reisens*, Februar–Mai
February–May 1997, S. p. 241)

Graham, 1994
Lichtsteiner, 1996

From the 1960s onward, both photographers and artists working with photography mostly approached the subject of clouds by relating the latter's opacity and volatility to time and by juxtaposing constant metamorphosis with instantaneity. An incessantly changing natural phenomenon is linked, in a way, to a here and now that is totally alien to it. For a cloud's mode of existence is one of constant movement in the atmosphere and within itself – changing direction, rearing up, being torn apart by the wind, accumulating, mingling with others, and huddling together. Nothing is more against the nature of clouds than this rupture in time that causes them to stop and freeze. Their great diversity of form is turned into momentary sculptural manifestations or concealed by mistiness – as if the abruptness of their appearance could be bridled by momentariness or a date and time.

This distinguishes photographed clouds from painted and drawn ones, whose authors try to catch up with their subject, but are constantly late and thus, in fact, know no accident unless it springs from their imagination in the form of an idea. Art photographers and photographing artists, on the other hand, invent a specific moment by entrusting accident to the speed of their apparatus, which produces an image that has never before been seen by anyone. Both media are involved in a permanent struggle with the factor of time, which, however, differs from case to case. The traditional visual arts are capable of negotiating the confrontation between movement and immobility, between an experienced or imagined present and one that is perceived when the picture is viewed as a single image, whereas the art of photography always needs several frames to do so.

We may still come across photographers – particularly among club amateurs – shooting pictures of cloud formations for the sake of atmosphere or bizarre arrangements. But most of those dealing with clouds produce series or sequences of frames, create images within an image or image-text combinations, retouch prints or negatives, modify clouds, or invent them digitally – whatever their goals may be. Therefore, there are always two or more moments in time involved when several pictures are taken in succession or extant images are modified or renamed or when a cloud is being constructed on the computer. In the following I would like to single out three examples from the field of combinations.

In 1996, the Swiss photographer Rudolf Lichtsteiner (born in 1938) referred to a cloudscape from 1982, affixing terms to it that virtually introduce movement into the picture: "arriving staying leaving."

In 1975, the Polish film and media artist Kazimierz Bendkowski (born in 1948) subtitled ten copies of the same cloud constellation with the names of different places: "Nuages sur Lodz, Nuages sur Lyon, [...] Nuages sur New York." The photographs' authenticity is thwarted by the arbitrariness of written categorization supplied at a later date, while the haphazardness of the cloud formations is related to subjective imagination.[31]

31 The ten photographs are arranged in the form of a signed tableau entitled *Photographie relative No. 1* and reproduced and commented upon in: Rolf H. Krauss, Manfred Schmalriede, Michael Schwarz, *Kunst mit Photographie. Die Sammlung Dr. Rolf H. Krauss*, exhibition catalogue, Nationalgalerie Berlin, Berlin: Frölich & Kaufmann, 1983, pp. 84–85.

permanenten Auseinandersetzung mit dem Zeitfaktor, der jedoch ein jeweils anders gearteter ist. Die traditionellen Künste vermögen die Konfrontation von Bewegung und Stillstand, von erlebter, vorgestellter und angesichts des Bildes wahrgenommener Gegenwart in einem einzigen Bild zu verhandeln, während die fotografische Kunst dazu immer mehrere benötigt.

So finden sich zwar immer wieder vereinzelte Lichtbildner – vor allem unter den Klubamateuren –, die Wolkenformationen ablichten und denen es um Stimmungen oder bizarre Anordnungen zu tun ist. Doch die meisten, die sich – mit welchen Zielsetzungen auch immer – mit Wolken beschäftigen, fotografieren in Serien oder Sequenzen, kreieren Bild-im-Bild- oder Bild-Text-Kombinationen, überarbeiten Abzüge oder Negative, verändern oder erfinden Wolken digital. Es sind demnach immer zwei oder mehr zeitliche Momente beteiligt, wenn mehrere Aufnahmen nacheinander entstehen, bestehende Bilder später bearbeitet oder umbenannt werden oder eine Wolke am Computer konstruiert wird. Ich möchte im Folgenden drei Beispiele aus dem Feld der Kombinationen herausgreifen.

Der Schweizer Fotograf Rudolf Lichtsteiner (geb. 1938) greift 1996 nach einer Wolkenaufnahme von 1982 und versieht sie mit Begriffen, die gleichsam Bewegung ins Bild bringen: „ankommen hiersein weggehen".

Der polnische Film- und Medienkünstler Kazimierz Bendkowski (geb. 1948) unterschreibt 1975 zehn Abzüge derselben Aufnahme einer Wolken-konstellation mit immer anderen Ortsnamen: „Nuages sur Lodz, Nuages sur Lyon, [...] Nuages sur New York". Die Authentizität der Fotografien wird mit der Beliebigkeit der nachgereichten schriftlichen Zuweisung konterkariert, die Zufälligkeit des Wolkengebildes zur subjektiven Vorstellung ins Verhältnis gesetzt.[32]

Der englische Fotograf Paul Graham (geb. 1956) fotografiert Wolken über diversen Orten in Nordirland, nachdem im April 1994 für drei Tage eine vorübergehende Waffenruhe vereinbart worden ist. Er nennt jedoch nicht Tag und Uhrzeit, sondern lediglich Monat und Jahr; auch wird der genaue Standort nicht bekannt gegeben, sondern nur die Stadt. Der Betrachter ‚bewegt' sich in einem eindeutig gemeinten politischen Kontext, aber zugleich in einem nicht klar fixierten Terrain und einer grob angegebenen Zeitspanne. In Korrespondenz dazu lässt der fotografische Ausschnitt bei aller Detail-genauigkeit weder den Umfang des Gebildes am Himmel noch dessen Geschwindigkeit ermessen. Wenn auch unter anderen Voraussetzungen entstanden und mit anderen Bedeutungen besetzt, führt diese Fotoserie mit ihren raumzeitlichen Dimensionen zurück zu jener von John Constable 1821/22 gemalten, die eingangs beschrieben ist.

Wolken sind wie Fotografien: Ergebnisse eines chemischen Prozesses, sodann Spiegel und Projektionsflächen, symbolhaft besetzbar, metaphorisch vielfältig zu nutzen, dem Zufall hörig; wendet man sich von ihnen ab, ist es wie ein Erwachen.

32 Die zehn Fotos mit Unterschrift sind als Tableau arrangiert, mit „Photographie relative Nr. 1" betitelt und abgebildet sowie kommentiert in: Rolf H. Krauss, Manfred Schmalriede, Michael Schwarz, *Kunst mit Photographie. Die Sammlung Dr. Rolf H. Krauss*, Ausstellungskatalog Nationalgalerie Berlin, Berlin: Frölich & Kaufmann, 1983, S. 84/85.

Paul Graham: „Ceasefire, Andersonstown, Belfast,
April 1994"
112 x 143 cm (aus from: *Prospect 96. Photographie in der
Gegenwartskunst,* Ausstellungs-katalog exhibition catalogue
Frankfurter Kunstverein, Schirn Kunsthalle Frankfurt,
Kilchberg/Zürich Zurich: Edition Stemmle, 1996, S. p. 158)

The English photographer Paul Graham (born in 1956) photographed clouds in several places in Northern Ireland after a temporary ceasefire of three days had been agreed upon in April 1994. He neither indicated the day nor the hour, but merely the month and the year; nor did he state the precise location, just the town. So the spectator "moves" within what was clearly meant as a political context, but also within an unclearly defined terrain and a roughly indicated period of time. Accordingly, the photographic field of view does not allow one to estimate either the celestial structure's size or its speed, despite the attention that has been paid to detail. Even if it was made under different circumstances and endowed with different meanings, this series of photographs, with its dimensions of space and time, leads us back to the series John Constable painted in 1821–22, described at the very beginning.

Clouds are like photographs: they are the results of a chemical process, but also mirrors and projection screens, versatile symbols and metaphors, slaves to randomness. Turning away from them is like waking up.

Eine kleine Literaturauswahl zur Wolkenfotografie
(ohne Meteorologie, in der Reihenfolge des Erscheinens)

Karl Ritter v. Stefanowski, „Ueber Wolkenplatten", in: *Photographische Correspondenz*, 13. Jg., 1876, S. 213–216.

H. P. Robinson, „Combinirte Photographien", in: ders., *Der malerische Effect in der Photographie als Anleitung zur Composition und Behandlung des Lichtes in Photographien*, Frei nach dem Englischen von C. Schiendl, Halle a. S.: Wilhelm Knapp, 1886, S. 167–168.

J. M. Eder, „Notizen zur Theorie und Praxis der Photographie. II. Wolkenaufnahmen mit orthochromatischen Platten hinter orangegelben Gläsern", in: *Photographische Correspondenz*, 23. Jg., 1886, S. 362–363.

A. Horsley Hinton, „Wolken in der Landschaft", in: ders., *Künstlerische Landschafts-Photographie in Studium und Praxis*, Berlin: Gustav Schmidt, [1896] ³1903, S. 87–98.

F. von Staudenheim, „Wolken", in: *Jahrbuch für Photographie und Reproductionstechnik*, 13. Jg., Halle a. S.: Wilhelm Knapp, 1899, S. 7–9.

Anton Mazel, „Himmel und Ferne", in: ders., *Künstlerische Gebirgs-Photographie*, Autorisierte deutsche Übersetzung von E. Hegg, Berlin: Gustav Schmidt, 1903, S. 119–127; darin: „Die Rolle der Wolken", S. 122–124.

A. Miethe, „Luft und Wasser", in: ders., *Künstlerische Landschafts-Photographie. Zwölf Kapitel zur Ästhetik photographischer Freilicht-Aufnahmen*, Zweite durchgesehene und vermehrte Auflage, Halle a. S.: Wilhelm Knapp, [1897] 1906, S. 82–98, darin: „Wolken", S. 83–90.

Curt Schmidt, „Wolkenphotographie", in: ders., *Die Photographie im Dienste wissenschaftlicher Forschung*, Wien, Leipzig: A. Hartleben, o.J. (1909) (Naturwissenschaftliche Taschenbibliothek, Bd. 3), S. 62–70.

A. Jencic, „Wolkenstudien", in: *Wiener Mitteilungen aus dem Gebiete der Literatur, Kunst, Kartographie und Photographie*, 17. Jg., 1912, S. 234–239.

Wolken im Luftmeer. Lichtbilder aufgenommen von deutschen Fliegern während des Krieges, Berlin: Rotophot, 1917.

Alfred Stieglitz, „Wie ich dazu kam, Wolken zu fotografieren" [„How I came to Photograph Clouds", 1923], in: *Wolkenbilder. Die Erfindung des Himmels*, hrsg. von Stephan Kunz, Johannes Stückelberger, Beat Wismer, Ausstellungskatalog Aargauer Kunsthaus, Aarau, München: Hirmer, 2005, S. 85–89.

Oskar Prochnow, *Wolken*, Berlin: Brehm, 1931 (Die Brehm-Bücher, 9).

Wolken über Land und Meer. 47 Naturaufnahmen, Königstein im Taunus, Verlag der Eiserne Hammer, 1932.

Wolf H. Döring, *Wolken ins Foto!* Halle a. S.: Wilhelm Knapp, 1936 (Der Fotorat, 30).

H. Reuter, „Der Wert der Wolken", in: *Fotografische Rundschau und Mitteilungen*, 75. Jg., 1938, S. 228–230.

Manfred Curry, *Wolken, Wind und Wasser*, Zürich: Schweizer Druck- und Verlagshaus, 1951.

Kurt Fritsche, *Wolken ins Bild*, Halle a. S.: Wilhelm Knapp, 1955 (Der Fotorat, 32).

Karl Jud, *Wolken. Eine Bildfolge*, Zürich, Stuttgart: Aldus Manutius, o.J. (1964).

Dorothy Norman, „The Equivalents", in: dies., *Alfred Stieglitz. An American Seer*, An Aperture Book, New York: Random House, 1973, S. 143–162.

Rosalind Krauss, „Stieglitz' Äquivalente" [„Stieglitz/Equivalents", 1979], übersetzt von Henning Schmidgen, in: dies., *Das Photographische. Eine Theorie der Abstände*, München: Wilhelm Fink, 1998 (Bild und Text, hrsg. von Gottfried Böhm, Karlheinz Stierle), S. 127–137.

Sarah Greenough, „Les nuages d'Alfred Stieglitz. Forme et sentiments", in: *Photographies*, No 7, Mai 1985, S. 37–39.

Langer, Freddy (Hrsg.), *Wolken*, Hamburg: Ellert & Richter, 1988 (Die weiße Reihe).

Philippe Dubois, *Der fotografische Akt. Versuch über ein theoretisches Dispositiv* [*Le Photographique. Pour une Théorie des Écarts*, 1990], aus dem Französischen von Dieter Hornig, hrsg. von Herta Wolf, Amsterdam, Dresden: Verlag der Kunst, 1998 (Schriftenreihe zur Geschichte und Theorie der Fotografie, Bd. 1); darin zu den „Equivalents" von Alfred Stieglitz: S. 199–213.

Herta Wolf, „Wolken, Spiegel und Uhren. Eine Lektüre meteorologischer Fotografien", in: *Fotogeschichte*, Heft 48, 13. Jg., 1993, S. 3–18.

Herta Wolf, „Fixieren – Vermessen: Zur Funktion fotografischer Registratur in der Moderne", in: *Riskante Bilder. Kunst, Literatur Medien*, hrsg. von Norbert Bolz, Cordula Meier, Birgit Richard und Susanne Holschbach, München: Wilhelm Fink, 1997, S. 239–261.

Ann Thomas, „,Temporäre Volumina': Die Wolkenfotografien Herwig Kempingers", in: *Camera Austria*, Nr. 74, 2001, S. 27–38.

Herta Wolf, „Wie man Wolken beobachtet", in: *Wolkenbilder. Die Erfindung des Himmels,* hrsg. von Stephan Kunz, Johannes Stückelberger, Beat Wismer, Ausstellungskatalog Aargauer Kunsthaus, Aarau, München: Hirmer, 2005, S. 75–83.

Archiv für Mediengeschichte – Wolken, hrsg. von Lorenz Engell, Bernhard Siegert, Joseph Vogl, Weimar: Verlag der Bauhaus-Universität, 2005; diverse Beiträge S. 95–137, 159–165, 193–195.

Johannes Karel

Clouds in Mythology

Wolfgang Buchta, O.T. Untitled, **1987**
Aquarell auf Papier watercolour on paper, 100 x 70 cm
Sammlung der Kulturabteilung der Stadt Wien MUSA Collection of
the Department for Cultural Affairs of the City of Vienna MUSA

Myths tell us about incidents from the world of gods and goddesses; they relate the deeds of famous heroes and heroines, explain how the world and the universe came into being, describe the creation of mankind, and provide guidelines for the latter's social and cultic interaction with deities. Such natural phenomena as rain, thunderbolts, droughts, and floods were signs of the active presence of the supernatural and supplied clues for men as to the gods' state of mind, which humans sought to influence positively through rituals and offerings.

Since rain and thunderbolts emanated from them, clouds were regarded as symbols of the supernatural powers. However, opinions about the origins of clouds and their functions differ from legend to legend.

The following provides a comparison of exemplary episodes from the mythologies of different civilizations. During my research the themes mentioned here crystallized as the main aspects of how clouds are understood. There are, in fact, further interpretations, which had to be neglected for the sake of conciseness.

Origins and Genesis

Depending on the cultural background of a civilization, there are different interpretations as to the origins of clouds. When they are directly referred to in the creation myths and not merely mentioned as the by-product of a creation process or the attribute of one of the deities, clouds are said to have derived from the body of a divine or celestial being.

Indian mythology, for example, has it that the gods and the giants carried Mount Mandar into the Sea of Milk, using the mountain to churn the ocean until Amrita, the nectar of immortality, emerged from the milk, which had curdled into butter. Performing this chore, Brahma is said to have been sweating so heavily that his perspiration rose up in the form of clouds and that the moon separated from him in a spark of fire. Brahma's epithet "Abija goni" declares him as the creator of the clouds and the moon.

The creation epic of ancient Mesopotamia relates that the two gods Apsu and Tiamat, symbolizing the primeval subterranean waters and the sea respectively, had brought forth four generations of deities. The great noise they made when playing in Anduruna, the dwelling of the gods, had become so unbearable for Apsu that he started planning to annihilate them. However, when Ea, who was considered the source of all knowledge, found out, he killed Apsu and succeeded him as ruler. Ea's son Marduk was such a superior being that "his divinity was twofold," which accounts for Marduk's four eyes and ears, with which he perceived just anything. Some gods became jealous and persuaded Tiamat to avenge Apsu's death, which led Tiamat to give birth to an army of frightening demons. Initially, they remained victorious in their battle against the gods. However, when the situation got out of hand, Marduk offered himself as their savior and succeeded in defeating Tiamat in a horrible fight. Marduk cut Tiamat's body in half, thus creating heaven and earth. He caused the Tigris and the Euphrates to spring from her eyes, and from Tiamat's saliva he formed the wind, the rain, and the clouds.

rächen. Tiamat gebar ein Heer Furcht einflößender Dämonen, und anfänglich blieben diese im Kampf mit den Göttern siegreich. In höchster Not bot sich Marduk als Retter an; es gelang ihm in einem schrecklichen Kampf, Tiamat zu bezwingen. Den Körper der Besiegten schnitt Marduk entzwei, erschuf daraus Himmel und Erde, aus Tiamats Augen ließ er Euphrat und Tigris strömen, Wind, Regen und Wolken hingegen formte Marduk aus Tiamats Speichel.

Auch in der nordischen Mythologie wird der Körper eines riesenhaften Wesens zum Baumaterial der Erde. In der Vorstellungswelt der skandinavischen Urvölker gab es mehrere, übereinanderliegende Welten, die durch Luft, Nebel oder Reifschichten voneinander getrennt waren. Am Anfang aber gab es nur das Reich der Kälte und Finsternis im Norden, Niflheim (Nebelheim), und im Süden die Licht- und Feuerwelt Muspelheim. Als die Sonnenstrahlen aus Muspelheim auf den Reif, der aus Niflheim kam, trafen, schmolz dieser, und aus den Tropfen entstand das erste lebende Wesen, der Frostriese Ymir, der der Stammvater des Geschlechtes der Riesen war. Zugleich mit ihm entstand aus der Vermengung von Wärme und Kälte die Kuh Andumbla, von deren Milch sich Ymir ernährte. Die Kuh wiederum beleckte Salzsteine, aus denen Bure, der Stammvater der nordischen Götter, hervorging. Die Enkel des Bure waren Odin, Wile und We, die zu den Herrschern des Himmels und der damals noch nicht erschaffenen Erde wurden. Zwischen ihnen und den Nachkommen des Ymir gab es stets Streit und Kampf, der damit endete, dass Odin und seine Brüder den Eisriesen erschlugen und in einen Abgrund warfen. Aus dem Leichnam erschufen sie die Welt. Ymirs Blut wurde zum Meer, aus seinem Fleisch die Erde, die Haare des Riesen wandelten sich in Bäume, seine Knochen bildeten die Gebirge und Felsen, die Hirnschale wurde, sinnigerweise von vier Zwergen emporgehalten, zum Himmelsgewölbe. Die Augenbrauen des Riesen wurden als Verschanzungen rund um Asgard, die Wohnstatt der nordischen Götter, wiederverwendet, während Odin und seine Brüder Ymirs Gehirn in die Luft warfen, um die Wolken zu formen.

Gottfried Ecker, Schädeldecken – lose Gedanken Scullcaps – Loose Thoughts, 1994
Farbstift auf Papier colour pencil on paper, Ø 79 cm
Leihgabe des Künstlers loan of the artist

Eine weniger gewalttätige Version der Weltentstehung aus dem Körper eines Urwesens kennt die chinesische Mythologie, deren Protagonisten oftmals nicht endgültig sterben, sondern eine Metamorphose erleben. So auch der Riese Pan Gu, dessen Name Gewundenes Altertum bedeutet. Seine Körperteile verwandelten sich in die Bestandteile des Kosmos, sein Fleisch wurde zur Erde, seine Augen zu Sonne und Mond, seine Körperflüssigkeiten zu Regen und Flüssen, und sein Atem wurde zum Wind und zu den Wolken.

Symbol für das Göttliche

Stellvertretend für die Darstellung einer Gottheit beziehungsweise deren Funktion oder Tätigkeit konnte das Bild der Wolke verwendet werden. Der Betrachter oder Leser wusste durch den Zusammenhang den jeweiligen Hintergrund zu entschlüsseln. Wolken können somit zu Metaphern entweder der Beschützerfunktion des Gottes, seines Zornes, seiner Enttäuschung oder des Aufenthaltsortes, sprich des Himmels, werden.

Im Alten Testament ist die Wolke mehrmals als Erscheinungsform Gottes genannt. Nach dem Auszug der Israeliten aus Ägypten erreichen diese unter der Führung von Mose und Aaron die Wüste Sin. Die Vorräte gehen zur

According to Norse mythology as well, the earth was built from the body of a gigantic creature. The primitive Scandinavian peoples imagined that there were several worlds mounted on top of each other, separated by air, mist, or layers of frost. In the very beginning, there were only Niflheim, the realm of cold and darkness, in the north, and Muspelheim, the realm of light and fire, in the south. When rays of sunlight from Muspelheim hit the frost in Niflheim, the frost melted and Ymir, the first living creature and ancestor of the race of the frost giants, was born from the drops. Simultaneously, the cow Audumbla emerged from the combination of heat and cold, and Ymir fed from its milk. The cow in turn licked the salty rock, which exposed Búri, the progenitor of the Norse deities. Búri's grandsons were Odin, Wili, and We, the future rulers of heaven and earth. They and Ymir's descendants were constantly involved in quarrels and fights, which were ended by Odin and his brothers killing the frost giant and throwing him into an abyss. From his body, they created the world. Ymir's blood became the sea and his flesh, the earth. The giant's hair was transformed into trees and his bones, into mountains and rocks. His brainpan, supported by four dwarfs, appropriately turned into the firmament. His eyebrows served to build the fortifications around Asgard, the seat of the Norse deities. Eventually, Odin and his brothers tossed Ymir's brain up into the air in order to produce clouds.

A less violent version of the creation of the world from the body of a primordial being is contained in Chinese mythology, whose protagonists often do not actually die, but undergo a metamorphosis. This is what is said to have happened in the case of the giant Pan Gu, whose name means "meandering ancient times." The parts of his body turned into the various components of the cosmos; his flesh became the earth, his eyes were transformed into the sun and the moon, his body fluids were turned into rain and rivers, and his breath into wind and clouds.

A Symbol of the Divine

The image of a cloud could represent a deity or stand for the latter's function or activities. The respective contexts gave the spectator or reader clues as to how to interpret such an image. Thus, clouds can be metaphors of a deity's protectiveness, rage, or disappointment, but also point to its domicile in heaven.

In the Old Testament, the cloud occurs repeatedly as a manifestation of God. After the exodus from Egypt, the Israelites, led by Moses and Aaron, reached the desert of Sin. They were running out of provisions, so that the people were growing impatient and wished to return to Egypt. Moses and Aaron promised to remedy the situation, saying that God, who had heard their grumbling, would feed them: "And it came to pass, as Aaron spake unto the whole generation of the children of Israel, that they looked toward the wilderness, and, behold, the glory of the Lord appeared in the cloud" (Exodus 16:10). In the evening, quails came up to the camp, and the following morning the ground of the desert was covered with something delicious and crispy – manna.

God also guided the Israelites through the desert, "by day in a pillar of a cloud, to lead them the way; and by night in a pillar of fire, to give them light" (Exodus 13:21). Furthermore, a cloud protected the Israelite people from their Egyptian persecutors: "[…] and the pillar of the cloud went from before their face, and stood behind them. And it came between the camp of the Egyptians and the camp of Israel; and it was a cloud and darkness to them, but it gave light by night to these" (Exodus 14:19–20).

Neige, das Volk ist unzufrieden und möchte nach Ägypten zurückkehren. Mose und Aaron versprechen Abhilfe, Gott wird die Israeliten sättigen, er habe ihr Murren gehört: „Während Aaron zur ganzen Gemeinde der Israeliten sprach, wandten sie sich zur Wüste hin. Da erschien plötzlich in der Wolke die Herrlichkeit des Herrn" (2 Mose, 16,10). Am Abend kamen Wachteln in das Lager, am kommenden Morgen lag auf dem Wüstenboden etwas Feines, Knuspriges – das Manna.

Gott führte die Israeliten auch durch die Wüste, „bei Tag in einer Wolkensäule, um ihnen den Weg zu zeigen, bei Nacht in einer Feuersäule, um ihnen zu leuchten" (2 Mose, 13, 21). Zusätzlich beschützt die Wolke das israelitische Volk vor den ägyptischen Verfolgern: „… und die Wolkensäule vor ihnen erhob sich und trat an das Ende. Sie kam zwischen das Lager der Ägypter und das Lager der Israeliten. Die Wolke war da und Finsternis, und Blitze erhellten die Nacht." (2 Mose 14, 19–20)

Aus christlicher Sicht ist die Wolke immer ein Symbol des Himmels. Engel stehen stets auf Wolken oder blicken aus diesen, und Christus wird bei seiner Wiederkehr am Ende aller Tage mittels einer Wolke auf die Erde herabkommen: „Dann sah ich eine weiße Wolke. Auf der Wolke thronte einer, der wie ein Menschensohn aussah." (Offenbarung des Johannes 14, 14)

Auch Maria, die Mutter Gottes, erscheint in einem Wolkenkranz, sei es auf volkstümlichen Votivbildern oder in Darstellungen großer Meister, etwa in der Szene, wenn Maria sich vom heiligen Lukas malen lässt.

Die griechische Mythologie glaubte in den Wolken ihre Götter verborgen. Hüllte sich der Gipfel des Olymp in Wolken, war es für die Griechen der Antike das Zeichen, dass sich die Götter dort versammelten.

Gleichzeitig manifestierten sich die Gottheiten in der Beherrschung der Wolken. Der höchste der olympischen Götter, Zeus, ist aus einem alten Wettergott hervorgegangen, daher auch seine Beinamen „Regner", „Blitzschleuderer", „Hochdonnernder" und „Wolkenballer". Homer erzählt, dass Zeus mit seiner Linken die Aegis, seinen furchtbar strahlenden und leuchtenden Schild, schüttelt, wenn er, Sturm und Gewölk erregend, mit seiner Rechten die Blitze schleudert und so bei den Menschen Angst und Schrecken verbreitet. Seine Macht über die Wolken setzt er beispielsweise ein, um Alkmene, die von ihm mit Herakles schwanger war, zu beschützen. Ihr Gatte Amphitryon geriet sehr in Wut, als er von dem Liebesabenteuer seiner Ehefrau mit Zeus erfuhr. Zur Strafe wollte er sie auf einem Scheiterhaufen verbrennen. Zeus sandte jedoch Wolken, die mit ihrem Regen das Feuer löschten und so auch seinen ungeborenen Sohn retteten.

Ebenso gebietet Poseidon, der Gott des Meeres, über die Wolken. Als Odysseus im Zuge seiner Irrfahrten einst von der Insel der Nymphe Kalypso, auf der er alleine gestrandet war, mit seinem selbst gezimmerten Floß aufbrach und schon das Land der Phäaken am Horizont sehen konnte, entfesselte der Meeresgott, der über den durch Odysseus verursachten Tod seines Sohnes, des Kyklopen Polyphemos, noch erzürnt war, einen Sturm: „Und jetzt versammelte er die Wolken, regte das Meer mit dem Dreizack auf und rief die Orkane zum Kampfe miteinander herbei, sodass Meer und Erde ganz in Dunkel gehüllt wurden." (Schwab, Sagen des Altertums, 1949, S. 613)

Pestsäule am Graben, Wien (Detail) Plague Column at Graben, Vienna (detail), **1687–1694** Marmor marble, © Johannes Karel

Christian Koller, Moses und Aaron Moses and Aaron, 1976
Kaltnadelradierung auf Papier dry point on paper, 38 x 51,5 cm
Sammlung der Kulturabteilung der Stadt Wien MUSA Collection of
the Department for Cultural Affairs of the City of Vienna MUSA

Franz Xaver Ölzant, Poseidon (Werk Nr. I,3)
work no. I,3, 1969
Bronze bronze, 205 cm
Sammlung der Kulturabteilung der Stadt Wien MUSA Collection of
the Department for Cultural Affairs of the City of Vienna MUSA

From a Christian perspective, the cloud is always a symbol of heaven. Angels commonly stand on or peer through clouds, and when returning at the end of all days, Christ is prophesied to descend to earth on a cloud: "And I looked, and behold a white cloud, and upon the cloud one sat like unto the Son of man […]" (Revelation 14:14).

The Virgin Mary likewise appears surrounded by clouds, be it in popular votive images or in pictures by great masters, such as in the scene of Saint Luke painting the Virgin.

In Greek mythology it was believed that the gods hid behind clouds. If the peak of Mount Olympus was wrapped in clouds, ancient Greeks took it as a sign that the gods were gathering there.

Simultaneously, godly power manifested itself in the ability to control clouds. The figure of Zeus, the king of the Olympian deities, goes back to an old weather god, thus giving Zeus the epithets "rain-giver," "wielder of the thunderbolt," and "cloud-gatherer." Homer relates that Zeus was furiously brandishing his gleaming shield, the aegis, with his left hand while throwing thunderbolts with his right, causing storms and clouds to come up and thus terrifying the people. He also used his power over clouds in order to protect Alcmene, who was pregnant with Heracles, Zeus's son. Her husband Amphitryon, finding out about his wife's amorous adventure with Zeus, flew into a terrible rage and wanted to punish her by burning her at the stake. Zeus, however, sent clouds, and the rain emanating from them extinguished the fire and thus also saved his unborn son.

Poseidon, the god of the sea, was likewise capable of commanding the clouds. When Odysseus, who had stranded on the island of the nymph Calypso during his wanderings and was leaving on a self-made raft, could already discern the land of the Phaiakians on the horizon, Poseidon, still enraged over the death of his son, the Cyclop Polyphemus, which had been caused by Odysseus, unleashed a storm: "He gathered the clouds and gripping his trident, he stirred the sea. And he raised all the blasts of every wind in the world and covered with clouds land and sea together" (Odyssey, V, 292–295).

A Link between the Gods and Men

Unless deities could be directly experienced by man in the form of such visible personifications as the sun and the moon, heaven was assigned to them as an abode, except for the godly rulers over the realms of the dead living in the underworld. Heaven was the sphere of godly activity, and in order to be able to descend to men on earth, gods needed a means of transport.

Persian mythology has Aredvi Sura Anahita, the goddess of the waters on earth and the source of the cosmic ocean. She rides a chariot drawn by four horses: wind, rain, clouds, and sleet.

For the Teutons, clouds served as steeds for the Valkyries. The messengers of Wotan rode them across the battlefield in order to take slain warriors to Valhalla.

However, it was the Norse deities who had the most wondrous vehicle at their disposition: the elaborate cloud ship Skidbladnir, which the dwarfs had built for Freyr. It was sufficiently spacious to accommodate all the Aesir, the Norse dynasty of gods, with all their suits of armor and weapons. As soon as the sails were

Verbindungselement zwischen Göttern und Menschen

Sofern Gottheiten für die Menschen nicht durch sichtbare Personifikationen, wie Sonne oder Mond, direkt erfahrbar waren, wurde ihnen, mit Ausnahme der in der Unterwelt beheimateten göttlichen Herrscher über die Totenreiche, der Himmel als Residenz zugedacht. Dieser war der Bewegungsraum der göttlichen Wesen. Um auf die Erde zu den Menschen zu gelangen, bedurfte es einer Transportmöglichkeit.

Die persische Mythologie kennt Ardvi Sura Anahita, die Göttin aller Gewässer der Erde und Quelle des kosmischen Ozeans. Sie fährt einen Wagen, der von den vier Pferden Wind, Regen, Wolken und Schneeregen gezogen wird.

Für die Germanen waren Wolken die Reitpferde der Walküren. Diese Botinnen Wotans ritten damit über die Schlachtfelder, um die gefallenen Krieger nach Wallhall zu rufen.

Das wohl wundersamste Gefährt besaßen die nordischen Götter: Das kunstvolle Wolkenschiff Skidbladnir hatten die Zwerge für Freir angefertigt. Es war so groß, dass alle Asen, also das gesamte nordische Göttergeschlecht, samt ihren Waffenrüstungen darin Platz hatten. Sobald die Segel gehisst waren, hatte es guten Wind, wohin auch immer die Götter gelangen wollten. Sobald das Wolkenschiff jedoch nicht mehr benötigt wurde, konnte man es ganz klein zusammenfalten und in die Tasche stecken.

Die griechisch-römischen Götter konnten fliegen, wie Hermes mit seinen Flügelschuhen, oder sie hatten von Vögeln gezogene Wagen, wie Aphrodite, die ein Gespann besaß, das von Tauben bewegt wurde, oder Hera, deren Wagen Pfaue zogen. Um von den Menschen jedoch weder bei ihrer Reise noch auf Erden entdeckt zu werden, hüllten sich die Olympier in Wolken.

Verhüllung und Blickentziehung

Unerklärliche Veränderungen und wundersame Vorgänge ließ die Mythologie hinter dem nebulösen Schleier einer Wolke stattfinden. Wolken waren die Tarnung für Helden und Götter oder das Trugbild für die Menschen.

Die wohl bekannteste Darstellung einer mythologischen Geschichte in Zusammenhang mit einer Wolke ist das von Antonio Allegri, gen. Correggio, um 1530 gemalte Liebesabenteuer des Zeus und der Io, heute im Kunsthistorischen Museum in Wien. Ovid erzählt in seinen „Metamorphosen", dass sich Zeus in die Jungfrau Io verliebte. Diese jedoch floh vor ihm, daher ließ der Gott dunklen Nebel aufsteigen, sodass Io nichts mehr sehen konnte und stehen blieb. Zeus raubte ihr die Unschuld, machte allerdings seine eifersüchtig über ihn wachende Gemahlin Hera durch die unerklärliche Nebelwolke auf sich aufmerksam. Der Entdeckung konnte er nur entgehen, weil er Io kurzerhand in eine weiße Kuh verwandelte.

Doch auch zum Schutz seiner Gemahlin setzte Zeus die Wolke ein. Einst war Ixion Gast der Göttertafel am Olymp. Doch statt sich dankbar zu erweisen, versuchte er Hera zu verführen. Zeus bildete aus einer Wolke ein Trugbild Heras, die Nephele. Mit ihr zeugte Ixion die Kentauren. Da er sich der Gunst der Götterkönigin rühmte, wurde Ixion zur Strafe im Tartaros auf ein glühendes und sich ständig drehendes Rad geflochten.

hoisted, they had favorable wind that would take them anywhere they wanted to go. However, when the cloud ship was no longer needed, it folded up small enough to fit in a pouch.

The Greco-Roman gods, such as Mercury (Hermes) with his winged shoes, were able to fly, or they had chariots drawn by birds, such as those of Venus (Aphrodite) or Juno (Hera), which were pulled by doves and peacocks respectively. However, in order not to be recognized either during their journey or down on earth, the Olympians enveloped themselves in clouds.

Disguise and Removal from Sight

In mythology inexplicable transformations or miraculous happenings take place under the nebulous veil of clouds. Clouds served as camouflage for heroes and gods and as a justification for the chimeras of man.

The picture of the amorous adventure between Zeus and Io painted by Antonio Allegri, called Correggio, around 1530 and now preserved in the Kunsthistorisches Museum in Vienna is probably the most famous representation of a mythological scene involving a cloud. In his Metamorphoses, Ovid tells the story of Zeus falling in love with the virgin Io. When she tries to escape, Zeus causes dark mist to appear so that Io can no longer see and is forced to stop. Zeus then robs Io of her virginity, but manages to attract the attention of his wife Hera, jealously watching over him, because of the mysterious cloud. He can only prevent them from being discovered by quickly turning Io into a white heifer.

However, Zeus also used a cloud to protect his wife. Once Ixion had been invited to the table of the gods on Olympus. But instead of showing his gratitude, Ixion tried to seduce Hera. Zeus shaped Nephele, a phantom of Hera, out of a cloud. From the union of Ixion and Nephele sprang the Centaurs. As a punishment for boasting of having won the favor of the queen of the gods, Ixion was transferred to Tartaros and bound to a fiery wheel that was constantly spinning.

The river god Alpheus fell in love with the nymph Arethusa when she was bathing in his waters. She rejected him and fled, but Alpheus emerged from the river and followed her. The harassed nymph prayed to Artemis, who hid her from the lecherous river god by wrapping her in a cloud. Alpheus, though, continued to pursue her, until Arethusa suddenly turned into water, transforming into a stream. Alpheus countered by taking on the shape of a river again, so that their waters could merge.

Gods interfered time and again with worldly happenings and the fate of men. An episode from the Trojan War relates that during an assault against the Greek fortifications, Apollo encouraged the young warrior Agenor to attack the hero Achilles. However, Agenor failed to wound Achilles, and the latter sprang at the former in a fury. Apollo enclosed Agenor in a cloud and assumed the form of the young warrior so that Agenor could return to Troy unmolested.

Following the conquest of Troy, Aeneas and some of his loyal followers managed to escape, and similar to Odysseus, Aeneas had to undergo a number of adventures during his travels across the Mediterranean Sea. Upon landing on the African coast, Aeneas met a young huntress who was nobody else than his mother Aphrodite. The goddess concealed the Trojan hero behind a cloud so that he could

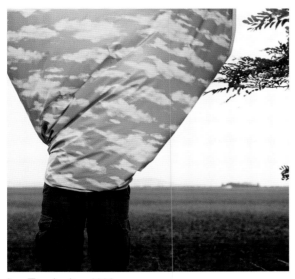

Lea Titz, Jupiter, 2006
Farbfoto auf Aluminium colour photograph on aluminum,
91 x 90,8 cm
Sammlung der Kulturabteilung der Stadt Wien MUSA Collection of the Department for Cultural Affairs of the City of Vienna MUSA

Der Flussgott Alpheus verliebte sich in die Nymphe Arethusa, als diese in seinen Gewässern badete. Sie wies ihn zurück und floh, doch Alpheus schwang sich aus dem Fluss ihr nach. Die Bedrängte flehte zur Göttin Artemis, welche die Nymphe, um sie vor dem lüsternen Flussgott zu verbergen, in eine Wolke hüllte. Doch selbst diese verfolgte Alpheus weiter, bis Arethusa plötzlich in Wasser zerfloss und zur Quelle wurde. Alpheus nahm nun wieder seine Flussgestalt an, um sich mit den Wassern der Arethusa verbinden zu können.

Immer wieder greifen die Götter in das irdische Geschehen und das Schicksal der Menschen ein. Eine Episode des Trojanischen Krieges berichtet, dass während des Angriffs auf die griechischen Verschanzungen der junge Krieger Agenor von Apollon ermutigt wird, den Helden Achilles anzugreifen. Er kann ihn jedoch nicht verwunden und Achilles stürmt nun wütend auf Agenor los. Apollon hüllt diesen in eine Wolke, nimmt selbst die Gestalt Agenors an und lässt sich vom griechischen Helden verfolgen, damit Agenor unbehelligt nach Troja zurückkehren kann.

Nach der Einnahme Trojas kann Aeneas mit einigen Getreuen fliehen, ähnlich wie Odysseus hat er einige Abenteuer auf seinen Fahrten durch das Mittelmeer zu bestehen. Nach der Landung an der afrikanischen Küste trifft Aeneas eine junge Jägerin, niemand anderes als seine Mutter Aphrodite. Die Göttin verbirgt den trojanischen Helden in einem Nebelgewölk, sodass er unentdeckt die nahe Stadt Karthago erkunden kann. Dort sieht er einige seiner bereits früher gelandeten Gefährten, die mit Königin Dido über eine Suche nach ihm verhandeln. Dido verspricht, die Trojaner zu unterstützen, und in diesem Augenblick lichtet sich die Aeneas umgebende Wolke, und er tritt verjüngt und strahlend vor die karthagische Königin.

Auch Odysseus wird von Athene in eine Nebelwolke gehüllt, als er, bereits aller Gefährten und Schiffe verlustig, endlich das Land der Phäaken erreicht hat und sich in den Palast des Königs Alkinoos begibt, um ihn um ein Schiff für die Heimfahrt nach Ithaka zu bitten. Der gastfreundliche König gewährt dieses, und als die Phäaken den schlafenden Helden am Strand seiner Heimatinsel abgesetzt haben, breitet Athene gleich über die gesamte Insel Nebelgewölk, damit sie mit ihm sein Vorgehen zur Rückerlangung seiner Herrschaft unbeobachtet beraten kann.

Vom 4. bis ins 13. Jahrhundert wird in der christlichen Kunst die „manus Dei", die Hand Gottes, die wichtigste symbolische Darstellungsform Gottvaters. Aus einem Licht- oder Wolkensegment des Himmels ragt die Hand als Symbol der Stimme oder als Veranschaulichung des Eingreifens Gottes in das irdische Leben. Die Darstellung Gottvaters selber wird gescheut, die Wolken verdecken ihn.

Apotheose

Durch Wolken den Blicken der Umstehenden entzogen werden auch Personen, die in den Himmel aufsteigen. Die Apotheose ist die Überwindung des Lebens auf Erden und die Aufnahme unter die Götter.

Der die Kunst über Jahrhunderte wohl am meisten inspirierende Heros der griechischen Antike war Herakles. Seine alles übertreffenden Heldentaten sicherten ihm einen Platz unter den Olympiern. Dennoch war sein irdisches

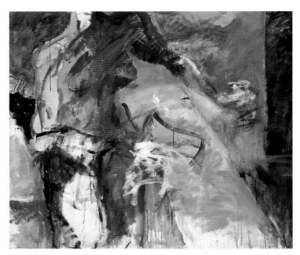

Herwig Zens, Hera, 1987
Acryl auf Leinwand acrylic on canvas, 130 x 150 cm
Sammlung der Kulturabteilung der Stadt Wien MUSA Collection of the Department for Cultural Affairs of the City of Vienna MUSA

Lovis Corinth, Odysseus und Nausikaa
Odysseus and Nausikaa, **1918**
Lithographie auf Papier lithograph on paper, **45,7 x 56,2 cm**
Sammlung der Kulturabteilung der Stadt Wien MUSA Collection
of the Department for Cultural Affairs of the City of Vienna MUSA

explore the nearby town of Carthage undetected. There he ran into some of his comrades who had arrived earlier and were negotiating with Queen Dido to organize a search for him. Dido promised to support the Trojans, and all of a sudden the cloud surrounding Aeneas lifted and he faced the Carthaginian queen rejuvenated and radiant.

Odysseus was likewise enwrapped in clouds by Athena when he – deprived of all of his attendants and ships – eventually reached the land of the Phaiakians and approached the palace of King Alkinoös in order to ask for a ship that would take him back to Ithaca. The hospitable king granted his request, and as soon as the Phaiakians had dropped the sleeping hero on the beach of his native island, Athena placed mist and clouds over the entire place so that they would remain unobserved while deliberating upon a strategy of how Odysseus could regain his power.

Between the fourth and the thirteenth centuries, the "manus Dei" – the hand of God – served as the chief symbolic form of representing God the Father. Rising from a light or cloud segment, the hand is a sign of the voice of God or illustrates His intervening with life on earth. People shrank from depicting the figure of God the Father, which was therefore covered by clouds.

Apotheosis

Individuals ascending to heaven are removed from the sight of bystanders through clouds as well. An apotheosis is the overcoming of life on earth and the assumption among the gods.

Heracles is probably the hero of Greek antiquity who has been most inspiring for art over the centuries. His unsurpassed feats secured him a place among the Olympian deities. His life on earth was tragic, though: once Heracles killed the centaur Nessus with one of his poisoned arrows to prevent him from raping Heracles' wife Deianeira. The dying centaur persuaded Deineira to collect his blood and keep it, claiming it was a powerful love potion: she had but to apply it to one of Heracles' garments. This is what the young woman remembered when she learned that Heracles had only bothered to conquer the town of Oechalia for the sake of the beautiful Iole. When Heracles put on the blood-soaked garment, the poison of his own arrow, which had mixed with the centaur's blood, ate through the hero's flesh, causing him indescribable agony. Heracles ordered himself to be burned on Mount Oita and was lifted to Olympus in a cloud of smoke.

In Roman mythology it is told that one day Romulus, the legendary founder of Rome, was inspecting the troops in the Campus Martius. During a sudden storm Romulus was swathed in a dense cloud and did not reappear. The credibility of this apotheosis was underlined by Julius Proculus, who swore that Romulus had appeared to him in order to confirm that he had been admitted among the divinities. The deified Romulus was worshipped under the name of Quirinus. Later on, the honor of being apotheosized was bestowed on Julius Caesar, as well as on some Roman emperors in his succession, and every now and then there were reports from alleged eyewitnesses who declared that they had seen the bodies of the deceased rising up to heaven.

Ende tragisch: Einst hatte Herakles den Kentauren Nessus mit einem seiner vergifteten Pfeile getötet, als dieser Herakles' Gemahlin Deianeira vergewaltigen wollte. Der sterbende Kentaure überredete Deianeira, sein Blut zu sammeln und aufzubewahren, es sei ein kraftvolles Liebeselixier. Sie müsse es nur auf ein Gewand des Herakles streichen. Daran erinnerte sich die junge Frau, als ihr zu Ohren kam, Herakles hätte die Stadt Oichalia nur der schönen Iole wegen erobert. Als Herakles das blutdurchtränkte Gewand anzog, fraß sich das Gift seines eigenen Pfeiles, das in das Kentaurenblut gelangt war, in das Fleisch des Helden und verursachte ihm unsägliche Qualen. Herakles ließ sich auf dem Berg Oita verbrennen, und mit der Rauchwolke stieg auch er zum Olymp auf.

In der römischen Mythologie wird berichtet, dass Romulus, der sagenhafte Gründer Roms, eines Tages die Truppen auf dem Marsfeld musterte. Während eines plötzlichen Unwetters wurde Romulus von einer dichten Wolke verhüllt und blieb verschwunden. Die Glaubwürdigkeit der Apotheose untermauerte Julius Proculus, der eidesstattlich erklärte, Romulus sei ihm erschienen und habe seine Aufnahme unter die Himmlischen bestätigt. Der vergöttlichte Romulus wurde unter dem Namen Quirinus verehrt. In späterer Zeit wurde sowohl Julius Cäsar als auch einigen nachfolgenden römischen Kaisern die Ehre der Vergöttlichung zuerkannt, und es gab immer wieder Berichte von angeblichen Augenzeugen, die gesehen haben wollen, wie die Körper der jeweiligen Verstorbenen in den Himmel aufgefahren seien.

Ein wichtiges Thema ist die Apotheose in der Barockmalerei. Christus selbst und auserwählte Heilige werden von Wolken in den Himmel getragen. Besonders anschaulich stellt Peter Paul Rubens in seinen zahlreichen Himmelfahrten Mariens die Überwindung des irdischen Daseins und den Einzug in das Himmelreich durch seine transzendenten, subtil gemalten Wolkenbereiche dar, die einerseits den Körper Marias den Blicken der umstehenden Apostel entziehen und andererseits bereits das auf die Aufsteigenden fallende göttliche Licht umrahmen.

Zeichen der Himmlischen

Mit Erscheinungen am Himmel teilten sich die Überirdischen den sie anbetenden Menschen mit. Man glaubte, dass sich in Naturerscheinungen oder dem Verhalten von Tieren der Wille der Götter widerspiegle und diese damit ihr Einverständnis zu einer Handlung geben oder den Menschen Warnungen zukommen lassen wollen.

Die angebliche Kunst, aus den Bewegungen der Luft, der Wolken und aus der Richtung des Windes wahrzusagen, wird Aeromantie genannt.

In der arabischen Mythologie gibt es eine Geschichte von König Scheddad, der eine überaus prächtige Stadt mit herrlichen Palästen und Gärten erbaute. Er und sein Volk beteten jedoch falsche Götter an. Der Prophet Hud predigte ihnen den einen wahren Gott, doch sie ließen nicht von ihrem Götzendienst. Ihre Strafe war eine dreijährige Dürre und große Hungersnot. Gesandte gingen zum heiligen Berge, flehten um ein Zeichen, und Gott sandte ihnen drei Wolken, eine weiße, eine rote, eine schwarze. Eine könne ihrem Elend ein Ende bereiten. Die gewählte schwarze Wolke brachte aber nicht den erhofften

Gertie Fröhlich, Das Hemd des Nessus
The Shirt of Nessus, **1985**
Mischtechnik auf Papier mixed media on paper, **55,5 x 76,1 cm**
Sammlung der Kulturabteilung der Stadt Wien MUSA Collection of the Department for Cultural Affairs of the City of Vienna MUSA

Hubert Sielecki, Levitation, 2007
Video, 3:00 min
Leihgabe des Künstlers loan of the artist

Apotheosis was an important subject in Baroque painting. Both Christ himself and selected saints were carried heavenward on clouds. The overcoming of earthly life and the admission to heaven was illustrated particularly impressively in Peter Paul Rubens' numerous Assumptions of the Virgin Mary. On the one hand, his transcendent, subtly painted layers of clouds remove the Virgin's body from the sight of the Apostles, while on the other hand they enclose the divine light falling on the rising figure.

A Sign of Heavenly Powers

Celestial phenomena were a means by which supernatural beings could communicate with those worshipping them. It was believed that natural phenomena or animal behavior reflected the will of the gods, demonstrating either approval of a specific action or pronouncing a warning.

The professed art of foretelling the future from air currents, clouds, and the direction of the wind is called aeromancy.

In Arabian mythology there is a story about King Sheddad, who built a magnificent town, with splendid palaces and gardens. However, he and his people prayed to the wrong gods. The prophet Hud preached to them about the one and true God, but they still did not refrain from their idolatry and in the end were punished with a three-year drought and a great famine. Messengers went to the Sacred Mountain and begged for a sign, and God sent them three clouds – a white, a red, and a black one. One of them was supposed to put an end to their misery. But when they chose the black cloud, it did not bring the rain they had hoped for, but a disastrous storm that devastated the entire land and brought about the downfall of all but a few who had obeyed Prophet Hud.

In Roman religion, augurs played a crucial role. Their task was to predict the will of the gods by studying the flight, the noises, and the intake of food of the birds, but also by analyzing both the intestines of sacrificial animals and phenomena in the sky. When observing the sky, an augur selected a specific place, made an offering, and then silently divided up the sky into quadrants with his staff: in front of him, behind him, to his left, and to his right. Depending on the direction from which he perceived particular signs and their nature – whether they were clouds, flashes of lightning, or thunder – the augur interpreted the will of the gods. Augurs enjoyed such a high reputation that they were even in a position to revoke decisions made by the Senate. Military leaders and emperors had their personal augurs who were obliged to accompany them at all times. This form of divination is sometimes said to date back to Numa Pompilius, the legendary second king of Rome, while according to others it even originated with Romulus.

The soothsayers of the northeastern European peoples were referred to as Wejones. They told the future from the force of the winds and the trail of the clouds.

Regen, sondern einen verheerenden Sturm, der das ganze Land verwüstete und allen den Untergang brachte, außer den wenigen, die dem Propheten Hud Folge geleistet hatten.

In der römischen Religion spielten die Auguren eine besonders wichtige Rolle. Ihre Aufgabe war es, aus dem Flug, dem Geschrei und dem Fressen von Vögeln, aus den Eingeweiden von Opfertieren, aber auch aus Zeichen des Himmels den Willen der Götter vorherzusagen. Bei der Himmelsbeobachtung wählte der Augur einen bestimmten Platz, brachte ein Opfer dar und teilte dann schweigend den Himmel mit seinem Stab in vier Bereiche: vor sich, hinter sich, links und rechts. Je nachdem, wo und welche Zeichen, wie Wolken, Blitz oder Donner, er wahrnahm, deutete der Augur dann den Willen der Götter. Das Ansehen der Auguren war so groß, dass sie selbst Senats-beschlüsse rückgängig machen konnten. Feldherren und Kaiser hatten persönliche Auguren, die sie immer begleiten mussten. Diese Art der Wahr-sagekunst soll auf Numa Pompilius, den sagenhaften zweiten König von Rom, nach anderen sogar schon auf Romulus selbst zurückgehen.

Die Wahrsager der nordöstlichen europäischen Völker nannte man Wejonen. Sie verkündeten aus der Gewalt der Winde und dem Zug der Wolken die Zukunft.

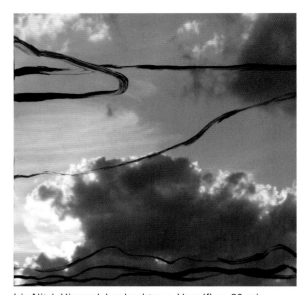

Iris Nitzl, Himmelsbeobachtung, Vogelflug, 30 min.
Sky Oberservation, Flight of Birds, 30 min., 2008
Farbfoto colour photograph, 20 x 20 cm
Sammlung der Kulturabteilung der Stadt Wien MUSA Collection of the Department for Cultural Affairs of the City of Vienna MUSA

Die natürliche Funktion

Die alten Kulturen sahen in der Wolke auch das Naheliegende – dass aus ihr der Regen kommt. Dieses Phänomen wurde ihren Vorstellungen nach aller-dings wiederum von Göttern hervorgerufen.

Für die alten Chinesen sind Wolken freundliche Naturkräfte, da sie den Fruchtbarkeit spendenden Regen bringen. Parallel dazu werden sie mit der Bedeutung Mitleid versehen, da sie Wirrnisse der Erde verdecken und sie dadurch schützen.

Einer der bekanntesten Gottheiten der keltischen Mythologie ist Nuadu. Er ist König eines göttlichen Geschlechts, der mythischen Ureinwohner Irlands vor den Kelten. Nuadu bedeutet „Wolkenmacher", was nahe legt, dass er ein Wettergott war.

Zeus war ursprünglich auf jeden Fall ein solcher, aber auch in anderen altgriechischen Riten spielen die Wolken eine Rolle. In der Geheimlehre der Orphiker, Anhänger einer damaligen religiösen Bewegung, wurden die Wolken mit besonderer Ehrfurcht herbeigerufen, auf dass sie mit ihrem Regen die Erde befruchten.

Viele Kulturen kannten auch ganz spezielle Regengötter, etwa Tischtrja in der persischen Mythologie, der im Stern Sirius personifiziert wurde. Seine größten Widersacher waren die Hexe Duzhjairja sowie der Dämon Apaoscha, deren Namen Missernte und Dürre bedeuten. In einem Kampf mit dem Dämon gelingt es Tischtrja, auf die ganze Welt Wasser niederströmen zu lassen, und vom Meer aufsteigender Dampf wird als Wolken vom Wind über die Länder getragen. Nach dem Regengott heißt der vierte Monat des iranischen Kalenders Tir.

The Natural Function of Clouds

Ancient civilizations also saw in clouds what was most obvious: that they brought forth rain. However, in their opinion, this phenomenon was in turn provoked by the gods.

For the old Chinese, clouds were benevolent natural forces, since they produced fertility-promoting rain. Simultaneously, they were associated with the idea of pity, since they concealed the chaos on earth and thus protected the latter.

Nuadu is one of the most well-known deities in Celtic mythology. He was the king of a godly dynasty, the mythical native inhabitants of Ireland preceding the Celts. Nuadu means "cloud-maker", which suggests that he was a weather god.

This is just what Zeus had been originally, but there are also other ancient Greek rites in which clouds play a role. In the secret teachings of the Orphics, disciples of a then-prevalent religious movement, clouds were summoned with particular reverence so that they would render the soil fertile with their rain.

Numerous civilizations also had their own rain gods, such as Tishtrya in Persian mythology, personified as the star Sirius. His most important adversaries were the witch Duzhyairya and the demon Apaosha, their names signifying "bad harvest" and "drought" respectively. In a fight against the demon, Tishtrya succeeded in causing water to pour onto the whole world, and steam rising from the sea was carried over the lands by the wind in the form of clouds. The fourth month of the Iranian calendar is named Tir after the rain god.

Ancient Indian civilizations in South America worshipped the rain god Tlaloc, whose veneration in Mexico can be traced back to the first century B.C. During the postclassical period, i.e., at the time of Columbus, he was depicted with a particularly pronounced upper lip, the teeth of a jaguar, and frames around his eyes reminiscent of spectacles.

In the Aztec creation myth we encounter Quetzalcoatl, a plumed serpent. One aspect of this god is Ehecatl, a wind god that also manifests himself in fertility-bearing rain clouds.

In Mesopotamia, in turn, people venerated the weather god Adad, who commanded over life-giving rain and whose symbols were a flash of lighting and a bull roaring like thunder.

Legend has it that Japan was rescued in 1274 by the god Raijin, whose name means "thunderbolt." He is depicted with a drum, symbolizing thunder. Enthroned on a cloud, he is said to have defeated the attacking Mongolian fleet by catapulting flashes of lightning against the invaders.

From antiquity until well into the modern era, people have regarded clouds as inexplicable and unapproachably distant phenomena. Their mystic appearance inspired in earlier civilizations imaginative and fantastic explanations that still influence our thinking and inform our imagery.

As a constantly changing natural spectacle, clouds are capable of releasing different emotions in people. We sense them to be threatening or serene, soft or sublime. The fascination emanating from clouds has caused men to associate their appearance with the unfathomable, the supernatural, and the divine. From an art historical perspective, mythic rapture and religious veneration essentially

Bei den indianischen Hochkulturen Südamerikas wurde der Regengott Tlaloc verehrt, in Zentralmexiko lässt sich dieser Regen- und Blitzgott bis ins 1. Jahrhundert vor Christus zurückverfolgen. Er wird in der nachklassischen Periode, also in der Zeit um Columbus, mit einer besonders ausgeprägten Oberlippe, Jaguarzähnen und einer an eine Brille erinnernde Augenumrandung dargestellt.

Im aztekischen Schöpfungsmythos begegnet uns Quetzalcoatl, die gefiederte Schlange. Ein Aspekt dieses Gottes ist Ehecatl, der sich als Windgott unter anderem auch in Fruchtbarkeit bringenden Regenwolken manifestiert.

In Mesopotamien wiederum verehrte man Adad, den Wettergott, der über den Leben spendenden Regen gebietet und dessen Symbol der Blitz und ein wie Donner brüllender Stier war.

Nach einer Legende soll Japan 1274 vom Gott Raiden gerettet worden sein. Sein Name bedeutet Donner-Blitz, er wird mit einer Trommel dargestellt, die den Donner symbolisiert. Er soll auf einer Wolke sitzend seine Blitze gegen die angreifende mongolische Flotte geschleudert und diese vernichtet haben.

Für die Menschen des Altertums, der Antike und bis in die Neuzeit galten Wolken als unerklärbare und unerreichbar ferne Phänomene. Die Mystik der Erscheinung hat die Kulturen früherer Epochen zu phantasievollen und phantastischen Erklärungen angeregt, die bis in unser heutiges Denken nachwirken und in unserer Bildsprache präsent sind.

Als stets wechselndes Naturschauspiel vermögen Wolken in den Menschen die unterschiedlichsten Emotionen auszulösen. Wir empfinden sie als bedrohlich oder heiter, sanft oder erhaben. Die Faszination, die von Wolken ausgeht, brachte ihre Erscheinungen in Verbindung mit dem Unbegreiflichen, dem Überirdischen, dem Göttlichen. Kunstgeschichtlich betrachtet, bestimmten die mythische Entrückung und religiöse Verehrung den bildlichen und skulpturalen Ausdruck im Wesentlichen bis ins 18. Jahrhundert. Erst danach hat man die Wolken, ihre Zusammensetzung und Formationen naturwissenschaftlich studiert, ihre Erscheinungsformen klassifiziert und benannt.

Zugleich mit ihrer materiellen und begrifflichen Bestimmung sind die Wolken mit neuen Inhalten aufgeladen worden, und Kunst und Literatur haben sich ihrer in vielfältiger Weise, meist in Form von Metaphern, angenommen.

Herwig Zens, Zeus, 1987
Acryl auf Leinwand acrylic on canvas, 130 x 150 cm
Sammlung der Kulturabteilung der Stadt Wien MUSA Collection of
the Department for Cultural Affairs of the City of Vienna MUSA

determined visual and sculptural expression until well into the eighteenth century. It was only later on that clouds and their composition and formation were explored scientifically and that their forms were classified and named.

Parallel to their material and conceptual identification, clouds were charged with new meanings, and the visual arts and literature have dealt with them in various ways, mostly in the form of metaphors.

Alle Personenbezeichnungen, die in diesem Text sprachlich in der männlichen Form verwendet werden, gelten sinngemäß auch in der weiblichen Form.

Literaturnachweis

Fritz Glunk, *Lexikon der Symbole*, 1997, S. 110.

Hans-K. und Susanne Lücke, *Helden und Gottheiten in der Antike*, Marix Verlag, 2006.

Wilhelm Vollmer, *Wörterbuch der Mythologie aller Völker*, Reprint-Verlag, 12. Reprintauflage nach Original von 1874.

Herbert Gottschalk, *Lexikon der Mythologie*, Heyne, 1993.

Iréne Aghion, Claire Barbillon, François Lissarrague, *Reclams Lexikon der antiken Götter und Heroen in der Kunst*, Reclam, 2000.

R. I. Page, *Nordische Mythen*, Reclam, 1993, S. 103f.

Lucilla Burn, *Griechische Mythen*, Reclam, 1993, S. 27, S. 89, S. 102f.

Henrietta Mc Call, *Mesopotamische Mythen*, Reclam, 1993, S. 49, S. 104ff, S. 124.

Miranda Jane Green, *Keltische Mythen*, Reclam, 1994, S. 26f.

Vesta Sarkhosh Curtis, *Persische Mythen*, Reclam, 1994, S. 19, S. 25f, S. 94, S.124f.

Karl Taube, *Aztekische und Maya-Mythen*, Reclam, 1994, S. 54f.

Jane F. Gardner, *Römische Mythen*, Reclam, 1994, S. 62f.

Anne Birrell, *Chinesische Mythen*, Reclam, 2002, S. 80, S. 82f, S. 117f.

Gustav Schwab, *Die schönsten Sagen des klassischen Altertums*, Ueberreuter, 1949.

http://www.zeno.org - Zenodot Verlagsgesellschaft mbH.

Barbara Frischmuth

Alles Wolken

„Das Leben ist eine Wolke, die entsteht,
der Tod eine Wolke, die sich auflöst." (Aus einem ostasiatischen Gedicht)

„Der Regen locht den See", sagte Noah. Und die Löcher gingen unter, so heftig ließen die Wolken ihr Wasser ab.

„Wolkenbruch", sagte Julie, „das ist ein Wolkenbruch."

„Wolkenbruch", wiederholte Noah einige Male, doch sein Akzent änderte sich nicht.

Der Himmel war eine einzige rattengraue Masse, als hätte der Blitz die Wolken zu einem aschenen Brei gesengt. Nur über ihren Köpfen bildete sich hellweißer Belag, der immer kompakter wurde.

Julie packte Noah am Arm und zog ihn ins Bootshaus. Es war Krieg zwischen Himmel und Erde, und die Wolken beschossen das Bootshaus mit Schloßen, groß wie Taubeneier.

„Hagel", sagte Julie, „das ist Hagel."

Noah konnte den Blick nicht von den nach dem Aufprall weiterhüpfenden Körnern wenden.

„Mach die Tür zu!" Julie stieß ihn an, und als er noch immer nichts dergleichen tat, schloss sie selbst die Tür. Das Bootshaus hatte kein Fenster, sie sahen nur noch auf den See. Der Hagel lochte das Wasser erst recht.

„Wow!", rief Noah und balancierte auf dem Trennbalken zwischen den Booten bis nach vorne, wo das Dach zu Ende war, um die Eisklümpchen aus nächster Nähe zu betrachten.

Noahs Vater hatte Julie gebeten, Noah zu ihren Freunden und Freundinnen mitzunehmen, damit er besser Deutsch lernte. „Schließlich stammen wir aus Wien, auch wenn man uns dort nicht haben wollte." Und er fügte hinzu: „Man kann nie genug Sprachen sprechen." Julies Vater kannte Noahs Vater noch von früher, sie selbst hatte ihn bisher nur von den Fotos gekannt.

Seit Noah mit seinem Vater im Hotel wohnte, steckten Julie und er andauernd zusammen. Noah fühlte sich nicht wohl unter den Dorfkindern. Sie machten sich über seine Aussprache lustig und schlugen ihm Brennnessel um die Waden. Julie und Noah brauchten niemanden. Es war schwierig genug, Julies kleinem Bruder Albin zu entkommen, aber es gelang ihnen immer öfter. Am liebsten lagen sie in der Wiese hinter dem Bootshaus, wo die Büsche eine Hecke bildeten. Die Nachmittage eigneten sich hervorragend zum Wolkenschauen, einer wie der andere.

„Siehst du den Zug?"

„Zug?" Noahs Schulter lag an Julies Schulter, und wenn sie den Arm hob, um mit dem Zeigefinger in den Himmel zu stechen, streifte sie gelegentlich sein Handgelenk.

„Ja, Zug!" Julie versuchte das Geräusch einer Dampflokomotive nachzuahmen und suchte gleichzeitig in ihrem das Schuljahr hindurch trainierten Klosterschulgedächtnis nach dem englischen Wort.

Barbara Frischmuth

Clouds Everywhere

"Life is a cloud emerging,
Death a cloud dispersing." (From an East Asian poem)

"The rain's making holes in the lake", said Noah. And the holes merged into a mass as the water bucketed down in the cloudburst.

"*Wolkenbruch*," said Julie, "the word for that is *Wolkenbruch.*"

"*Wolkenbruch*", Noah repeated a few times, but his accent didn't change.

The sky was a mass of steely grey, as if the lightning had made the clouds sink into some ashy soup. It was only over their heads that a pale white coating was forming and becoming more and more compact.

Julie grabbed Noah's arm and tugged him into the boathouse. War had broken out between heaven and earth and the clouds were pelting the boathouse with hailstones the size of golf balls.

"*Hagel*," said Julie, "that's called *Hagel.*"

Noah couldn't tear his gaze from the hailstones bouncing along after they hit the ground.

"Shut the door!" Julie nudged him, and when he didn't respond she closed the door herself. There was no window in the boathouse and they could only see the lake. The hail was now really making holes in the water.

"Wow!", Noah cried and balanced along the beam between the boats to where the roof came to an end at the front, so he could get a close-up view of the lumps of ice.

Noah's father had asked Julie to take Noah along with her friends so that he could improve his German. "After all, we're originally from Vienna, even if they didn't want us there." And he added: "You can never speak enough languages." Julie's father had known Noah's father from earlier days but she only knew him from photos.

Noah and Julie had been inseparable since he had been staying with his father at the hotel. Noah didn't like hanging around with the village children. They made fun of his accent and whacked his calves with stingy nettles. But Julie and Noah didn't need anyone. It was hard enough to escape Julie's little brother Albin, but they were getting better and better at that. Their favourite pastime was to lie in the meadow behind the boathouse where the bushes formed a hedge. Afternoons were perfect for a spot of cloud gazing, one no different from the next.

"Can you see the *Zug*?"

"*Zug*?" Noah's shoulder was resting against Julie's shoulder and when she raised her arm to point at the sky she occasionally brushed his hand.

"*Ja, Zug*!" Julie tried to imitate the sound of a steam train, searching for the English word in the vocabulary lists that had been drummed into her at the convent school.

In the meantime the train had disintegrated into a heap of carriages, as if somebody had set the points wrongly.

"That's not a train!", said Noah, who by now had cottoned on to what she meant. With his forefinger he nudged her forefinger further to the west. "Some horses with long tails. Look at that", he said.

Der Zug war inzwischen in seine Waggons zerfallen, und die türmten sich übereinander, als hätte jemand die Weichen falsch gestellt.

„Kein Zug!", sagte Noah, der inzwischen begriffen hatte, was sie meinte.
Er stupste mit seinem Zeigefinger ihren Zeigefinger etwas weiter gegen Westen.
„Mehre Pferde. Mit langem Schwanz. Schau hier", sagte er.

„Kamele, wenn du mich fragst. Zweihöckrige." Sie machte mit der Hand eine Wellenbewegung. Noah schaute auf ihre Brust, auf der zwei kleine Hügel im Entstehen waren.

„Depp du! Not here, in the sky." Sie sprach Englisch, wie um ihn zu bestrafen.

Noah richtete den Blick wieder nach oben und schnippte mit den Fingern.
„Ein weißer Mercedes!" Er sprach das C wie ein S und nicht wie ein Z.

„Ich kann ihn sehen." Julie lachte vor Freude über die Gemeinsamkeit.
„Wer sitzt am Steuer, du oder ich?"

„Ich. Weil ich früher mein license kriegen kann."

„Dein Vater!", rief Julie plötzlich, und Noah rückte ein wenig von ihr ab, als sollte sein Vater ihn nicht so sehen, eng neben Julie im Gras liegend.

„Da oben!" Julie klang genervt ob seiner Begriffsstutzigkeit. „Sein Wolkengesicht. Wie echt. Die Nase, die querstehenden Augenbrauen. Seine Hängebacken." Sie sagte das etwas leiser, als sei es ihr peinlich, die Dinge beim Namen zu nennen. Aber Hängebacken waren Hängebacken. Allerdings übertrieben die Wolken gewaltig und ließen die Backen ordentlich überhängen.

Noah hatte die Augen zusammengekniffen. „Okay. Hätte ich bloß mein Fotomaschin dabei." Noah sah seinem Vater ähnlich. Ob er auch einmal Hängebacken kriegen würde? Wenn er alt war? So alt wie sein Vater jetzt?

„Wie alt ist denn dein Vater?"

Noah starrte noch immer auf das Wolkengesicht, das rasch an Kontur verlor und sich zu einem langgestreckten Körper verzog, von dem Julie sogleich behauptete, er ähnle den Flugmenschen, die Albin seit Wochen malte.

„Schade, dass er es nicht sehen kann. Er würde in Ohnmacht fallen."

„Ohnmacht?"

„Na, du weißt schon, Albin sagt immer: Ich fall um! Bei jeder Gelegenheit."

„Ach das." Und dann zeichnete Noah mit dem Finger eine Himmelsschlange nach, die sich aufbäumte und einen mageren Blitz ausspie, den ersten Vorboten des Gewitters.

„Vierundfünzig", sagte Noah.

„Vierundfünfzig was?"

„Mein Vater. Du hast gefragt."

„Ganz schön alt", und als sie sah, dass Noah das nicht gerne hörte, sagte sie: „Für eine Wolke."

Noah verstand, was sie meinte, er grinste sogar. „Oh, er ist alt für mehre Wolken."

Ein riesiges Fischmaul mit Kugelaugen und einem ausfransenden Leib versuchte, sich einen Wolkengupf einzuverleiben, stieß sich aber am immer dunkler werdenden Kampfgeschwader und wurde von der nächsten heranstürmenden Front zermalmt.

"They're camels if you ask me – with two humps", Julie replied in German and made a wavy motion with her hand. Noah looked at her chest and the two small mounds that were developing.

"You idiot! Not here – in the sky!" This time she spoke English, as if to punish him. Noah looked up again and snapped his fingers. "A white Mercedes!" He pronounced the C like an S and not a Z.

"I can see it." Julie laughed happily because they both got it. "Who's driving, you or me?"

"Me, because I can get my licence before you."

"Your father!", Julie cried out suddenly, and Noah moved away from her slightly, as if his father shouldn't see him lying so close to Julie in the grass.

"Up there!" Julie sounded irritated by his slowness. "His cloud face, as if it's real – the nose, the slanting eyebrows. His flabby cheeks." She lowered her voice when she said this, as if it was embarrassing to call a spade a spade. But flabby cheeks were flabby cheeks – even if the clouds exaggerated and made the cheeks even flabbier.

Noah had screwed up his eyes. "Okay. If only I had my camera with me." Noah looked like his father. Would he also have flabby cheeks one day? When he was old? As old as his father now? "How old is your father?"

Noah was still staring at the cloud face, which was rapidly losing its outline and becoming distorted into an elongated figure. Julie said this looked like the winged figures Albin had been painting for weeks.

"It's a pity he can't see it. *Er würde in Ohnmacht fallen.*"

"*Ohnmacht?*"

"Oh, you know. Albin's always saying, 'I'll faint', any chance he has."

"Ah, that." And then Noah traced with his finger in the sky the snake that reared up and spat out a thin prong of lightning – the first signs of the storm.

"Fifty-four", said Noah.

"Fifty-four what?"

"My father. You asked how old he is."

"That's really old", and, noticing that Noah didn't like hearing that, she added: "for a cloud."

Noah understood what she meant and even grinned. "Oh, he's old enough for several clouds."

A giant fish mouth with bulging eyes and a frayed body tried to absorb a cloud gloop but collided with a thickening mass of fighter planes and was crushed by the next wave that came storming in.

Noah sat up. "There's going to be a thunderstorm. We have to go back to the hotel."

"Spoilsport!" It wasn't clear whether Julie was addressing Noah or the clouds. "You can't see any more figures. Those fat lumps are just rolling around."

Julie had now sat up as well. The wind blew through her blouse, in through one sleeve and out through the other. It tore at the hedge and blew red dust from the nearby tennis court into their eyes. The water wasn't warm enough to swim in yet and so nobody was lying on the boathouse's sundeck. It was too late to return to the hotel.

Noah richtete sich auf. „Das gibt ein Donnersturm. Wir müssen zum Hotel gehen."

„Spielverderber!" Es war nicht sicher, ob Julie Noah meinte oder die Wolken. „Man kann keine Figuren mehr sehen. Diese fetten Brocken wälzen sich nur einfach so." Auch Julie hatte sich aufgerichtet. Der Wind fuhr ihr durch die Bluse, zum einen Ärmelloch hinein und zum anderen wieder heraus. Er riss an der Hecke und blies ihnen rötlichen Staub vom nahe gelegenen Tennisplatz in die Augen. Das Wasser war noch nicht warm genug zum Schwimmen, und so lag auch niemand auf dem Sonnendeck des Bootshauses. Es war zu spät, um zum Hotel zurückzugehen.

„Sie sind alle verrückt geworden", rief Julie und lief zum Bootshaus.

„Wer ist verrückt?" Noah lief hinter ihr her.

„Warum können sie nicht einfach nebeneinander herziehen? Der Himmel ist groß genug."

Noah schüttelte den Kopf. „Sie haben kein Platz. Alles Wolken. Jede mit einer anderen Geschwindigkeit."

„Weil sie es viel zu eilig haben", maulte Julie. „Dann kracht es eben."

„Es hat auch mit die Temperatur zu tun", versuchte Noah etwas zu erklären, was Julie nicht erklärt haben wollte.

„Schon gut. Aber du kannst es auch anders sehen. Wie die Wolkenbilder."

„Die zergehen schon gleich." Noah stand jetzt neben ihr und starrte auf das Wasser.

„Aber einen Augenblick lang kann man sie anschauen. Einen Augenblick lang sind sie etwas Bestimmtes." Julie gab nicht so schnell auf.

Mit einem Mal ließen die Wolken ihr Wasser ab. „Der Regen locht den See", sagte Noah.

Der Wind spuckte kleine Schaumkronen auf die heranstürmenden Wellen, die im Bootshaus an die Kiele der zu Wasser gelassenen Boote schlugen. Es donnerte in immer kürzeren Abständen. Julie hielt sich die Ohren zu und schloss die Augen. Es war das erste Gewitter des Jahres, und als Noah sie fragte, ob sie Angst habe, erklärte sie, sie müsse sich erst wieder daran gewöhnen, dass es so etwas wie Gewitter gab.

„Das ist nichts", sagte Noah, „nur Wolken, die miteinander kämpfen."

Als der Blitz einschlug, bildete das Wasser einen Fontänenkreis um die Stelle, an der er in den See gefahren war. Einen Augenblick war alles still. Dann rollte der Donner über das Bootshaus hinweg, dass es zitterte und bebte. Julie und Noah hielten sich aneinander fest, und Julie weinte vor Schreck ein paar Tränen.

„Ich weiß, wo ihr euch beim Gewitter versteckt habt", sagte Albin, als sie auf dem Balkon frühstückten. Er hatte ein Bild mit mehrfarbigen Wolken gemalt, die aussahen, als wären sie gekotzt.

„Klar haben wir uns versteckt, hätten wir uns vom Blitz erschlagen lassen sollen?" Die Art, in der Julie wir sagte, brachte Albin auf, und er setzte mit dicken schwarzen Strichen zwei Flugmenschen in die Wolkenkotze.

Vom See stieg Nebel auf, der im Höhersteigen zerging. Der Himmel war so glatt und blau, dass keine Wolke eine Chance hatte.

"They've all gone mad", Julie shouted and ran to the boathouse.

"Who's mad?" Noah ran after her.

"Why can't they just float along beside each other? The sky's big enough."

Noah shook his head. "They don't have any space. Clouds everywhere. Each one moving at a different speed."

"Because they're in much too much of a hurry", Julie grumbled. "Then it's bound to explode."

"It's related to the temperature", Noah tried to explain something to Julie that she really didn't want explained.

"Yeah right. But you can also see it in a different way – like the cloud pictures."

"They immediately dissolve." Noah stood next to her and stared at the water.

"But for a moment you can look at them. For a moment they are something definite." Julie didn't give up so easily.

All of a sudden the clouds chucked down their water. "The rain's making holes in the lake", said Noah.

The wind spluttered foaming crests on the waves that rolled in, beating against the keels of the boats left in the water. The intervals between the claps of thunder became shorter and shorter. Julie covered her ears and shut her eyes. It was the first storm that year and, when Noah asked her if she was scared, she told him that she had to get used to the idea that there was such a thing as storms.

"It's nothing," said Noah, "just clouds fighting with each other."

When the lightning struck the water a ring of jets formed where it had hit. Everything went still for a moment. Then the thunder rolled over the boathouse making it tremble and shake. Julie and Noah held onto each other and Julie shed a few frightened tears.

"I know where you hid in the storm", said Albin while they were having breakfast on the balcony. He had painted a picture with multicoloured clouds that looked as if they had been puked onto the paper.

"Of course we hid; should we have stood and waited for the lightning to strike us?" The way in which Julie said we infuriated Albin and he drew two winged people in thick black lines in the cloud puke.

Mist was rising from the lake and evaporating as it went up. The sky was such a smooth blue that clouds didn't have a chance.

"Where do you think the clouds have gone then?" Albin asked in an undertone, as if he was showing himself up.

Julie tried to catch the honey that dribbled from her bread. "To hell's kitchen. That's it, to hell's kitchen!"

Albin added horns with red crayon to his winged figures. "But they'll be back anyway. For the next storm."

"They come and go." Julie could see Noah with a book tucked under his arm heading from the garden to the boathouse where he was going to wait for her. Albin didn't see him because he had his back to the lake.

"I've got to go somewhere", she said casually. "I'll be back soon."

"You don't have to go anywhere", cried Albin.

„Was glaubst du denn, wo die Wolken hin sind?", fragte Albin mit einem Unterton, als vergebe er sich etwas.

Julie versuchte den Honig, der vom Brot tropfte, aufzufangen. „In Teufels Küche. Ja, sicher, in Teufels Küche!"

Albin setzte den Flugmenschen mit roter Ölkreide Hörner auf. „Sie kommen trotzdem wieder. Fürs nächste Gewitter."

„Sie kommen und gehen." Julie konnte sehen, wie Noah mit einem Buch unterm Arm aus dem Gastgarten kam und sich in Richtung Bootshaus verzog, wo er auf sie warten würde. Albin bemerkte ihn nicht, weil er mit dem Rücken zum See saß.

„Ich muss kurz weg", sagte sie beiläufig, „bin aber bald wieder da."

„Du musst nicht weg", schrie Albin.

„Ich komme und gehe wie die Wolken", summte Julie.

„Und ich", schrie Albin, „ich komm mit."

„Vergiss nicht, dass du heute mit Paps zum Großmarkt fährst", summte sie weiter. Es stimmte zwar nicht, aber sie wollte Albin auf keinen Fall dabeihaben an diesem letzten Tag, bevor Noah mit seinem Vater nach New York zurückflog.

"I come and go like the clouds", Julie murmured.

"And me," Albin cried, "I'm coming with you."

"Don't forget that you're going with Dad to the market today", she continued murmuring. It wasn't true, but she certainly didn't want Albin tagging along on this last day before Noah flew back with his father to New York.

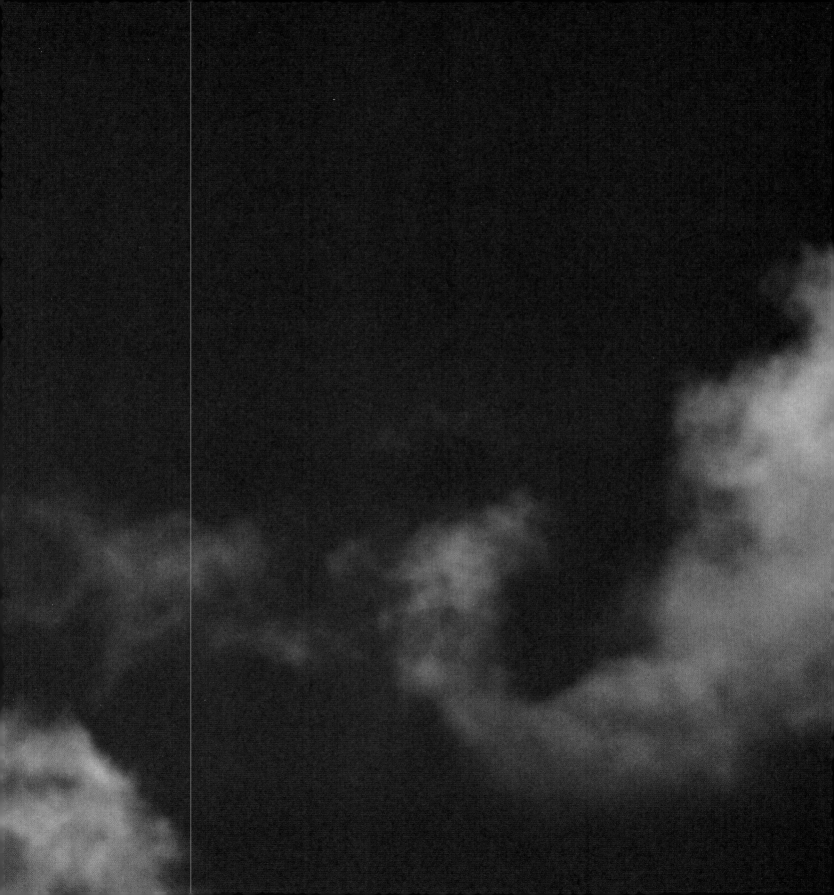

Siegrun Appelt

Clouds, 1996
Dia-Installation slide installation, Größe variabel size variable

Im Werk von Siegrun Appelt bilden transitorische Motive, wie das ständig mutierende Objektmotiv des Wolkenhimmels, die konzeptuelle Basis für einen Diskurs über apparativ gesteuerte Wirklichkeitswahrnehmung. In der Erweiterung der traditionellen Gattungsgrenze zwischen statischer und bewegter Bildpräsentation wird durch das technische Mittel der überblendenden Dia-Projektion die Seh- und Wahrnehmungserfahrung neu konstruiert.

Die Regieführung der Montage zur Serie übernimmt Siegrun Appelt in der präzisen Auswahl der Bildfolge. Die Künstlerin interpretiert damit gewohnte Sinneserfahrung und veränderte Wirklichkeitswahrnehmung durch filmische Artikulation einer inszenierten Wahrnehmung. Die serielle Abfolge der fotografischen Bilder thematisiert den Moment der Bewegung an sich und präsentiert gleichsam die medial aufbereitete Realität durch die technische Apparatur. Die meditative Dynamik der Wolkenbewegung – erzielt durch die apparative Manipulation der Überblendung – gipfelt in einer Bilddramatik voll emotionaler Stimmungswerte und ephemerer Bildstrukturen.

Ein zusätzliches Moment der Wahrnehmungsirritation bilden die Dia-Projektionen in einem geschlossenen Innenraum, indem die reproduzierte Realität des fragmentierten Naturphänomens als „Raumarbeit" inszeniert wird. Sonja Huber

In Siegrun Appelt's work, transitory motifs, like the constantly changing cloudy sky, form the conceptual basis for a discussion about the perception of reality controlled by technical apparatus. She expands the traditional boundary between static and moving pictures by superimposing slide projections and in this way reconstructs the experience of seeing and perceiving.

Siegrun Appelt directs the montage of the series, precisely selecting the sequence of images. In this way the artist interprets accustomed sensory experience and how filmic articulation changes and manipulates our perception of reality. This series of photographs deals with the moment of movement itself and at the same time presents a media-based manipulation of reality using technical apparatus. The meditative dynamics of scudding clouds – achieved by superimposing the images – culminates in a pictorial drama full of emotions, atmospheres and ephemeral images.

The fact that these slides are projected in an enclosed interior adds a further sense of confusion to our perception as this reproduced reality of a fragmented phenomenon in nature is staged as a work in an interior space. Sonja Huber

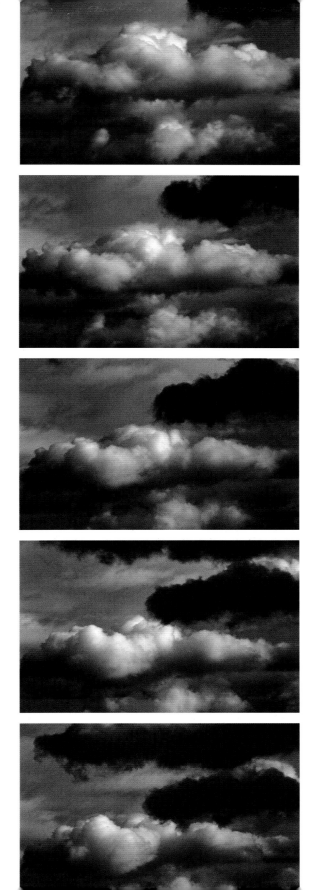

Ona B.

Nordlicht Northern Lights, 1992
Acryl auf Leinwand acrylic on canvas, 200 x 200 cm

„Nordlicht" gehört in eine Werkgruppe, in der Ona B. meist ein Gemälde in einen
Zusammenhang mit Architektur oder im Raum vor der Malerei platzierten Objek-
ten gestellt hat. Kristallkugeln oder Metallgestänge dienen als Bezugspunkte zur
Umgebung und erzeugen eine mystische Verbindung von Malerei und Objekt.
Ona B. entlässt die Malerei aus dem Zwang der Gegenstandsbeschreibung. Ein
dichtes flirrendes Farbgewölk überspannt die gesamte Fläche, ohne ein Zentrum
oder Randgebiete erkennbar machen zu wollen. Bei längerer meditativer Betrach-
tung lassen sich in diesem Farbhimmel, der wie ein Ausschnitt aus einem baro-
cken Deckenfresko erscheint, Figuren und Köpfe festmachen, die jedoch von
großer Flüchtigkeit sind. Mögen diese Schemen auch zufällig entstanden sein, so
verleihen sie dem Gemälde doch Lebendigkeit und Dynamik. Die Farbe Rot, die in
späteren Werken dominiert, wäre auch im Falle des Nordlichtes erwartbar,
kommt hier aber nicht zum Einsatz; die Künstlerin legt ihr Augenmerk auf die
ebenfalls häufige Erscheinung eines mehrfarbigen, aber kühlen Nordlichts, das
sie mit ihrer wolkig aufgewühlten Malweise fusioniert. Damit weicht sie von einer
realistischen Darstellung ab und bindet das Phänomen des Nordlichts in ihre
Bildsprache ein. Michaela Nagl

"Northern Lights" belongs to a group of works in which Ona B. usually placed a
painting in relation to architecture or objects positioned in the space in front of the
picture. Crystal balls or metal rods create points of reference to the surroundings and
evoke a mystical connection between painting and object. Ona B. releases painting
from the obligation to describe an object. A dense, shimmering cloud of colour covers
the entire surface without seeking to indicate a centre or edges. The picture seems
like a section from a baroque ceiling fresco and if one gazes meditatively at the image,
figures and heads emerge fleetingly in the coloured sky. Although these shadowy
figures may be coincidental, they endow the painting with vitality and dynamism. The
colour red, which dominates in later works, could have been expected in connection
with northern lights but does not feature in this work. The artist focuses her attention
on the multicoloured but cooler northern lights, which also frequently appear, and
merges this with her cloudy, churning style of painting. In this way she departs from a
realistic representation and incorporates the phenomenon of northern lights in her
pictorial language. Michaela Nagl

Hildegund Bachler

Touching the sky (Agnolo Bronzino), 1997
Farbfoto auf Papier colour photograph on paper, 47 x 84 cm

Das Gemälde von Agnolo Bronzino, Mitte des 16. Jahrhunderts entstanden, ist
reich an Titeln und Deutungen. Im Zentrum stehen Venus und Amor, dargebracht
als Kind, das seine Hand auf die Brust der Frau legt. Hildegund Bachler hat diese
Berührung aus ihrem bildlichen Zusammenhang entführt und in den Himmel
gehoben. Der Allegorie der Liebe unterlegte sie einen aktuellen Sinn, nachdem
das Bild jahrelang über dem Esstisch gehangen hatte, in jenem Raum, der immer
wieder alle Familienmitglieder zusammenführt. Wenn die Künstlerin darüber
nachdenkt, was das Gemälde für sie bedeutet hat, wählt sie nicht die Sprache der
Kunst, sondern jene des Lebens: „Dann hat mir meine Tochter die Hand auf den
Busen gelegt." Das Bild habe für Begriffe wie Vertrauen, Ernährung, Mütterlich-
keit gestanden.

Die Vielschichtigkeit der individuellen Erfahrungen und Empfindungen findet eine
besondere Entsprechung in einer mehrstufig angelegten medialen Transformation.
Die gedruckte Wiedergabe wird fotografisch reproduziert, ein Detail extrahiert
und digital mit einem Wolkenhimmel verbunden. Alles wird ins Blaue überführt,
in die Farbe der Unendlichkeit, der lichten Höhe und dunklen Tiefe, die auch die
Liebe kennt, und so auch des gelebten Daseins. Timm Starl

The painting by Agnolo Bronzino, created in the mid-sixteenth century, has inspired
many titles and interpretations. At the centre we see Venus and Cupid, shown as a
child placing his hand on the woman's breast. Hildegund Bachler took this touch out of
its pictorial context and placed it in the skies. She also gave the allegory of love a more
topical relevance as the picture hung for years above the dining-table in the room
where all the family members gathered. If the artist considers what the painting meant
to her, she doesn't choose the language of art but of life: "Then my daughter placed
her hand on my bosom." The picture stood for concepts like trust, nourishment and
motherliness.

The complexities of individual experiences and emotions were given a special
equivalent in a media-based transformation that occurred in several stages. The artist
photographed the print of the picture, extracted a detail from it and combined it
digitally with a cloudy sky. Everything is transferred into blue, the colour of infinity, of
bright heights and dark depths, a colour that love also knows and as a result is part of
our living existence. Timm Starl

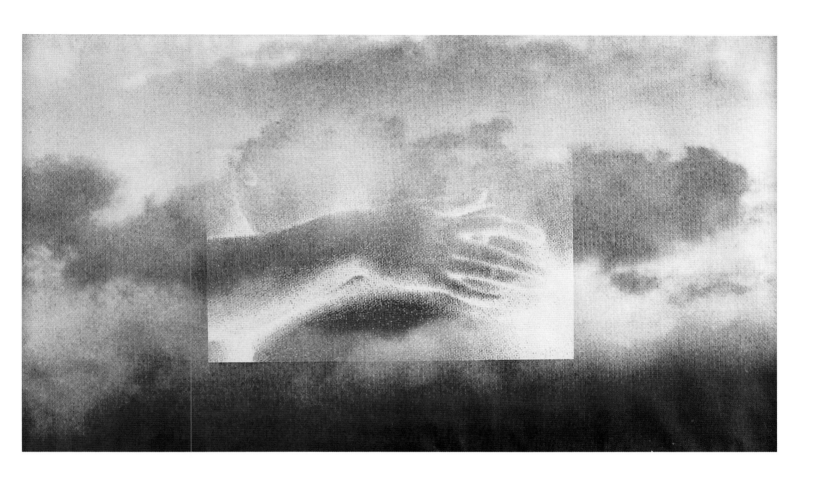

Gerhard Baldasti

O.T. Untitled, 1996
Öl auf Leinwand oil on canvas, 220 x 170 cm

Bedrohlich türmen sich Wolkenberge im gesamten Bildgeviert auf. Tiefe Schatten lassen sie besonders dreidimensional erscheinen, aber Rinnspuren zeugen von der malerischen Konzeption. Das lasierend und dünnflüssig gearbeitete Bild stellt nicht seine Gegenständlichkeit in den Vordergrund, sondern möchte mit Hilfe eines nahezu monochromen Farbauftrages einen Raum entstehen lassen.

Sein spezifisches Aussehen verdankt das Bild der zwischen Zufall und Kontrolle changierenden Malweise Gerhard Baldastis: Die Farbe rinnt, weil die Schwerkraft mitarbeitet, und der anfangs monochrome Farbauftrag wird durch verschiedene Eingriffe des Künstlers strukturiert. Erst dann entstehen Bilder im Kopf des Malers, das Gemälde wird in weiteren Arbeitsschritten dieser Vorstellung angeglichen und dadurch konkretisiert. Dass sich hier der Eindruck einer gefahrenvollen Wolkenmasse schier aufdrängt, hängt vor allem mit der gewählten Farbharmonie – dunklem Blau und Grau – zusammen. Das rahmenlose Bild, so Gerhard Baldasti, soll den Raum erfüllen, die BetrachterInnen emotional angehen, sie unwillkürlich berühren. Alexandra Matzner

Cumulus clouds loom threateningly, covering the entire picture space. Dark shadows make the clouds appear particularly three-dimensional but the trickles of paint demonstrate the essentially painterly character of the work. The picture, which is built up in thin glazes of paint, does not place an emphasis on its objecthood but aims to create a space using an almost monochrome application of paint.

The picture's specific appearance arises from Gerhard Baldasti's style of painting that alternates between coincidence and control. The paint trickles down with gravity and the artist intervenes and structures the originally monochrome application. It is only then that images are conjured up in the painter's mind and in stages he then attunes the painting to his imagined pictures, giving them concrete form. The fact that in this work we cannot help but see a dangerous mass of clouds is largely a result of the colour harmony of dark blue and grey. The frameless picture should, according to Gerhard Baldasti, fill the space, grab viewers' emotions and involuntarily move them. Alexandra Matzner

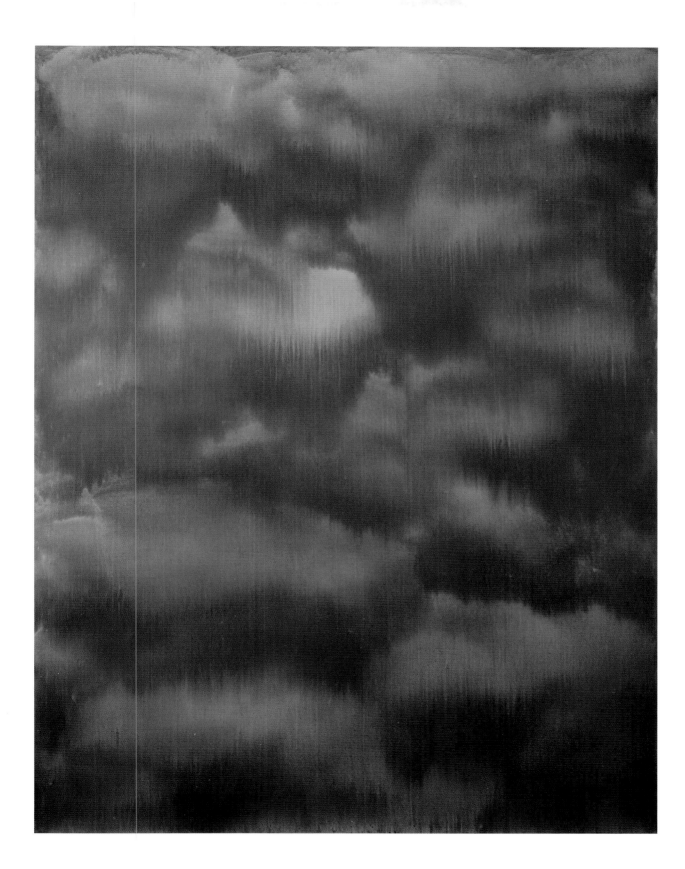

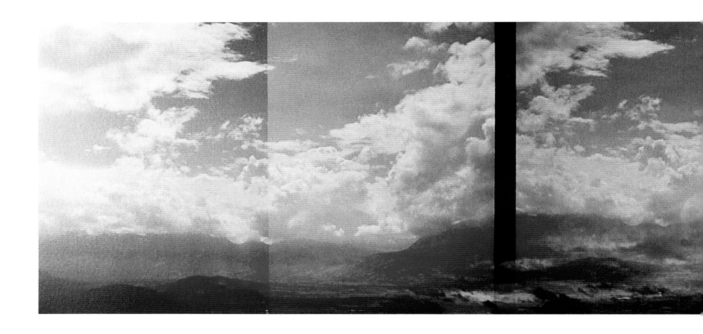

Astrid Bechtold

O.T. Untitled, 2001
Doppelbelichtete Farbfotos auf Aluminium double exposured
colour photographs on aluminum, 30 x 150 cm

Eine Wolke ist Substanz ohne Umriss und bestimmte Form, ist Kondensat, eine Schwade aus Dampf. Etwas, das Licht durch dessen Brechung sichtbar macht und dadurch selbst erst zu sehen ist. Wolken sind also „Lichtmaschinen" (Philippe Dubois) – so wie die Fotografie: Schwebende Wasserdampfkorpuskeln arbeiten wie Halogenidkristalle als Entwickler. Beide produzieren Phantome aus Licht. Die Fotografie allerdings arretiert, fixiert, während eine Wolke sich fortwährend ändernd vorüberzieht.

All dies wird in der Arbeit von Astrid Bechtold anschaulich gefasst. So komplex und so rätselhaft das Bild anfangs scheinen mag – es ist relativ einfach gemacht: nämlich analog doppelt belichtet. Zwei nacheinander vorgefundene Stimmungen am selben Ort wirken in der Überblendung beider Sequenzen zu einem einzigen Panorama künstlich. Das Vaporose der Wolken und das Transluzide des Films legen sich übereinander, fallen in eins – wobei durch die Verschiebung um einen halben Kader sich im Bereich zwischen den Einzelbildern jeweils andersfarbige vertikale Streifen bilden: als Sollbruchstellen mit einem veränderten Spektrum an Farben – was der nahezu glimmenden Stimmungslandschaft die nötige konzeptuelle Kühle gibt. Ulrike Matzer

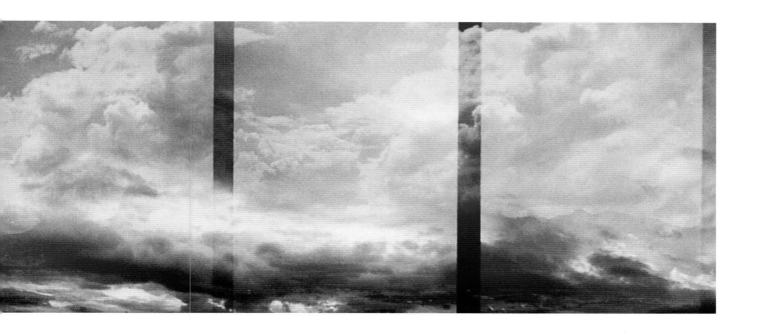

A cloud is a substance without an outline or definite form; it is condensed watery vapour, wisps of mist. Clouds make light visible through its refraction and in this way become visible themselves. They are therefore "light machines" (Philippe Dubois) – like photography: floating particles of water vapour act as developers in the same way as halogenide crystals. Both produce phantoms out of light. Photography, however, freezes and sets an image while a cloud is continually changing it as it floats past.

All of this is vividly captured in Astrid Bechtold's work. Although the picture initially appears complex and puzzling it has actually been made using a simple process: double exposure with an analogue camera. Sequences showing two consecutive atmospheres at the same location have been superimposed to create one panorama that appears artificial. The vaporosity of the clouds and translucence of the film are superimposed and merge into one. However, by bringing the images out of line by half a frame, different coloured vertical stripes have formed between the separate pictures. These are introduced as predetermined breaking points with an altered spectrum of colours that add the necessary conceptual coolness to this virtually gleaming atmospheric landscape. Ulrike Matzer

Fritz Bergler

Himmel Heaven, 2004

Öl, Paraffin auf Karton oil, paraffin on cardboard, je each 61 x 46,5 cm

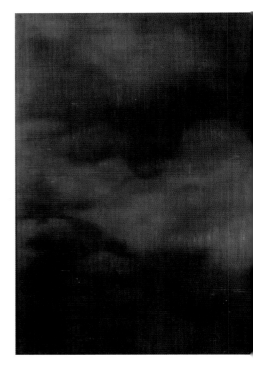

Fritz Berglers künstlerisches Interesse kreist seit einigen Jahren vornehmlich um Abbildungs- und Wahrnehmungsstrategien. In seinen Werken bedient er sich daher der Gegenüberstellung von Textfragmenten, Begriffen und Abbildungen. Bekannte Motive werden als Close-Up(s) monumentalisiert und fragmentiert zu Bildrätseln. Den BetrachterInnen kommt die aktive Rolle zu, die einzelnen Teile zusammenzusetzen und die Bildcodes zu entschlüsseln.

Die vierteilige Komposition „Himmel" gehört zu einem Werkblock gemalter S/W-Arbeiten der letzten Jahre, der durch Fragmentierung und Teilung die Frage nach Vollständigkeit und Wiedererkennbarkeit stellt. Es entstehen so spannungsreiche Kompositionen zwischen Abstraktion und Gegenstandsbezug. Bergler knüpft an bereits Bekanntes, an vorgefundene Bilder an, um Erinnerungen und Beobachtungen, aber auch erlerntes Wissen abzurufen. Meist zeigt er unscheinbare, alltägliche Objekte – wie in diesem Fall den Himmel. Durch eine doppelte Verfremdung – farblose Wiedergabe und Fragmentierung – bedarf es förmlich der Serie, um aus den abstrakt wirkenden Einzelteilen die Information „Himmel" destillieren zu können. Alexandra Matzner

For several years Fritz Bergler's artistic interest has revolved mainly around strategies of illustration and perception. He juxtaposes fragments of text, terms and images. Well-known subjects are monumentalized as close-ups and fragmented into pictorial puzzles. Viewers are given the active role of piecing together the image and deciphering the pictorial code.

The four-part composition "Sky" belongs to a group of works he created in recent years comprising black-and-white paintings that are fragmented and divided. As a result these pose questions about the image's completeness and recognizability. Exciting compositions emerge that hover on the brink between abstract and representational art. Bergler draws on known and existing images to recall memories, observations and also acquired knowledge. He usually shows unspectacular, everyday objects and motifs, as the sky in this example demonstrates. By altering and alienating the image in two ways – making the motif colourless and fragmenting it – the viewer needs the series in order to extract the information "sky" from the seemingly abstract sections. Alexandra Matzner

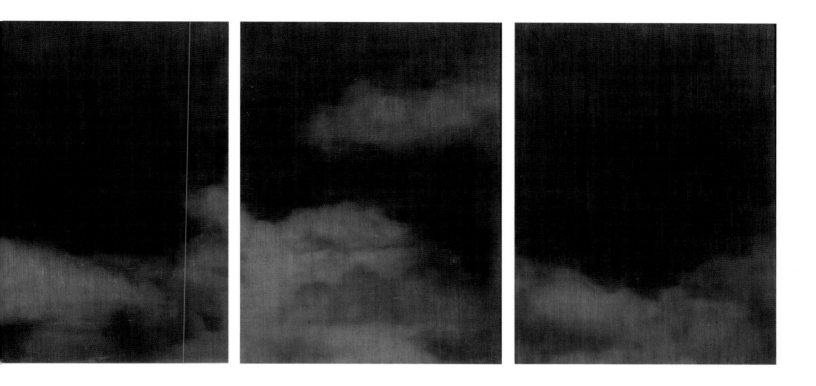

Aimée Blaskovic

Luft Air, 1998

Polaroidfotos, Plexiglas, Aluminium polaroid photographs,
plexiglass, aluminum, je each 10,1 x 10,3 x 3,5 cm

Polaroids sind eine Welt für sich: einzigartige, in sich geschlossene autarke Bilder,
die sich selbst entwickeln. Objekt- und körperhaft per se, führen sie Flüssigkeit in
sich. Dies und die Tatsache, dass sie sich durch ihre relative Dicke, durch ihr
Format und durch den weißen Rahmen wie kleine Guckkästen ausnehmen, hinter
denen sich neue Räume auftun und weiten können, regte Aimée Blaskovic wohl
zu dieser Serie an: Rücklings über einer Wolke liegend, fliegend vor Sternen im
All werden Träume und Wünsche wahr – oder sichtbar zumindest im Bild.
Für diese Reise in den Weltraum begab sie sich erst auf einen Tisch; um davon
abzuheben, öffnete sie die Polaroids und wischte die sie selbst umgebende
liquide Fotoschicht weg. Plexiglas vor den abfotografierten Hintergrundmotiven
hält sie räumlich in Schwebe: Wie von Peter Pan angeleitet segelt da eine dahin.

Die spielerische Leichtigkeit und Unbekümmertheit sowohl des Bildmotivs wie
auch des Umgangs mit medialen Materialitäten äußert sich auch darin, dass hier
der Trick aus der Frühzeit der Fotografie, Wolken einzukopieren, umgekehrt
wurde: Die Künstlerin selbst nämlich ist es, die sich in die Atmosphäre fügt,
in die Welt des Bildes, ganz nach Belieben. Ulrike Matzer

Polaroids occupy their own world: unique, self-contained autarkic pictures that develop
themselves. The films are substantial, contain liquid and are intrinsically object-like.
Moreover, their relative thickness, format and white frames make them appear like
views from a peep-show where new spaces unfurl before our eyes. These two factors
must have inspired Aimée Blaskovic to create this series. Lying on her back over a
cloud, flying amidst stars in space, she shows dreams coming true – or at least
becoming visible in a picture. For this trip into outer space she first lay on a table and
to make herself lift off, she opened the Polaroids and wiped away the liquid layer of
the photo around her. The Perspex placed in front of the photographed backgrounds
enhances the sense of floating in space. The figure flies through the sky as if guided
by Peter Pan.

The playful, carefree approach to both subject and materials is also expressed by the
fact that this work inverts the trick used in early photography of copying clouds into a
photograph. Here it is the artist who has placed herself in the atmosphere, into the
picture's world, just as she pleases. Ulrike Matzer

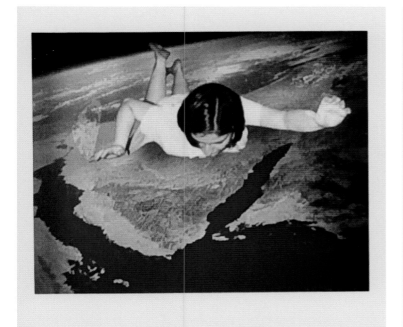
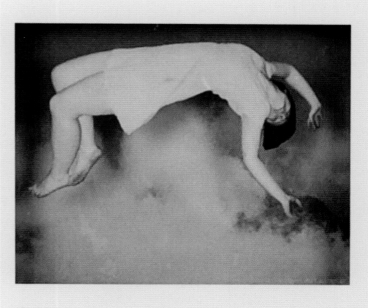
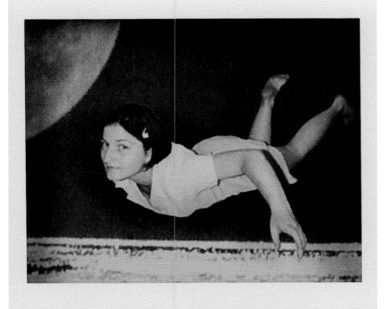
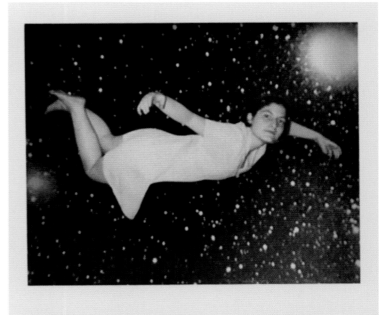

Eva Choung-Fux

Nebelbild Mist Picture, 2004

Hochdruck auf Japanbütten letterpress on Japanese handmade paper, 52,5 x 25 cm

Eva Choung-Fux, gebürtige Wienerin, reiste schon sehr früh „durch die Wolken des Himmels", um in ferne, asiatische Länder zu gelangen. Japan, Korea und China waren Stationen ihrer „Lebensreise". Es sind Länder und Orte, deren Kultur und Philosophie sie bereits sehr früh in den Bann gezogen haben. Erst durch das Eintauchen in diese Kulturen – so die Künstlerin in einem Interview anlässlich ihres 70. Geburtstags – sei sie zu einer „gefestigten Europäerin" geworden, blieb aber dennoch eine „Wanderin zwischen den Welten".

Das vorliegende Blatt „Nebelbild" zeigt in vielerlei Hinsicht ihre künstlerischen Bezugspunkte zum asiatischen Raum. Auf Japanbütten gedruckt und durch wenige Farbabstufungen charakterisiert, schuf die Künstlerin auf schmalem Format ein Wolkenmeer aus dicht an dicht gereihten Nebelschwaden. Die Grafik erinnert an asiatische Tuschebilder. Sie transponiert eine Witterungsstimmung, wie sie in den weitläufigen, zu bestimmten Jahreszeiten immer wieder von Dunst und Nebel durchzogenen Kulturlandschaften der asiatischen Bergregionen auftritt. Die Arbeiten von Eva Choung-Fux sind darüber hinaus immer wieder mit den persönlichen Empfindungen und Erfahrungen der Künstlerin, die sie auf den diversen Reisewegen machte, in Verbindung zu bringen. Eine erst kürzlich während einer Chinareise entstandene Fotoserie (2008) mit dem Titel „Anflug auf Beijing" zeigt Luftbildaufnahmen ähnlicher Stimmung.

„In Memoriam" ist auch auf dem Nebelbild zu lesen. „Erinnern" – ein Thema, dem sich Eva Choung-Fux generell verbunden fühlt: Auf künstlerische Weise versuchte sie, unter anderem in ihrem fotografischen Hauptwerk „Menschen über Leben 1945–1995" (1995), die „Nebelschwaden und Wolkenberge" der Geschichte zu lichten – gegen das Vergessen und zur mahnenden Erinnerung. Markus Schön

Eva Choung-Fux is Viennese by birth but at an early age she travelled through the "clouds in the sky" to far-off countries in Asia. Japan, Korea and China were all stations on her "life journey". The culture and philosophy of these countries and places had cast their spells over her at a young age. In an interview on her seventieth birthday, the artist stated that immersing herself in these cultures had actually made her a "true European" although she always remained a "traveller between these worlds".

"Mist Picture" demonstrates its links with Asian art in many ways. Printed on Japanese hand made paper using just a few gradations of colour, the artist captured dense bands of cloud that fill the narrow format with a sea of misty vapours. The print recalls Asian ink paintings. It conveys the weather's atmosphere to be found in Asia's sprawling mountainous regions where in certain seasons the landscapes are often bathed in mist and fog. Eva Choung-Fux's works can also be connected with her own feelings and experiences on her many travels. "Flying into Beijing", a recent series of aerial photographs created on a trip to China in 2008, captures a similar atmosphere.

We can also read the words "In Memoriam" on the "Mist Picture". Remembering is a subject that lies close to Eva Choung-Fux's heart. In her art – and her major photographic work "Survivors on Life 1945–1995" (1995) is a case in point – she tries to clear the "mists and clouds" of history, as a warning and as a reminder to prevent us from ever forgetting. Markus Schön

Helga Cmelka

Cumulus humilis – entstehen mittags, Auflösung abends, meist beständiges
Schönwetter Cumulus humilis – Fair Weather Clouds that appear at Midday
and disperse in the Evening, **2008/2009**
Verzinkter Eisendraht, Polyestergewebe galvanized iron wire, polyester fabric, **diverse** various Ø
Leihgabe der Künstlerin loan of the artist

Die Natur in der Kunst abbilden: ein Versuch, der so alt ist wie die Kunst selbst.
Die Natur aber mit Kunst bespielen, als wäre die Kunst Natur? Und dabei das
Immaterielle materiell fassbar machen? Helga Cmelka nähert sich mit ihrer Serie
von „clouds" diesem scheinbar zum Scheitern verurteilten Versuch erfolgreich
an. Sie konturiert, bindet, verdichtet und modelliert Wolkenkörper aus verzinktem
Eisendraht und durchwebt diese Körper mit einem dichten Netz von weißen,
grobmaschigen Gewebebändern aus Polyester. Eine erstaunliche Kombination:
hartes Eisen und synthetisches Polyester als Material für etwas, das per
definitionem aus Wasserdampf und Dunst besteht. Doch die materielle Um-
widmung funktioniert, wie Cmelkas Installationen zeigen. Im Außenbereich
schweben die „clouds" oder schmiegen sich wie überdimensionale Watte-
bäusche an Baumkronen und Astwerke und berichten vergnügt von der Leichtig-
keit des Seins. Nicht die Natur wird abgebildet, auch nicht bespielt, sondern
Kunst und Natur treten in einen stillen Dialog. In der abstrakten Umgebung des
Galerieraumes hingegen steigert sich der verspielte und dreidimensionale
Charakter des immateriellen Materials. Martina Griesser-Stermscheg

Depicting nature in art is an attempt as old as art itself. Yet what about art taking the
stage in nature, as if art was nature? And what about art transforming something
immaterial in nature into a material, tangible object? With her series of clouds, Helga
Cmelka successfully approaches this challenge that seems doomed to failure. She
outlines, ties, compresses and models clouds out of galvanized iron wire and weaves
these structures with a thick network of white, loose-knit polyester fabric strips.
An astonishing combination: hard iron and synthetic polyester as materials for
something that by definition is composed of vapour and mist. Yet this redesignation
of the materials works, as Cmelka's installations demonstrate. Outside the clouds
float or nestle into treetops or branches like oversized cotton wool balls, and happily
convey the lightness of being. Nature is not being depicted; it's also not acting as a
stage, but art and nature are entering into a quiet dialogue. By contrast, the abstract
surroundings of the gallery have the effect of enhancing the playful and three-
dimensional character of this immaterial material. Martina Griesser-Stermscheg

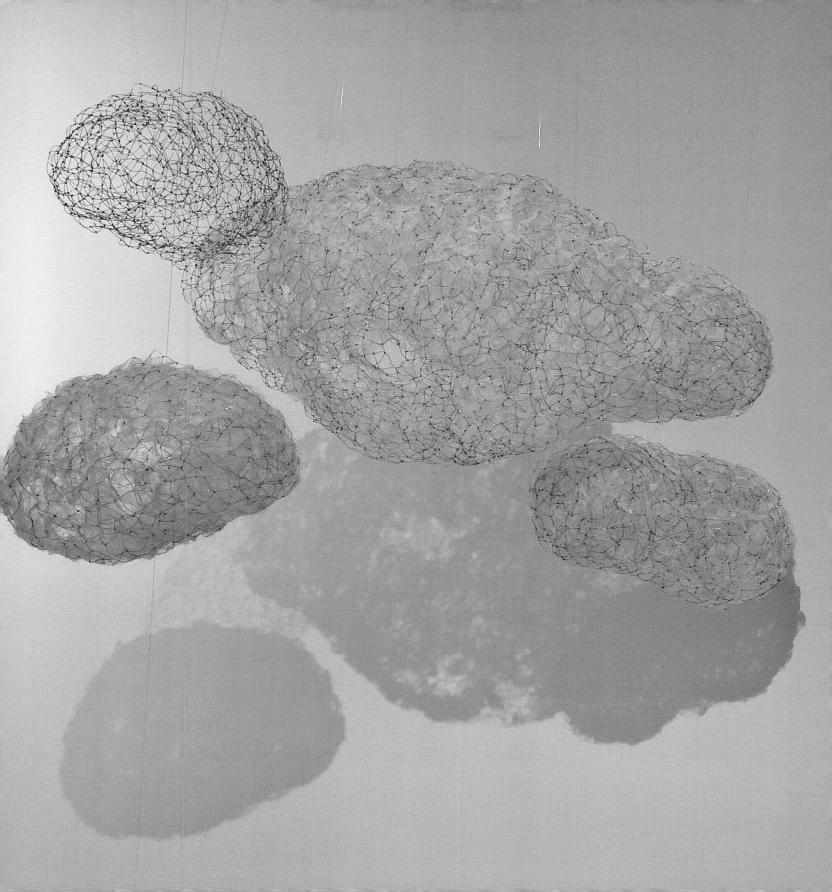

Béatrice Dreux

ciel // purpur 01–04, 2008
Farbfotos colour photographs, je each 30 x 53 cm
Leihgabe der Künstlerin loan of the artist

In ihren malerischen und fotografischen Arbeiten bestimmt Béatrice Dreux Natur und Landschaft als Projektionsräume, in denen sich für die BetrachterInnen emotional besetzte Erinnerungen an Schönheit, Dramatik, unendliche Tiefe und Vergänglichkeit mit medialen und geschichtlichen Komponenten verbinden. Wesentliche historische Bezugspunkte sind dabei die Arbeiten des Fotografen Gustave Le Gray und des Malers Casper David Friedrich, deren medial verschiedene Konstruktionen einer romantisierten Landschaft Dreux weiter fokussiert und interpretiert. Es ist also nicht die unberührte Natur oder der Glauben an deren unverbrüchliches Bild, das sie vermittelt, vielmehr stellt sie das vermeintlich Natürliche und Ewige als bereits historisch Gebrochenes und Aufbereitetes vor Augen und erweist die Annäherung an die Natur auch als unumgängliche Annäherung an deren bereits existierende Bilder.

Die zwitterhafte Eigenschaft der Natur als Träger evolutionärer Logik wie auch als Ort unvorhersehbarer Turbulenzen und Katastrophen ist thematische Grundlage, mit der das Flüchtige, Vergängliche und Veränderliche in den Vordergrund gestellt wird: verschwimmende Wolkengebilde, zwielichtige Dämmerungen und das changierende Spiel des Sonnenlichts sind in diesen Darstellungen der sichtbare Ausdruck verborgener Kräfte und Prozesse. Die Auffassung von Landschaft als historisch-ästhetisch konstruierter Natur, als Werk des kulturellen Gedächtnisses und des menschlichen Geistes wird sowohl malerisch als auch fotografisch mit herausfordernden Aspekten des Mythischen und Emotionalen angereichert und erprobt. Wie die atmosphärischen Wolkenbilder, deren bildhafte Erfassung die Grenzen zwischen fotografischer Präzision und malerischer Erscheinung auflöst, zeigen, gibt es auch zwischen dem Rationalen und dem Emotionalen keine wirklichen Trennlinien, sondern nur Übergänge in Permanenz. Rainer Fuchs

In her paintings and drawings, Béatrice Dreux sees nature and landscape as projection spaces where viewers' emotional memories of beauty, drama, endless depth and transience are linked with components from media and history. Important historical references are the images created by the photographer Gustave Le Gray and the painter Caspar David Friedrich. Dreux focuses and interprets these artists' different constructions of a romantic landscape. She does not present untouched nature or the belief in some sacrosanct image. Instead, she shows this alleged natural and eternal subject as something that has a tradition and has been tampered with by history, demonstrating that approaching nature inevitably entails approaching already existing images.

It is this dual quality of nature as a bearer of evolutionary logic and a place of unpredictable turbulence and catastrophe that lays the foundations for focusing on nature's fleeting, transient and changeable characteristics. Blurred cloud formations, dusky twilights and the shimmering play of sunlight in these images are a visible expression of hidden forces and processes. The view of landscape as nature that is historically and aesthetically constructed, as a work of cultural memory and the human spirit is enhanced with inviting mythical and emotional aspects. As demonstrated by the atmospheric cloud pictures, which dissolve the boundaries between photographic precision and a painterly image, there is also no true dividing line between the rational and emotional but only permanent transitions. Rainer Fuchs

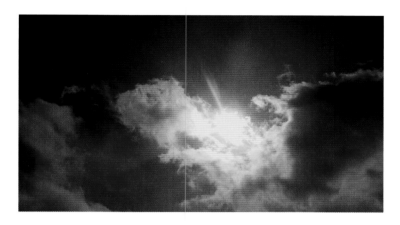
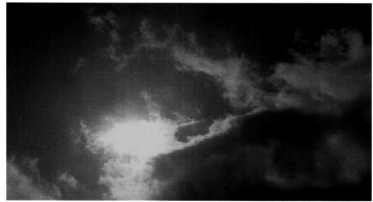

Irma Eberl

O.T. Untitled, **1992**
Acryl auf Leinwand acrylic on canvas, 150 x 142 cm

Wolken sind gewissermaßen gegenstandslose Gegenstände: Bilder für eine Gegenständlichkeit ohne Gegenstand.

Die Vorstellung von einem Gegenstand ist eine Sache, diesen Gegenstand zu beschreiben eine andere. Noch schwieriger wird es, wenn es sich bei diesem Gegenstand um ein Bild handelt, das selbst dazu tendiert, ein Verhältnis zur Beschreibbarkeit herzustellen. Dann hat man ein Bild vor sich, das die Form der Beschreibung selbst zu seinem Gegenstand erklärt. Im Unterschied zur begrifflichen Sprache kann sich die Malerei wie jene von Irma Eberl einer Schrift bedienen, die gleichermaßen das Schreiben wie den Gegenstand der Beschreibung umschreiben kann. Was dann erscheint, sind keine Buchstaben, sondern skripturale Figuren, die ans Schreiben erinnern, und zugleich visuelle Notationen, die eine Gegenständlichkeit evozieren, die nur angedeutet bleibt. Um dieses Changieren zwischen den Ebenen des Gegenständlichen, des Visuellen und Imaginären als synchrone Figuren zu entwickeln, bedient sich Irma Eberl einer Textur aus Schichtungen: Was davor gemalt wurde und was danach, greift ineinander und behauptet eine Gleichzeitigkeit verschiedener Perspektiven, die nur gemeinsam gelesen werden können, um ein möglichst realistisches Bild der Welt zu skizzieren, so abstrakt dieses auch erscheinen mag. Andreas Spiegl

Clouds can be seen as non-objective objects: pictures reflecting objecthood without an object.

The idea of an object is one thing, describing it is another. This becomes even more difficult when this object is a picture that itself tends to dwell on descriptiveness. Then you have a picture before you that takes the form of description itself as its object. In contrast to conceptual language, painting – as in the work of Irma Eberl – can use a script that can convey both writing and the object being described. What emerges are not letters but calligraphic figures, recalling writing, which are at the same time visual notations evoking objecthood, although this is never more than a suggestion. To develop synchronous figures conveying this alternation between the various levels – object, visual and imaginary – Irma Eberl uses a texture composed of layers. What was painted before is interwoven with what was painted afterwards and asserts the simultaneous character of different perspectives. It is only when these perspectives are taken as a whole that a realistic image of the world is outlined, however abstract this may seem. Andreas Spiegl

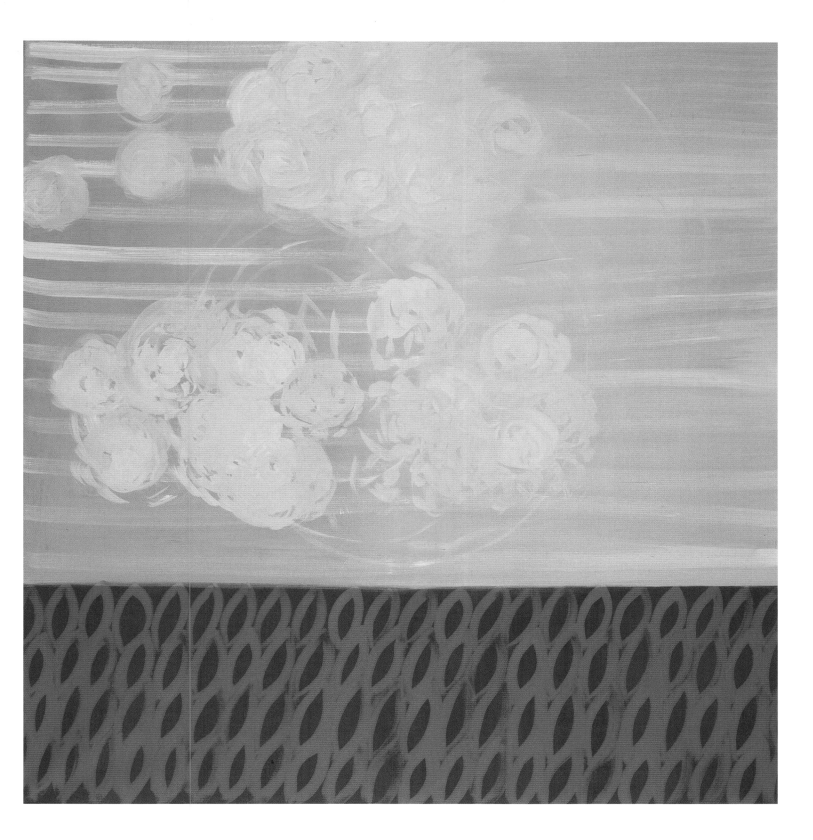

Gottfried Ecker

Schädeldecken – lose Gedanken Scullcaps – Loose Thoughts, 1994
Farbstift auf Papier colour pencil on paper, je each Ø 79 cm
Leihgabe des Künstlers loan of the artist

Das künstlerische Schaffen von Gottfried Ecker zeichnet sich durch das
Nebeneinander und die Kombination der Gattungen Malerei, Skulptur und
Zeichnung aus. Sein offenes Arbeitsfeld ermöglicht momenthafte Konstellationen
sowie einen analytischen Umgang mit den Gestaltungsmitteln und inhaltlichen
Bezugsfeldern. Auch die Zeichnungen der Serie „Schädeldecken" sind variabel in
ihrer Anordnung und Anzahl. Die für jeden Mensch individuelle und durch klare
Konturen charakterisierte Form der Schädeldecke wird durch die zarte grafisch-
malerische Technik und das runde, Unbegrenztheit suggerierende Format des
Papiers optisch dematerialisiert und erinnert dadurch an die zufällige und
instabile Formation einer Wolke. Das kulturgeschichtlich mit Totenkult, mensch-
licher Vergänglichkeit und Reliquienmystik verbundene Motiv der Hirnschale wird
auf den Papierarbeiten, die auf Platten quasi frei schwebend im Raum angebracht
sind, durch vielfältige formale und inhaltliche Bezüge angereichert. Zwischen
topografischer Inselform, gestaltpsychologischer Projektionsfläche, kuppel-
artigem Firmament und luftigem Himmelsgewölk spiegeln die Formen dabei
gleichzeitig das freie Schweben eines Gedankens im Raum. Elisabeth Fritz

Gottfried Ecker's artistic work is characterized by combining and juxtaposing painting,
sculpture and drawing. This open scope allows for temporary combinations and an
analytical approach to his media and the subjects to which he alludes. The drawings in
the series "Skullcaps" also vary in number and arrangement. The characteristic shape
of each person's clearly delineated skullcap is depicted in a soft graphic, painterly
technique on round paper suggesting boundlessness. This has the effect of
dematerializing this object and recalls the random, unstable formation of a cloud. Seen
in the context of cultural history, the braincase was linked with cults of the dead, the
transience of life and the mysticism of relics. These images are mounted on boards
that float almost freely in space and conjure up all sorts of associations in terms of
form and subject. Somewhere amidst all these associations – a topographical island,
a projection surface of Gestalt psychology, a domed firmament or an airy cloud – these
forms also reflect a thought roaming freely in space. Elisabeth Fritz

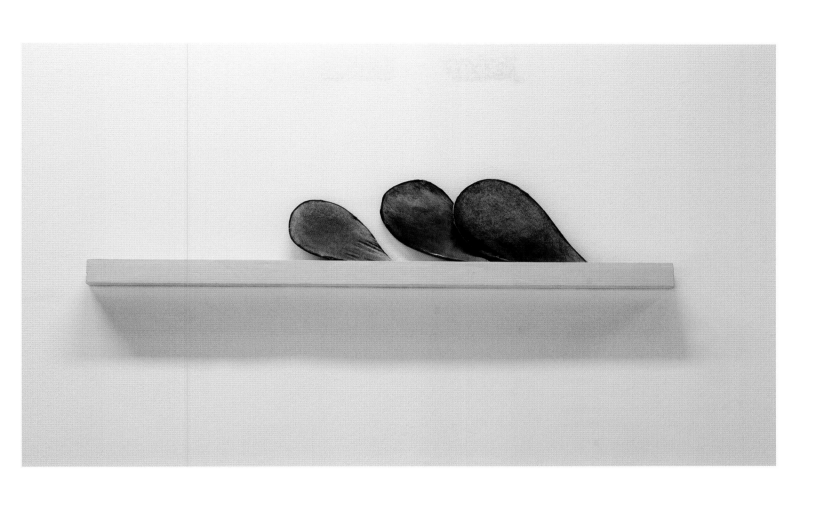

Khy Engelhardt

Ufos über Simmering Ufos over Simmering, **1996**
Video, 18:15 min

Mit staunenswerter Energie und Konsequenz verwandelt Engelhardt Khy alles, was er erlebt, alles, was er sieht, und alles, was ihm zustößt, in Kunst. Dabei ist er ein echter Medienkünstler, er arbeitet in einem liquiden Feld zwischen Malerei, Fotografie, Video und Texten aller Art. Es entsteht ein Gesamtkunstwerk; ausgehend vom dokumentarischen Notieren, Sammeln, Festhalten fließt alles ein und wird alles umgewandelt in Bilder oder Bücher oder Videofilme. So auch die Tagebücher: Seit vier Jahrzehnten ohne Unterbrechung täglich geführt, für jeden Tag eine Seite voll von Erlebnissen, Zusammentreffen und Reflexionen, quellen sie über von eingeklebten Fotos, Aufzeichnungen, malerischen Hinzufügungen, Heilkräutern, auf der Donauinsel gesammelt. Als ordnendes und verwandelndes Prinzip dominiert seit den 1970er Jahren vereinheitlichend die Symmetrie, Motive, Figuren, Lichterscheinungen werden horizontal und vertikal gespiegelt und so in eine Phantasmagorie der Vielfalt, Lebendigkeit und potentiellen Unendlichkeit des Lebens verwandelt. Auf großen Paneelen aufgeklebt, entsteht eine flimmernde Ornamentik; in Videos werden die gespiegelten Silhouetten der Wiener Gasometer zu fliegenden Untertassen. Die Symmetrie vermag mit ihren magischen oder sakralen Bezügen die BetrachterInnen nachhaltig zu irritieren. Ulrich Gansert

With astonishing energy and resolve, Engelhardt Khy transforms everything that he sees, experiences and encounters into art. A true media artist, he works in a fluid zone between painting, photography, video and all sorts of texts. He thus creates a "total work of art". He starts out by documenting and noting, collecting and capturing and then transforms everything into pictures, books or video films. This also applies to his diaries. For four decades and without interruption the artist has kept a daily diary. He allocates a page to each day, filling this with his experiences, meetings and reflections and adding a wealth of photos, notes, paintings or medicinal herbs gathered on Vienna's Donauinsel (Danube Island). Symmetry has dominated in his work since the 1970s and acts as an ordering and transforming precept. Motifs, figures and light effects are mirrored horizontally or vertically and are thus transformed into a phantasmagoria of the diversity, vitality and potential endlessness of life. Applied to large panels these create a shimmering array of ornamentation. In videos the mirrored silhouettes of the Gasometer in Vienna become flying saucers. This symmetry conjures up magical or religious allusions and can evoke a lasting effect of confusion for the viewers. Ulrich Gansert

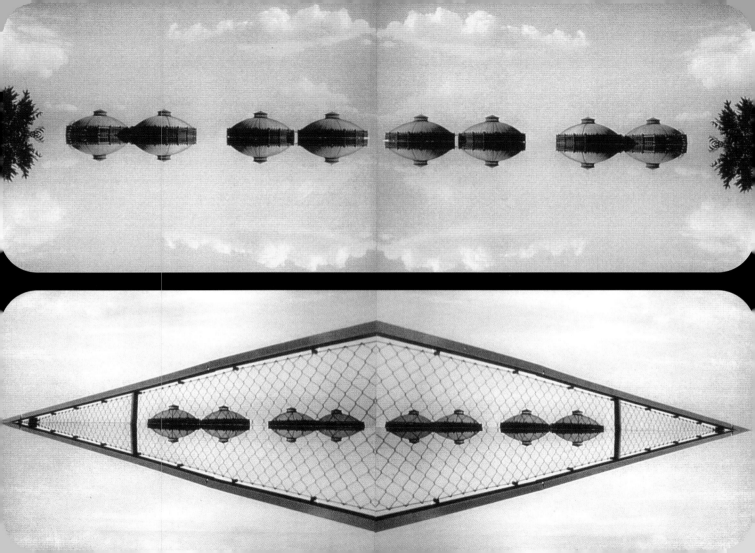

Gyula Fodor

O.T. (Donautal mit geschlossener Wolkendecke)
Untitled (Danube Valley with Closed Cloud Cover), **2006**
C-Print auf Aluminium C-print on aluminum, **90 x 120 cm**

Was auf den ersten Blick wie ein Satellitenbild wirkt, könnte auch – kennt man
Fotos von Gyula Fodor – eine bodennahe Aufnahme des zugefrorenen Neusiedler
Sees sein. Tatsächlich ist es ein aus dem Flugzeug geschossenes Motiv, wie uns
der Zusatz in der Titelangabe verrät: das Flussbett der Donau bei geschlossener
Wolkendecke, von durchschnittlicher Reiseflughöhe aus gesehen, darüber der
Blick in die Stratosphäre. Als feine Furche durchzieht der Flusslauf das Bild und
den irisierenden Lichtkreis an der Fensterscheibe: Kaltluftpakete über dem
Wasser sinken ab, während über städtischen Ballungsräumen wärmere Luft in
ein höheres Wolkenstockwerk aufsteigt.

Aus der Welt treten durch Fotografieren: für Gyula Fodor eine Lebensnotwendig-
keit, seit er 1981 aus Ungarn geflohen ist. „Im Orbit des Imaginären" (Dietmar
Kamper) unterwegs, versucht er ein neues Universum für sich zu finden, sucht er
bisweilen banale Objekte so zu sehen wie noch nie: Bilder, die von den Reisen
eines Raumschiffs künden, letztlich aber bloß Codes darstellen für solche
Odysseen – zeitlose Bilder aus ungewöhnlichen, mitunter schrägen Perspektiven;
Bilder, die mysteriös wirken und zugleich Symbole für Elementares sind. Ulrike Matzer

What at first glance looks like a satellite picture could also – if you know Gyula Fodor's
photos – be a picture of a frozen Lake Neusiedl taken close to the ground. However, it
is indeed a photo taken from an aeroplane, as the description added to the title shows:
the Danube river bed covered by a blanket of cloud, seen from a plane's average
altitude with a view of the stratosphere above. The river is a faint furrow traversing the
picture and the iridescent circle of light on the window-pane: above the water parcels
of cold air sink while above the conurbations warmer air rises to a higher cloud etage.

Stepping out of the world using photography – this has been absolutely vital for Gyula
Fodor since he fled Hungary in 1981. Travelling "in the orbit of the imaginary" (Dietmar
Kamper), he is trying to find a new universe for himself, seeing unspectacular objects
in a completely new light. They are pictures that tell of a spaceship's voyages but
ultimately only represent codes for such odysseys – timeless pictures seen from
unusual, sometimes bizarre perspectives; pictures that seem mysterious but at the
same time are symbols of something fundamental. Ulrike Matzer

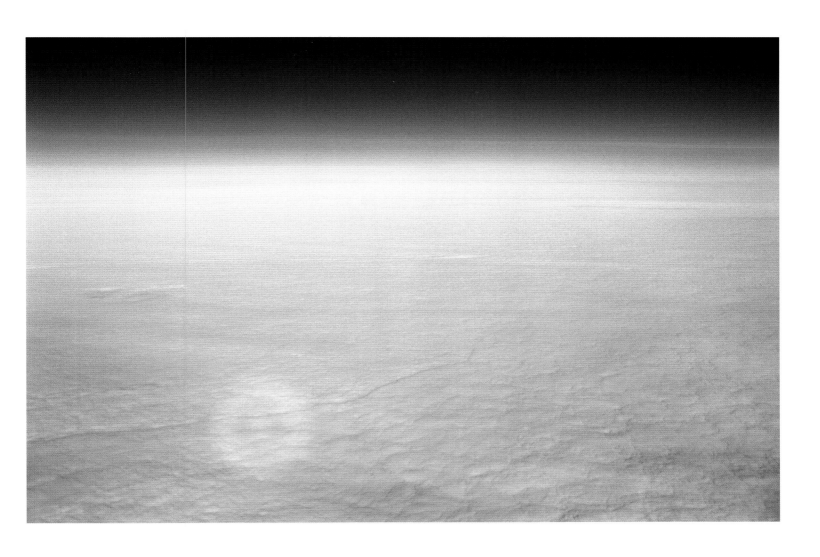

Heinz Gappmayr

vertikal vertical, **1979**
Schwarzweißfoto black and white photograph, **60 x 50,2 cm**

Das intermediäre Verhältnis von „Begriff" und „Objekt(-welt)" ist seit den frühen 1960er Jahren zentraler Inhalt im Werk des Konzeptkünstlers Heinz Gappmayr, der durch äußerste Reduktion der künstlerischen Mittel komplexe Bedeutungen und Zusammenhänge konstruiert und somit sinnliche Wahrnehmung durch „Denkbilder" konkretisiert. Neben puristischen Arbeiten auf Papier (Künstler-bände, wie „zeichen I bis IV" oder „vertikale") entstehen ab den 1970er Jahren Text- und Rauminstallationen und im weiteren Schaffensprozess auch Arbeiten im öffentlichen Raum, die alle in kontinuierlicher, werkkonformer Relation zur visuellen oder konkreten Poesie stehen.

Die ab 1979 entstandenen Fototexte zeigen eine konzeptuelle, grammatikalische Raumbestimmung durch extreme Essentialität in der gegenseitigen Durch-dringung von Sprache und fotografischer Bildwirklichkeit. Durch Verwendung universell-relationaler Begriffe, wie „oben", „unten", „horizontal" oder wie im vorliegenden Werk „vertikal", konstruiert sich der Raum der fotografisch erfassten Objektwelt zwischen Himmel und Erde – zwischen räumlich gegen-übergestellten visuellen Informationen – durch die Materialität der Sprache. Der Begriffsinhalt wird durch diesen konkretisierten Sehraum sinnlich erlebbar. Die Beziehung zwischen Sichtbarem und Gedachtem wird zum Spiel mit den Leerräumen, die durch das aktive Präsenzerlebnis der RezipientInnen konkrete Wirklichkeit von gegensätzlichen Wahrnehmungselementen schafft. Sonja Huber

The intermediary relationship between "term" and "object (world)" has been central to the work of the conceptual artist Heinz Gappmayr since the 1960s. Using an extreme reduction in artistic means, he constructs complex meanings and connections and makes sensory perception concrete in "thought images". Besides purist works on paper ("signs I to IV" or "verticals"), since the 1970s he has been creating text and room installations, followed by works for public spaces. These have consistently conformed with the ideas of visual or concrete poetry.

The photo texts, which he started in 1979, show a conceptual and grammatical dictation of space that is reduced to essentials in the interpenetration of language and photographic reality. By using universal, relational terms like "top", "bottom", "horizontal" or, as in this work, "vertical", the space of this photographed object world between the skies and the earth – between visual information juxtaposed in space – is construed out of the materiality of language. The meaning of these terms can be experienced in a sensory way in this definite visual space. The relationship between what we see and what we imagine becomes a play with the empty spaces that through the recipient's active experience creates a concrete reality out of contrasting perceived elements. Sonja Huber

vertikal

Markus Maria Gottfried

Manuela zerschlägt ein Glas Manuela Breaks a Glass, 1999
Siebdruck auf Papier screenprint on paper, 68 x 50 cm

In den abstrakten Arbeiten von Markus Maria Gottfried stehen Formen, Farben und die Überlagerung und Kombination von Flächen und Linien im Mittelpunkt des künstlerischen Interesses. Aus einer Vielzahl wahrgenommener Sinnesein-drücke – mitunter sind es architektonische Strukturen oder aber auch alltägliche Gegenstände, die in ihrer formalen und farblichen Disposition auf den Künstler anregend wirken – entstehen ganz persönliche innere Abbilder, die als „gespei-cherte Sammlung" den Ausgangspunkt für Gottfrieds Arbeiten darstellen. Der anschließende Druckvorgang (Siebdruck) ist wesentlicher Teil des künstlerischen Gestaltungsprozesses. Gottfried verfolgt dabei jedoch nicht das Ziel einer monotonen Vervielfältigung; die Besonderheit seiner Arbeitsweise liegt vielmehr im konstanten Verändern und Retuschieren einer am Anfang des Druckprozesses formulierten Bildidee. Diese bewusste „Manipulation" in den verschiedenen Druckstadien lässt in der seriellen Betrachtung eine Abfolge voneinander ab-weichender, aber in den Grundformen und Farben ähnlicher Bild- kompositionen erkennen. Die einzelnen „Sequenzen" – Standbilder einer endlosen Bewegungs-abfolge – stehen jedoch nicht immer in einem verbindlichen Folgeverhältnis zueinander. Die hier gezeigte Arbeit von 1999 versteht sich als Teil einer derartigen „Siebdruck-Choreografie". Durch den Titel „Manuela zerschlägt ein Glas" – der Satz entstammt einem Prosatext des Künstlers – wird den Betrachter-Innen die Möglichkeit für eine Erweiterung der visuellen Bildauffassung geboten: Er lässt Raum für fantasievolle Assoziationen und freie Sichtweisen; inklusive (vermeintlicher) „Wolkensymbolstimmungen". Markus Schön

In Markus Maria Gottfried's abstract works, forms, colours and the combination and layering of planes and lines are at the heart of his artistic interest. From a multitude of sensory impressions, Gottfried creates personal inner images that form a "stored collection" and the starting-point for his work. These impressions include architectural structures or everyday objects with forms and colours that inspired the artist. The screen printing that follows on from this is an essential part of the artistic process. Gottfried does not aim to produce a monotonous reproduction. Indeed, what singles out his working method is the constant changing and retouching of the initial pictorial idea at the start of the printing process. This deliberate "manipulation" during the various stages of printing means that when viewing the images as a series, one sees a sequence of different compositions with similar basic forms and colours. However, the separate "sequences" – stills in a constant chain of motion – are not placed in a set order. This work of 1999 belongs to one of these "screen-print choreographies". The title "Manuela Breaks a Glass" is from a piece of prose by the artist and opens up wider opportunities for viewers when they interpret the picture. It provides scope for imaginative associations and free ways of seeing, including (supposed) atmospheres and symbols of clouds. Markus Schön

Silvia Grossmann

Westwärts 5–8 Westwards 5–8, 2006
Schwarzweißfotos auf Baryt black and white photographs on barite, je each 39,5 x 55,3 cm

Die Schiffsreise findet im November 2005 statt und geht von La Spezia über Marseille, Barcelona und Valencia nach Newark, New Jersey. Zwei Wochen verbringt Silvia Maria Grossmann auf dem Frachter, besichtigt seine Einrichtungen, fotografiert Besatzungsmitglieder, denen sie später Abzüge senden wird. Zugleich entsteht eine Serie, in der keine Menschen vorkommen: „Westwärts". In die 22 Aufnahmen geht ein, was die Künstlerin zu der Fahrt inspiriert hat und welchen Eindrücken sie ausgesetzt gewesen ist: die Arbeit, wie sie sich in den Hafenanlagen und den Containerburgen an Bord vergegenständlicht hat; die Langsamkeit, mit der man auf einen immer gleichen Horizont zufährt, in dessen Unendlichkeit der Blick Halt sucht; die Bewegungen am Wasser und am Himmel, die ständig neue Formen hervorbringen. Im Nacheinander und im Nebeneinander treten die Gegensätze hervor: Das Gewirr der gewaltigen Kräne an den Kais wird abgelöst von der Eintönigkeit der Reise; die Geometrie der Containerstapel steht gegen die Wölbungen und Kräuselungen der Wolken und der Meeresoberfläche; ein ständiges Vorwärts scheint den Bildern eingeschrieben. Das Vermögen des Fotografischen liegt auch in der Beherrschbarkeit des Gleichzeitigen. Timm Starl

The voyage was in November 2005 and started in La Spezia, travelling via Marseille, Barcelona and Valencia to its destination in Newark, New Jersey. Silvia Grossmann spent two weeks on the freighter, looked round the ship and photographed members of the crew, later sending them copies. At the same time she created a series in which there are no people: "Westwards". The twenty-two photographs reflect what inspired the artist to embark on this voyage and her impressions during the trip: the visible evidence of work revealed at the docks and in the stacked shipping containers on board; the slow, relentless movement towards the same horizon, where one's eyes seek something to latch onto in its boundlessness; the movements of the water and sky, perpetually creating new forms. Side by side and in a sequence, these contrasts emerge: the complex maze of the massive cranes on the quays switches to the monotony of the journey; the geometry of the stacked containers is contrasted with the undulating, rippling shapes of the clouds and sea. The images seem ingrained with a sense that they are constantly moving forwards. The power of photography also lies in its ability to capture simultaneous occurrences. Timm Starl

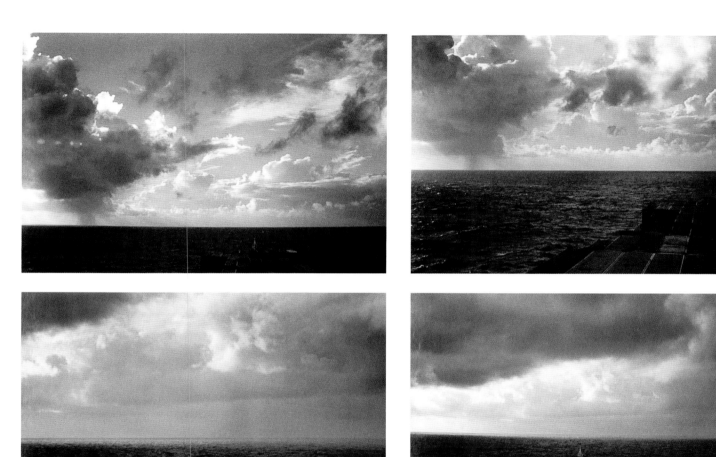

Ursula Heindl

O.T. Untitled, 1993
Öl auf Holz oil on wood, 120 x 90 cm

Die Wiener Künstlerin Ursula Heindl versteht ihre abstrakte Malerei als
„Forschungsreise" in das Mittel der Farbe selbst. Rot, das neben Grün im
Zentrum ihrer Farbexpeditionen steht, setzt sie dabei in all seinen Tönen ein, von
hell bis dunkel, innerlich bis expressiv, zart bis kraftvoll. Seit Anfang der 1990er
Jahre hat sie sich zudem von der rechtwinkeligen Bildfläche distanziert, um sich
der Ellipse als barocker und organischer Form zu widmen. Heindls flammende
rote „Wolkenbilder" verbinden die sinnliche Pinselführung der Künstlerin mit
einem dynamischen Über- und Ineinanderschichten von Farbe, was der Ober-
fläche gleichzeitig plastische Tiefe und haptische Materialität verleiht. Die
Gemälde erinnern an die irdischen Elemente und Naturgewalten ebenso wie
an sakrale Bezüge zu Himmel oder Hölle. Durch die offene und frei im Raum
flottierende Anbringung der Bilder im Innenraum oder im Freien, am Boden oder
an der Wand nehmen sie zudem Bezug auf ihren Ort, in den sie sich einfügen, wo
sie aber auch zum optischen Störfaktor werden können. Dabei machen sie nicht
nur die realen räumlichen Bedingungen bewusst, sondern erweitern auch die
Imaginationsmöglichkeiten beim Betrachten. Elisabeth Fritz

The Viennese artist Ursula Heindl sees her abstract painting as an "exploratory trip"
into colour itself. Together with green, the colour red is at the very heart of her colour
expeditions and she uses it in all its tones – from light to dark, contemplative to
expressive, subtle to bold. Since the early 1990s she has also distanced herself from
the rectangular picture and adopted the baroque and organic form of the ellipse.
Heindl's flaming red "cloud pictures" combine the artist's sensual brushwork with a
dynamic layering and merging of paint, giving the surface a sense of three-dimensional
depth and tactile materiality. The paintings recall earthly elements and forces of nature
as well as conveying religious allusions to heaven and hell. These pictures are shown
freely floating in space, inside or outside, attached to the floor or the wall. In this way
they are related to the place into which they have been integrated, although they can
also become an optical disruption. However, in this setting they not only make viewers
aware of the real spatial conditions but also expand their scope for imagination while
they are gazing. Elisabeth Fritz

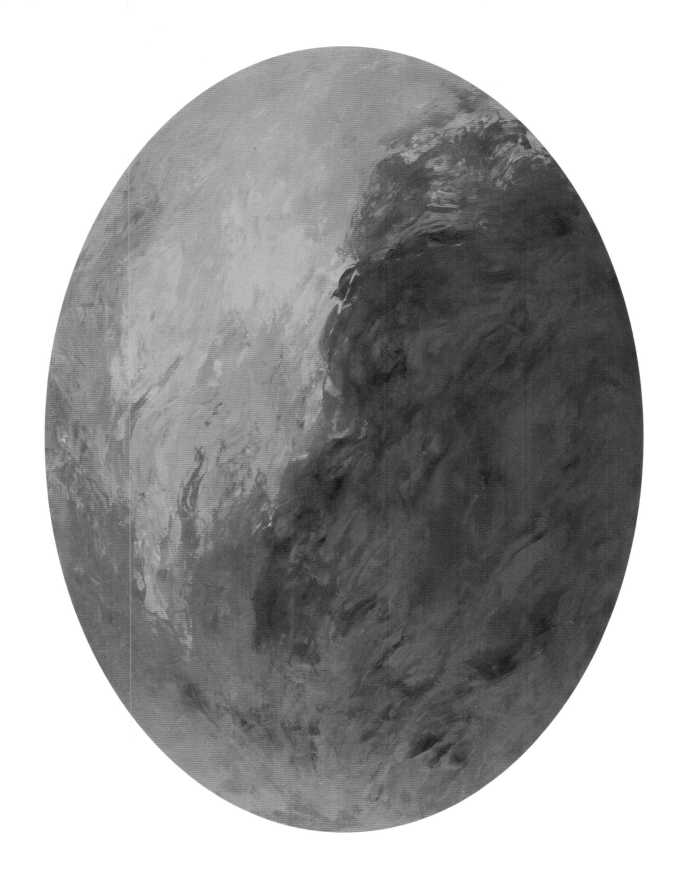

Karl Hikade

Sky, 1972
Eitempera, Acryl auf Molino egg tempera, acrylic on molino, 110 x 115 cm

Schichtenweise übereinander gelegte Pastelltöne in Rosa, Hellblau, Türkis und Ocker visualisieren das Naturerlebnis einer sich vor uns aufbauschenden Wolkendecke, gleichsam eine Beschreibung unglaublich weicher, federleicht schwebender Wolkenschwaden. Mit großer Sensibilität fixiert Karl Hikade die sich in ständiger Veränderung befindlichen, ziehenden Wolkenfetzen, aber auch Licht und Luft. Unendliche Varianten des Lichtspiels lassen nicht nur den Schluss auf eine bestimmte lichte Wetterstimmung zu, sondern vermitteln auch den Eindruck einer psychischen Gestimmtheit.

Das 1972 von Karl Hikade gestaltete Gemälde spürt seiner Biografie nach: In Wien geboren, in England aufgewachsen, reiste der Maler oftmals mit dem Flugzeug und bannte das Erlebnis der von weit oben beobachteten Natur auf Leinwand. Im Lauf der folgenden Jahrzehnte entwickelte Hikade eine raumbezogene, installative Malerei. Noch immer von Landschaftsformen ausgehend, gestaltet er abstrakte Kompositionen, die mehr als nur bemalte Fläche sein wollen. Die Bedeutung der Räumlichkeit, die Hikades Installationen seit den frühen 1990er Jahren kennzeichnet, lässt sich in den frühen Gemälden bereits als beständiges Suchen nach Tiefenwirkung belegen. Alexandra Matzner

Layers of pastel shades in pink, pale blue, turquoise and ochre visualize an experience in nature of a blanket of cloud rising up before us, like a description of incredibly soft, gossamer-light wafting clouds. With great sensitivity, Karl Hikade has frozen the constantly changing, moving wisps of cloud as well as the light and the air. The endless variations in this play of light not only convey the impression of bright weather conditions but also suggest a state of mind.

Karl Hikade's painting of 1972 traces his biography: born in Vienna, the artist grew up in England and often travelled by plane. High up in the skies he would capture on canvas his observations from nature. During the following decades, Hikade developed a space-related, installational approach to painting. Still starting out with the forms of landscape, he composed abstract compositions that aspire to being more than just a painted surface. The significance of space, which has characterized Hikade's installations since the early 1990s, can be identified in his early paintings as a constant quest for the effect of depth. Alexandra Matzner

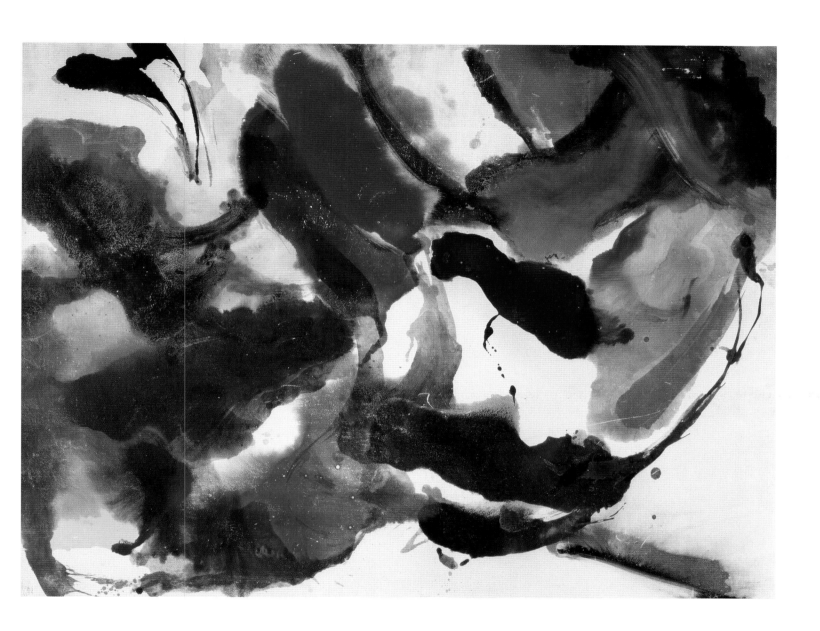

Gottfried Höllwarth

Grüner Wolkensitz (Modell) Green Cloud Seat (Model), **1980**
Holz, Holzfaserplatte wood, wood fiber plate, 81 x 76 x 76 cm
Leihgabe des Künstlers loan of the artist

Gottfried Höllwarth erarbeitete zwischen 1979 und 1980 für den dritten Wiener Gemeindebezirk das Projekt „Grüner Wolkensitz". Als „Kunst(werk) am Bau" verbindet es Integration von zeitgenössischer Kunst im öffentlichen Raum, soziales Anliegen des Künstlers und Benutzbarkeit durch die AnwohnerInnen des Wohnhauses, in dessen Mitte die podestartige Skulptur aufgestellt wurde. Das Modell aus mitteldichten Holzfaserplatten zeigt einen runden Aufbau in der Mitte, über den sich eine weich geschwungene Wolkenformation aufbauscht, sowie zwei von kleinen Wolken bekrönte Säulen. Naturform Wolke und Kunstform Turm bzw. Podest verbinden sich in dieser sozialen Plastik, wobei die Ausführung in grünem Osttiroler Serpentin ohne die als „Wolkenfänger" bezeichneten Türme auskommt.

Die sich ständig verändernde Natur einfangen kann als Leitmotiv in Gottfried Höllwarths Schaffen Ende der 1970er und Anfang der 1980er Jahre bezeichnet werden. Aus dem Gegensatz zwischen Wandel/Wolke und Beständigkeit/Stein schöpfte der Bildhauer die Grundidee für eine Skulptur, die einlädt, als Sitzgelegenheit verwendet zu werden. Nicht das Denkmalhafte, das Erhöhen ist Zweck der Unterkonstruktion, sondern sie soll als eine Einladung zur Kommunikation verstanden werden. Durch zwangloses Treffen der AnrainerInnen im Hof, gemeinsames Sitzen auf den Stufen und den dabei erfolgenden nachbarlichen Austausch wird die Skulptur zu einem Ort der Begegnung. Alexandra Matzner

Between 1979 and 1980, Gottfried Höllwarth worked on the project "Green Cloud Seat" for the third district in Vienna. As part of the project "Kunst am Bau", it combines the integration of contemporary art in a public space, the artist's social interests and practical use for those living in the apartment block where the sculpture is exhibited. The model is made of medium density fibreboards and has a round structure in the centre, with a soft, undulating cloud formation billowing above it, and two columns surmounted by small clouds. The cloud's natural form and the art form of the tower and base are thus combined in this social sculpture. The final version, however, is made of green serpentine from East Tyrol and omits the towers that are termed "cloud catchers".

Capturing nature's constant changes was the dominant theme in Gottfried Höllwarth's work in the late 1970s and early 1980s. Out of the contrast between the transience of clouds and permanence of stone, the sculptor devised the idea of a sculpture that can be used as a seat. The lower part of the construction does not aim to evoke a monumental or elevated effect but is an invitation to communication. Residents of the apartments bump into each other in the courtyard, sit on the steps and chat with their neighbours, thus transforming the sculpture into a place where people congregate and meet. Alexandra Matzner

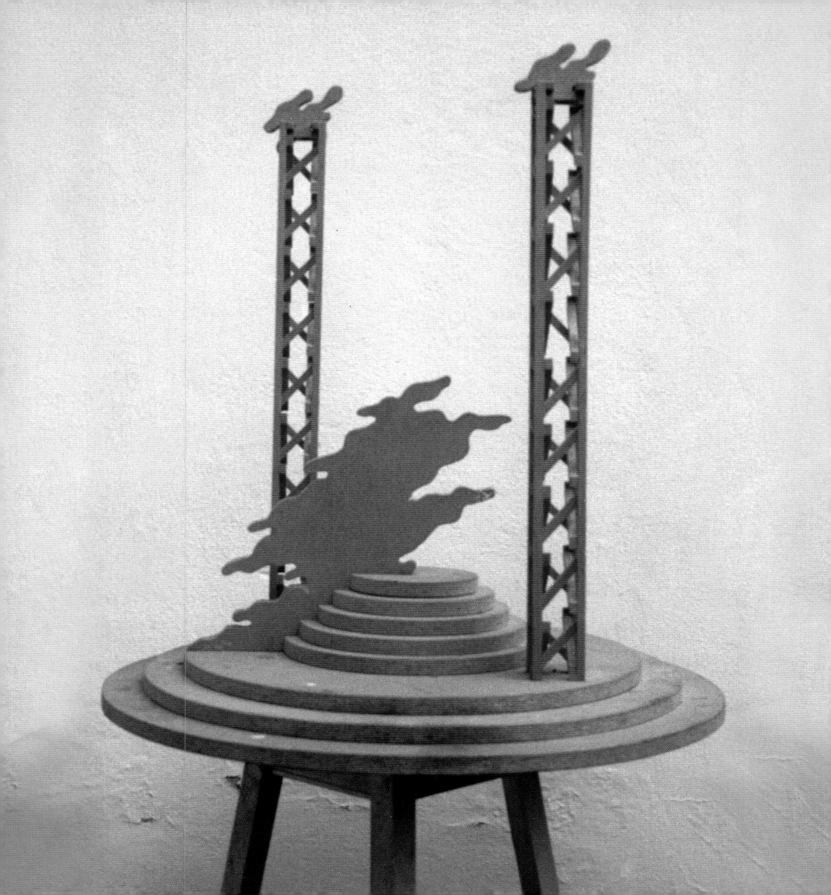

Lisa Huber

„Von Plage und Strafe Gottes" aus der Serie „Das Narrenschiff"
"Of God's Plagues and Punishments" from the series "The Ship of Fools" **2001**
Farbholzschnitt mit Acryl-Untermalung auf Papier woodcut with arcrylic
underpainting on paper, **Druckplatte** printing plate **39,7 x 30,7 cm**

„Feuer vom Himmel" wird es auf die Erde regnen! Das Bild steht in vielen
Kulturen, so auch in der christlich geprägten, für einen drastischen Akt göttlicher
Strafe. Die Bedrohung kommt in Lisa Hubers Holzschnitt zunächst ganz
traditionell vom Himmel, hier konkret in Form einer heraufziehenden
dunkelblauen Wolke, aus der bereits die gelb-orangen Flammen züngeln und die
bevorstehende Zerstörung ankündigen. Die Künstlerin bringt das Menetekel
gestalterisch auf den Punkt. Ihre Arbeit mit dem Titel „Von Plage und Strafe
Gottes" stammt aus der Serie „Das Narrenschiff", die von dem berühmten
gleichnamigen Werk des Humanisten Sebastian Brant inspiriert ist, dem
weitestverbreiteten moralisch-satirischen Lehrgedicht seiner Zeit im
deutschsprachigen Raum. Der Autor bemüht für seine Warnungen im Text den
alttestamentarischen Rachegott, was sich auch in den Illustrationen
widerspiegelt. Lisa Huber greift die textlichen und bildlichen Vorgaben zwar auf,
doch nur, um dadurch inspiriert einen neuen, zeitkonformen Ausdruck zu
formulieren: Eine Wolke, die wie eine machtvolle symbolhafte Geste wirkt, bringt
Unheil. Es ist das Feuer, das zerstören wird und auch dadurch eine Reinigung im
Sinne einer höheren Ordnung vornimmt. Der unendliche Gott bleibt unsichtbar.
Die Künstlerin nimmt damit in der Bildgestaltung eine Abstrahierung vor, die sich
nicht nur in der einfachen Formen- und Farbsprache des Holzschnitts sowie im
knappen Bildausschnitt und dem Detailreiz des Handabzugs äußert. Lisa Huber
geht weiter: Mit der formal reduzierten Bildsprache konzentriert sie den Ausdruck
und vergrößert bewusst den Deutungshorizont im Hinblick auf das „Feuer", das
aus dem „Ort/Nichtort Wolke" über die Menschen kommen wird. Franz-Xaver Schlegel

"Fire from the sky" will rain down on the earth! In many cultures, including those
shaped by Christianity, this image reflects a drastic act of divine punishment. Following
this tradition, in Lisa Huber's woodcut the threat also comes from the sky and takes on
the form of a dark blue cloud with flickering yellow and orange flames heralding
approaching disaster. The artist has succinctly captured this warning sign in her
composition. Her work entitled "Of God's Plagues and Punishments" is from the
series "The Ship of Fools" and was inspired by the humanist Sebastian Brant's work
of this name. This was the most widely disseminated moralistic, satirical didactic
poem in the German-speaking world at that time. The author called upon the Old
Testament's vengeful God for his warnings in the text and this emerges clearly in the
illustrations. Lisa Huber may take up the ideas from text and image but only as a
source of inspiration to create a new image more appropriate to today: a cloud, like a
powerful and symbolic gesture, is bringing disaster. It is fire that will destroy but will
also purify, when seen in the context of the higher order of things. The infinite God
remains invisible. The artist abstracts elements for her composition and this is
reflected in the woodcut's simple language of forms and colours, the tightly cropped
picture and the details arising from printing by hand. Lisa Huber goes further: the
formal reduction of the pictorial language concentrates the expressiveness and
deliberately adds a wider scope for interpreting the "fire" that will rain over humanity
from the "place/non-place of the cloud". Franz-Xaver Schlegel

1 Sebastian Brant, The Ship of Fools, trans. by Edwin Hermann
Zeydel (Dover Publications, 1988).

Gerhard Hutar

Landschaften mit Einschnitten Blots on the Landscape, 1976
Mischtechnik auf Papier mixed media on paper, 83,5 x 105 cm

Die Arbeit stammt aus einer Werkgruppe, mit der Gerhard Hutar die Eindrücke
mehrerer Amerikareisen künstlerisch umsetzte. Im Fokus seiner Beobachtungen
stand das hemmungslose Eingreifen des Menschen in die Natur und die rück-
sichtslosen Veränderungen an ihr. Das Bild zeigt die Konstruktionsschichten
einer Straße, die in übereinandergelegten, flächigen Ebenen den streng parallel
ausgerichteten Vordergrund bildet. Anfangs- und Endpunkt liegen außerhalb des
Bildes und verweisen damit auf die endlos fortschreitende Umweltzerstörung.
Das technoide Menschenwerk steht im direkten Kontrast zur hügeligen Land-
schaft im Mittelgrund. Wie eine nicht mehr benutzte alte Fahrspur ziehen sich
leicht schräg Streifen über den Hügel, die gleichwohl an die Planung einer
zusätzlichen Schnellstraße und daher an einen weiteren Einschnitt in die Natur
erinnern können. Der in die Fläche gedrückte Wolkenhimmel negiert die Tiefen-
entwicklung, lediglich der linke Hügel spielt auf den Raum an. Die Schrägstellung
der Wolken pointiert nochmals die Diskrepanz zwischen technischem Fortschritt
und Bewahrung der Umwelt und weist darüber hinaus auf das sensible
Gleichgewicht zwischen Ökonomie und Ökologie hin. Johannes Karel

This landscape is from a group of works that Gerhard Hutar based on impressions
from several trips to America. His observations focused on man's unrestrained
tampering with nature and his thoughtless changes. The picture shows the layers
in a road's construction, forming the strict parallels of the foreground in a stacked
series of planes. The beginning and end are outside the picture, alluding to the steady
destruction of the environment. This technical work of humanity directly contrasts with
the hilly landscape in the middle ground. Stripes lead across the hill in a slight diagonal,
looking like old tracks that have fallen into disuse. Yet these could also be a reminder
that another highway is planned and thus more meddling with nature. The planar
cloudy sky negates any effect of depth and it is only the hill on the left that evokes a
sense of space. The clouds' diagonals once again point out the discrepancy between
technical progress and protecting the environment, also alluding to the subtle balance
between economics and ecology. Johannes Karel

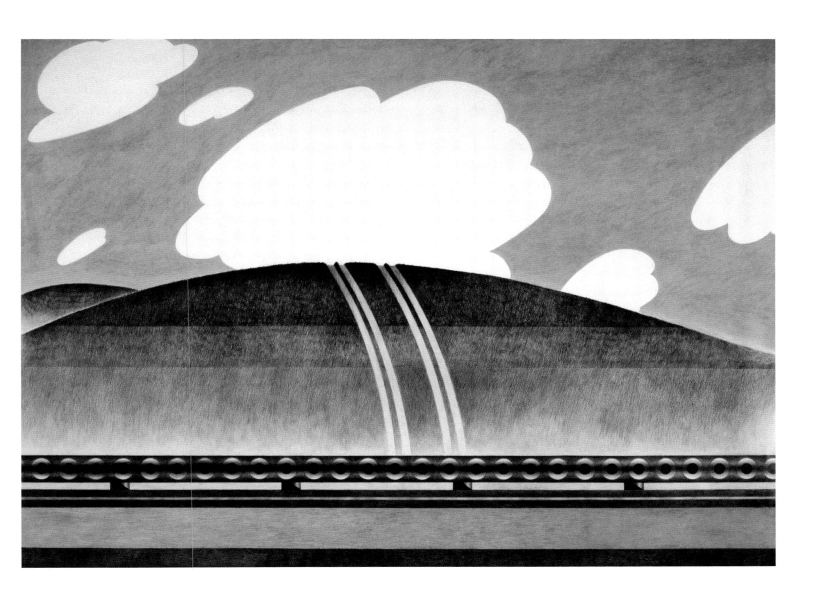

Gerhard Jaschke

Austria forever, 2002
Collage auf Papier collage on paper, 41,5 x 31,5 cm

In der Schule haben wir gelernt, dass Österreich die Form einer Keule hat. Zwei minutiös ausgeschnittene Österreich-Keulen collagiert Gerhard Jaschke über-einanderliegend, die obere gefüllt mit unnatürlich steil aufsteigenden Wolken-bändern, die untere zeigt eine Landkarte des Grenzgebiets zwischen Polen, Ungarn, Rumänien und der Ukraine. Die ehemaligen Kronländer erinnern an die Monarchie, gleichzeitig aber an wiedergewonnene Nachbarn seit der politischen Neuordnung nach 1989. Jaschke, mehr Literat als bildender Künstler, spielt gern mit Wörtern. Die Lettern am unteren Bildrand „Zu ebener Erd' und im elften Stock in den Wolken: Austria forever!" spielen mit dem Titel der Nestroy-Posse „Zu ebener Erde und erster Stock oder Die Launen des Glücks" (1835). Nestroy teilt in seinem Stück die Bühne horizontal in zwei Ebenen und gibt gleichzeitig Einblick in das verschwenderische Leben der Familie Goldfuchs in der Beletage und, ein Geschoss tiefer, in die ärmliche Unterkunft der Familie Schlucker. Wohnt Familie Goldfuchs im heutigen Österreich in der Chefetage eines Wolkenkratzers? Das Schicksal erfährt bei Nestroy eine überraschende Wendung. Die Armen werden reich und die Reichen arm. Austria forever? Martina Griesser-Stermscheg

At school we learnt that Austria is in the shape of a club. Gerhard Jaschke has collaged two meticulously cut out Austria "clubs", one above the other. The Austria at the top is filled with bands of clouds, rising at an unnaturally steep angle; the lower country shows a map with the border region between Poland, Hungary, Rumania and the Ukraine. These former crownlands recall the Austro-Hungarian Monarchy as well as neighbours that have been regained since 1989 in the new political order. More writer than visual artist, Jaschke likes playing with words. At the base of the picture there is an inscription that can be translated as: On the ground floor and in the eleventh storey in the clouds: Austria forever! This is a play on the title of the Nestroy farce "Zu ebener Erde und erster Stock oder Die Launen des Glücks" (On the Ground Floor and First Storey or the Whims of Fortune) (1835). In his play, Nestroy divided the stage into two levels and at the same time provided an insight into the extravagant life of the Goldfuchs family on the bel étage and the miserably poor dwellings of the Schlucker family below. Does the Goldfuchs family live on a skyscraper's executive floor in Austria today? Fate takes an unexpected turn in Nestroy's play. The poor family become rich and the rich people poor. Austria forever? Martina Griesser-Stermscheg

Hans Jöchl

Wolkenbild Cloud Picture, **1985**
Farbstift auf Papier colour pencil on paper, **94,5 x 71 cm**

„Die Sonne erschien auf einen Augenblick zwischen den schüchternen Wolken. –
[...] Wir hieben und schaufelten an den Rändern herum, rafften gafften erschöpft
in perlmutternem perlmutternes Gewölk ..." (Arno Schmidt, Leviathan oder Die
Beste der Welten, 1949). Dieses Zitat erscheint auf der Einladung zu Hans Jöchls
Ausstellung „Wolken. Gekräuseltes Leben" von 1994 und charakterisiert sehr
treffend die behutsame Auseinandersetzung mit dieser Thematik, die den Künstler
seit 1977 beschäftigte. Nach eigenen fotografischen Vorlagen (Polaroid) schuf
Jöchl anfänglich mit Acryl, später mit Farbstiften Kompositionen der Wolken-
formationen, wobei die Verwendung von Farbstiften eine wesentlich eindring-
lichere Vorstellung von der Transluzidität dieser schwebenden Gebilde vermittelt.

Im vorliegenden Blatt erinnert der Ausblick in einen leicht bewölkten Himmel an
ein barockes Deckenfresko, aus dem die Putti entschwunden sind. Eine sehr
dünne Farbschicht korrespondiert mit der etwas rauen Oberfläche des Papiers
und verleiht der Flüchtigkeit des Bildinhaltes eine besondere Steigerung.

Im Werk Hans Jöchls stellt die Serie der Wolkenbilder eine gewichtige Position
dar, vergleichbar den thematischen Auseinandersetzungen mit Traumwelten und
Gedichten von Christine Lavant, die ebenfalls von subtiler Einfühlung geprägt
sind. Michaela Nagl

"The sun appeared for a moment between the timid clouds. [...] We hacked and
shovelled around the wheels, gawping with exhaustion at the mother-of-pearl clouds"
(Arno Schmidt, "Leviathan" or "The Best of Worlds", 1949). This quote was published
on the invitation to Hans Jöchl's exhibition "Clouds: Rippled Life" of 1994 and aptly
reflects the artist's careful consideration of this subject that has interested him since
1977. Based on his own Polaroids, Jöchl created compositions showing cloud
formations – first using acrylic and later with crayons. Of these works, his images in
crayon convey a more convincing impression of the translucency of these floating forms.

This view recalls the light clouds in the sky on a baroque ceiling fresco, where the
putti have vanished. The thin application of colour corresponds with the rather rough
surface of the paper and enhances the fleeting, ephemeral qualities of the subject.

In Hans Jöchl's work the series of cloud pictures hold an important position, comparable
with his studies of the dream worlds and poems by Christine Lavant, which reflect the
same subtle sensitivity. Michaela Nagl

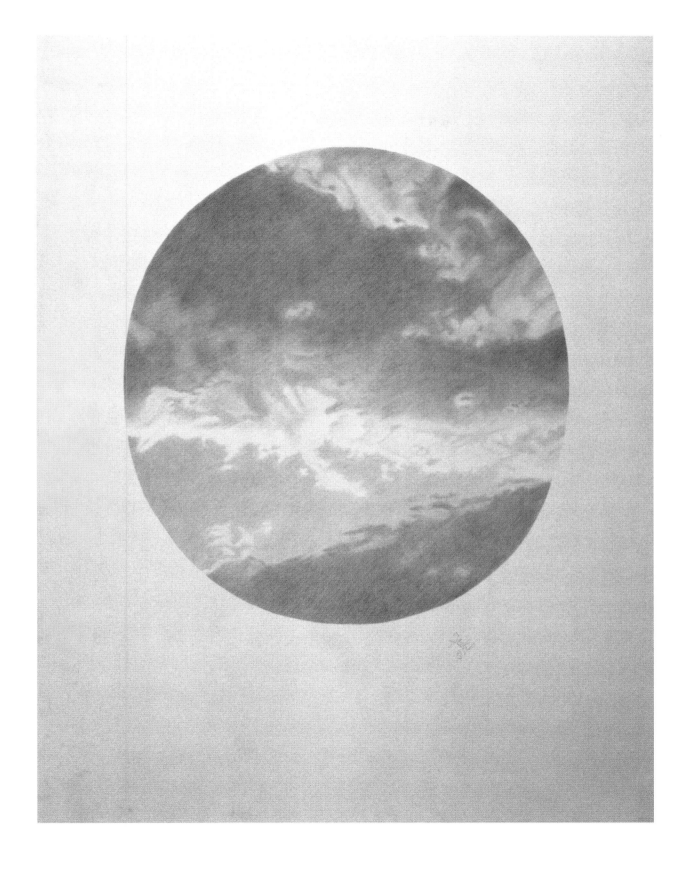

August Kampfer

O.T. Untitled, 1969
Bleistiftzeichnung auf Papier pencil drawing on paper, 21 x 29 cm

Diese akkurat ausgeführte Bleistiftzeichnung entstand noch während der
Studienzeit von August Kampfer an der Akademie der bildenden Künste Wien in
der Klasse von Wolfgang Hutter. Der Phantastische Realist bildete seine
Studenten zu akademischen Zeichnern, indem er sie immer wieder anhielt, ihre
Zeichentechnik zu perfektionieren. Aus seiner Perspektive sei sie der Grundstein
eines jeden Gemäldes. Mit Hilfe von subtilsten Abstufungen der Bleistiftspur,
einer nuancierten Verteilung von Hell und Dunkel erzielt Kampfer den Eindruck
von Licht und Schatten und schafft so eine dreidimensionale Wiedergabe eines
phantastischen Wolkenberges. Die Cumulus-Wolke entwickelt sich aus Dunst und
Nebel, aber auch aus Spiralenformen. Das Gewölk kann phantasievolle, amorphe
Gestalten annehmen, sich verändern und entfalten, als ob es einen eigenen
Willen hätte. Unbelebtes und Belebtes vermischen sich, gehen ineinander über
oder ineinander auf. August Kampfer beschäftigte sich intensiv mit den Fragen
nach spannungsvollen Bezügen zwischen Chaos und Ordnung, nach Form und
Verformung. Getreu seiner Überzeugung von der ständigen Veränderung der
Umwelt, von einem Streben der Ordnung ins Chaos wird die Wolke zu einem
Sinnbild des Wandels. Alexandra Matzner

August Kampfer drew this accurate drawing while he was still studying at the
Academy of Fine Arts in Vienna in Wolfgang Hutter's class. This Fantastic Realist
trained his students as academic draughtsmen, perpetually urging them to perfect
their drawing skills. He believed that drawing was the foundation stone of every
painting. With the subtlest gradations of pencil marks and light and dark distributed in
delicate nuances, Kampfer evoked the impression of light and shadow creating a
three-dimensional representation of a fantastical cloud formation. This cumulus cloud
has evolved from mist or fog but is also composed of spiral shapes. The cloud takes
on imaginary, amorphous forms and can change and unfurl as if of its own will.
Inanimate and animate shapes form a swirling mixture, merging together and
engulfing one another. August Kampfer was fascinated by the tension between chaos
and order, between form and deformation. True to his conviction about the constantly
changing environment and aspiring to impose order in chaos, the cloud becomes a
symbol of change. Alexandra Matzner

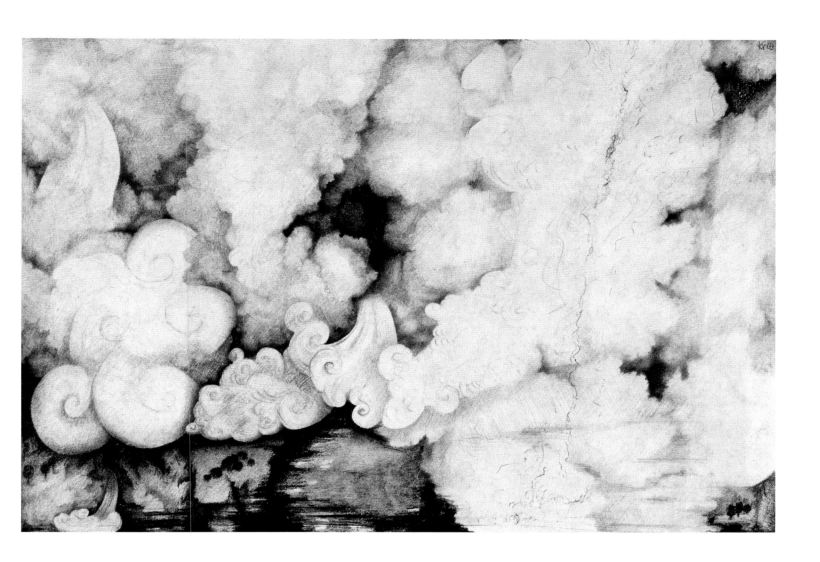

Herwig Kempinger

070499-300699, 1999

Computerfotografie auf Acrylglas und Aluminium
computer photograph on acrylic glass and aluminum, 200 x 130 cm

Herwig Kempinger fotografierte unterschiedliche Wolkenformationen zu verschiedenen Tageszeiten und in allen möglichen Beleuchtungssituationen. Mit Hilfe des Computers wurden einzelne Fotoausschnitte dann mit anderen kombiniert. Die Ergebnisse spiegeln weder einen konkreten Ort noch eine konkrete Stunde, sondern addieren sich zu einem Bildraum, dessen evozierende Plastizität und subtile Schattierungen mit Assoziationsfähigkeit und Formgefühl des Betrachters spielen.

Doch dienen sie Kempinger keinesfalls als „Equivalents" im Sinne von Alfred Stieglitz: Weder persönliches Empfinden noch transzendentale Erkenntnis wird im Werden und Vergehen der ausgefransten oder zusammengeballten Formationen gesucht oder verkörpert. Dass die Dunstgebilde vielen Künstlern (auch) als Möglichkeit dienten, bestimmte, im Bild erwünschte Stimmungen zu kreieren oder zu intensivieren, nutzt er als Referenz. Weniger Kempinger selbst spielt durch die Anordnung, Farbigkeit und Plastizität der Wolkenberge mit den Gefühlen des Betrachters, als dass dieser schon „vorgeprägt" ist durch die mehr oder weniger bewusste Erinnerung an Gemütslagen in Bildern alter Meister. Monika Faber

Herwig Kempinger photographed a variety of cloud formations at different times of day and in all sorts of light situations. Using a computer he then combined separate sections from the photo with others. The results reflect neither a definite place nor a particular time but in sum create a pictorial space that evokes three-dimensionality and is imbued with subtle shades, playing with the viewer's sense of form and capacity for association.

Yet for Kempinger these are not "Equivalents" in the manner of Alfred Stieglitz. He doesn't aspire to or embody personal emotion or transcendental knowledge in the growth and dispersal of these wispy or billowing formations. The fact that many artists used these vaporous forms as an opportunity to create or intensify a desired mood in a picture is something Kempinger uses as a reference. In the arrangement, colour and three-dimensionality of these towering clouds, Kempinger is not himself playing with the viewer's feelings but these have in fact already been moulded by a more or less conscious recollection of moods evoked in pictures by the Old Masters. Monika Faber

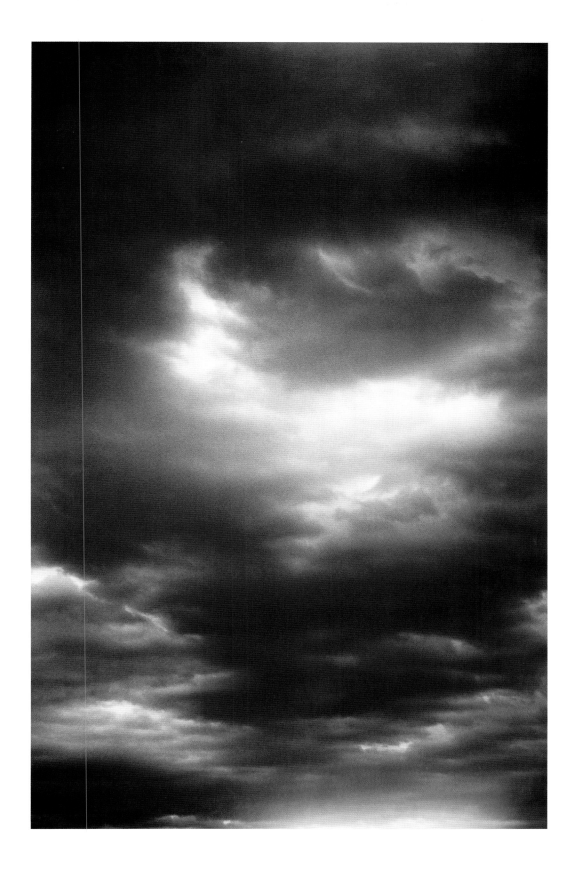

Alfred Klinkan

Tradition der Wolke Tradition of the Cloud, **1985**
Siebdruck auf Papier screenprint on paper, 49,9 x 65,6 cm

Alfred Klinkan lässt die Sehnsucht des Künstlers nach dem Unmöglichen in der mythologischen Figur des Orpheus sichtbar werden. Er setzt die Erzählung des größten Sängers der griechischen Mythologie in einem Zyklus von 12 Blättern um, wobei er eine Gliederung in die Bereiche „Aufgaben", „Abenteuer" und „Botschaft" vornimmt. Das vorliegende Blatt „Tradition der Wolke" gehört dem Bereich „Botschaft" an. Im Begleittext zur Edition beschreibt Klinkan eine Welt, die als Gegenpol zur Wirklichkeit funktioniert und in der sich Orpheus „schwebend der Tradition entmächtigt".

Der Orpheus-Zyklus entstand während Klinkans produktivster Schaffensphase in Antwerpen. Tiere, menschliche Wesen sowie Misch- und Fabelwesen bevölkern das Gesamtwerk des Künstlers und treten stets in einem friedlichen Mit- und Nebeneinander auf. Hier liegen der „Wolkenbläser" und die „Katzenathene", wie Klinkan seine Protagonisten bezeichnet, in trauter Einheit auf einer Wolke. Der intensive rot-blaue Farbakkord kontrastiert mit dieser ruhigen Szenerie.

Die kräftige Farbigkeit und eine wilde, heftige Malweise sind Charakteristika jener Gruppe von Malern, die Anfang der 1980er Jahre als sogenannte „Neue Wilde" oder Vertreter der „Neuen Malerei" bezeichnet wurden. Zu ihnen zählen, neben Alfred Klinkan, Siegfried Anzinger, Alois Mosbacher, Hubert Schmalix, Gunter Damisch, Roman Scheidl, Herbert Brandl und Hubert Scheibl. Michaela Nagl

Alfred Klinkan gives visual expression to the artist's yearning for the impossible in the mythological figure of Orpheus. He interprets the story of Orpheus, the greatest singer from Greek mythology, in a series of twelve prints, dividing this into the sections "Tasks", "Adventure" and "Message". This print, "Tradition of the Cloud", belongs to the section "Message". In the text accompanying the edition, Klinkan describes a world that functions in the opposite way to reality and where Orpheus "floats away from the power of tradition".

Klinkan created the Orpheus series during his most productive phase in Antwerp. Animals, human figures, and hybrid and mythical creatures populate the artist's œuvre and are shown in peaceful coexistence. Here we see two of Klinkan's protagonists, called "Cloud-Blower" and "Cat Athene", lying in close union on a cloud. The combination of intensive reds and blues contrasts with the calm scenery.

Bold colours and wild, vigorous painting are characteristics of the group of painters dubbed the "Neue Wilde" (New Wild Ones), who were regarded as representatives of the "New Painting" in the early 1980s. Besides Alfred Klinkan, these artists include Siegfried Anzinger, Alois Mosbacher, Hubert Schmalix, Gunter Damisch, Roman Scheidl, Herbert Brandl and Hubert Scheibl. Michaela Nagl

Claudia Klučarić

Drüber, unwissendes Blau, der Himmel (nach Christa Wolf,
Kein Ort. Nirgends) The Unknowing Blue of the Sky Above
(after Christa Wolf, No Place on Earth), **1995**
Bleistift und Buntstift auf Papier pencil and coloured pencil on paper, 35,1 x 49,7 cm

„Drüber, unwissendes Blau, der Himmel" ist Teil einer Serie von drei Zeich-
nungen, deren andere den Titel „Manchmal, wenn sie luftknapp auf ihrem Bette
liegt, denkt sie, sie brauche doppelt soviel Luft wie andere Menschen, als
verwende ihr Körper einen Vorrat für heimliche Zwecke" (I & II) tragen.

Dieser Satz, wie die Bezeichnung des hier ausgestellten Blattes ein Zitat aus
Christa Wolfs Erzählung „Kein Ort. Nirgends", verweist auf den in der Biografie
der Künstlerin liegenden Ausgangspunkt der Arbeiten: allnächtlich auftretende
und als akut lebensbedrohend empfundene Asthmaanfälle.

Das vorliegende Blatt fasst die zutiefst existentielle Thematik in ein überwiegend
abstraktes Farb- und Formgefüge, das sich assoziativ folgendermaßen erschließen
lässt: Die beiden Rottöne stehen für das Leben, einerseits in seiner körperlich-
rohen, gleichsam ‚blutigen' Form, andererseits als Quelle von Kraft und Energie,
die Nichtfarbe Schwarz für die absolute, negative Leere und die Angst davor,
während die streumusterartig darüber verteilten Blütenformen die Hoffnung
repräsentieren.

Blumen, vielleicht aber auch Sterne: Selbst wenn dieser Himmel nur als Idee
existiert, so ist diese doch eine rettende. Harald Jurkovic

"The Unknowing Blue of the Sky Above" is part of a series of three drawings.
The others have the title "Sometimes when she is lying short of breath in bed she
thinks that she needs double the amount of air as others, as if her body is using a
supply for secret purposes" (I & II).

Like the title of the exhibited work, this sentence is quoted from Christa Wolf's book
"Kein Ort. Nirgends" (No Place on Earth). It alludes to what triggered these works:
asthma attacks that the artist suffers each night and experiences as acutely life-
threatening.

The work shown here captures this subject that is so profoundly existential in a
predominantly abstract structure of colours and forms. These can be interpreted as
follows: the two red shades reflect life, both in its raw and physical, almost "bloody",
form and as a source of strength and energy; the non-colour black signifies the total,
negative emptiness and fear of this, and the flower forms strewn across the picture
represent hope. These flowers, perhaps even stars, show that even if these heavens
exist only as an idea, they can still save you. Harald Jurkovic

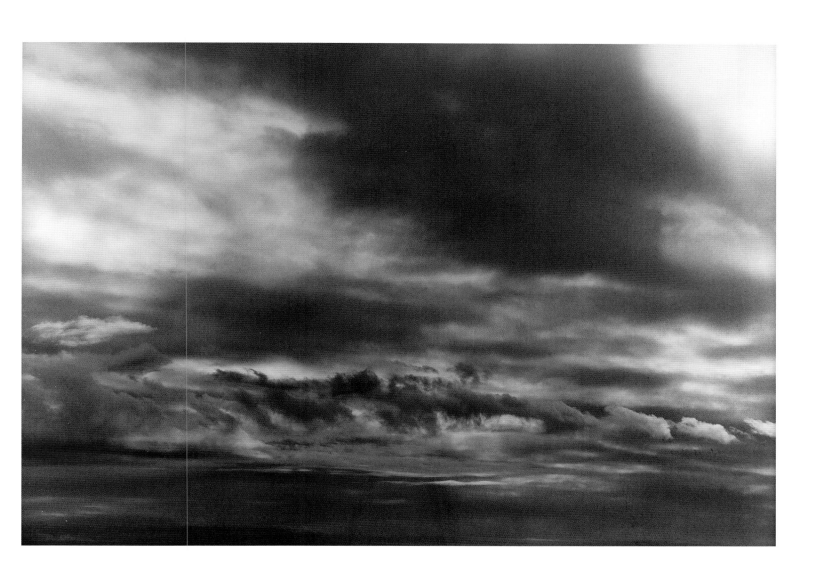

Christine Meierhofer

Florian (Raum mit gestohlenem Bild: C.D. Friedrich, Nebelschwaden, 1820)
Florian (Room with stolen picture: C.D. Friedrich, Wafting Mist, 1820), **1997**
Inkjet-Print nach Computer-Montage inkjet print of a computer montage, **65 x 100 cm**

Christine Meierhofer spielt mit der Wunschvorstellung so manches Kunstlieb-
habers, wenn sie vorschlägt: „Wollten Sie nicht immer schon Ihr Wohnzimmer
mit einem echten Caspar David Friedrich schmücken oder Ihre neueste Eroberung
mit einem echten Botticelli im Schlafzimmer beeindrucken? Nichts einfacher als
das! Wählen Sie einfach aus dem nachfolgenden Katalog ein Bild aus und
schicken Sie uns ein Foto Ihrer Wohnung! Alles andere erledigen wir für Sie."
In der Folge integriert Meierhofer das gewählte Kunstwerk in ein Foto des
heimatlichen Domizils.

Der Witz des Konzepts speist sich nicht nur aus der Diskrepanz zwischen den
Kunstwerken und den Einrichtungen, ihren teils skurrilen Präsentationen,
sondern auch aus der Tatsache, dass alle auf www.auftragsdiebstahl.de „ange-
botenen" Werke wirklich gestohlen worden waren. Das Bild „Nebelschwaden"
von Caspar David Friedrich wurde am 28. Juli 1994 entwendet und im August 2003
zurückgegeben. Der deutsche Romantiker Friedrich gilt als Meister von Nebel-
und Wolkenszenerien. Zeitgenössische Kritiker beklagten das Moment der
Verunklärung der Landschaft, heute wird dieser Effekt des Geheimnisvollen als
Paradigma romantischer Geisteshaltung besonders hoch geschätzt. Alexandra Matzner

Christine Meierhofer is toying with a dream of many art connoisseurs by suggesting:
"Haven't you always wanted to decorate your living-room with a genuine Caspar David
Friedrich or impress your latest conquest with a real Botticelli in your bedroom?
Nothing could be easier! Simply chose a picture from this catalogue and send us a
photo of your apartment! We'll take care of everything else for you." Meierhofer then
integrates the selected artwork into a photo of your home.

The twist is not only that the artworks and interiors don't match, resulting in some bizarre
presentations, but also that all of the works "available" at www.auftragsdiebstahl.de have
actually been stolen. "Nebelschwaden" (Wafting Mist) by Caspar David Friedrich was
stolen on 28 July 1994 and returned in August 2003. The German Romantic artist
Friedrich is regarded as a master of mist and cloud scenes. Contemporary critics
complained about the way this fogged over the landscape's clarity but today this
mysterious effect is admired as a paradigm of the Romantic spirit. Alexandra Matzner

Elfriede Mejchar

Rote Wolken Red Clouds, 1962
Foto in Baryt-, Splittingtonung photograph in barite-, splitting tone, 25,4 x 23,5 cm

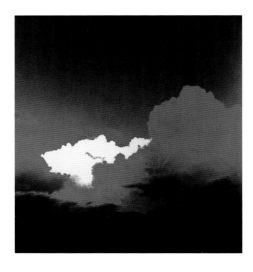

Ihre Aufnahmen aus der Simmeringer Heide seien, wie Elfriede Mejchar meint, nicht das gewesen, was sie unter „Landschaft" versteht. Dort und damals wäre es mehr ein festhaltendes Aufzeichnen, etwas Dokumentierendes und Dokumentarisches gewesen. Gefühle wurden dabei hintangestellt (wenn nicht gar unterdrückt). Hauptsache war, was und wie es gewesen ist (und wie es damals noch gesehen und fotografiert werden konnte).

Bei den zwischen 1965 und 1980 in Oberösterreich und in der Steiermark entstandenen „Landschaften" lässt Elfriede Mejchar diese voll „wirken" und zur Geltung kommen. Das Quasi-Theatralische ist dabei bewusst „dick aufgetragen". So sind es vor allem dramatische (von Telegrafenmasten akzentuierte) Wolkensituationen, regelrechte „Schlagoberslandschaften" (wie sie Elfriede Mejchar selber so nennt).

Um alles das gehörig hinzukriegen, hat sie sich auch eine besondere Art und Weise ihrer Ausarbeitung zurechtgelegt. Die Bilder sind im Splitting-Ton zweifarbig ausgeführt, wie das die Wirkung, auf die sie angelegt sind, erheblich unterstützt. Otto Breicha

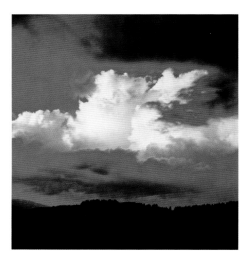

Elfriede Mejchar does not regard her photographs of Simmeringer Heide as "landscapes". At that place and time they were more of a record, something that documented and was documentary. Feelings were set aside (or even suppressed). The priority was what she saw and what it was like (and how it could be seen and photographed at that time).

Elfriede Mejchar photographed these "Landscapes" between 1965 and 1980 in Upper Austria and Styria, aiming to produce maximum effect. The quasi-theatrical impact has been deliberately "laid on thick". We see dramatic cloud situations, accentuated by telegraph masts, in scenes that the artist called "whipped cream landscapes".

To achieve this she produced the pictures in a special way. The photographs use split-toning in two colours and this considerably adds to the artist's intended effect.
Otto Breicha

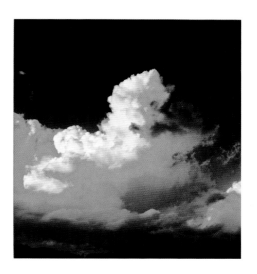

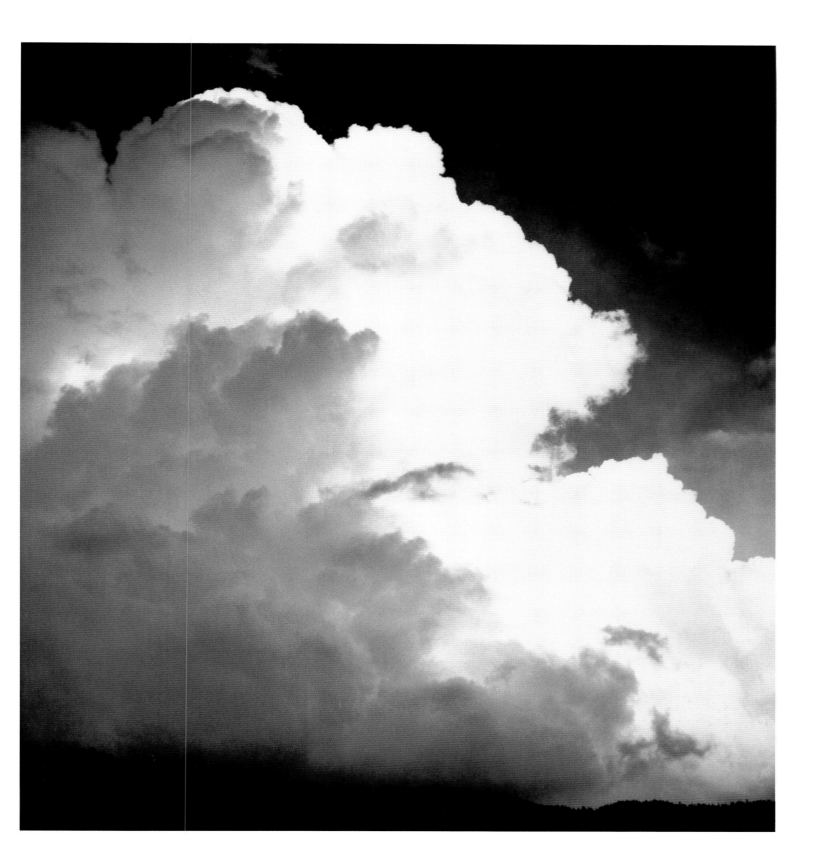

Moje Menhardt

Donau-Ostwind-Wolken Danube-Eastwind-Clouds, **2000-2002**
Acryl auf Leinwand acrylic on canvas, 190 x 160 cm

Die Bilder von Moje Menhardt entstehen sowohl assoziativ als auch in
Auseinandersetzung mit ihrer eigenen Biografie. Die Serie „Donaubilder" aus
den Jahren 2000 bis 2002 führte die in Hamburg geborene Künstlerin in ihrem
Freilichtatelier auf der Ruine Weitenegg aus. Die Burganlage befindet sich auf
einem Felssporn an der Einmündung des Weitenbachs in die Donau und bietet
ihren Besuchern einen Blick bis zum Stift Melk. Moje Menhardt ist in ihrer
Kindheit oft in der Ruine gewesen. Die Donau, ihre Farbe – oder besser ihren
Farben –, aber auch ihr Rauschen inspirieren die Künstlerin zu abstrakten Bildern,
die ihre Kraft aus der reinen Farbe und der Pinseltechnik schöpfen. Sie arbeitet
immer an vielen Gemälden gleichzeitig, lässt sie zwischendurch ruhen und
beschäftigt sich nach Wochen oder Monaten erneut mit ihnen.

Zu Menhardts „Donaubildern" lässt sich sagen: Natur wird Kunst, denn die
Donau in ihren unterschiedlichen, von Wind- und Wetterlage abhängigen Farb-
stimmungen bestimmt die harmonische Farbpalette. Bei Ost-Wind ist der Strom
blau, braun bei Hochwasser. Meditativ ruhige Bildräume und skripturale,
gestische Pinselarbeiten wechseln einander ab. Der Himmel „reagiert" auf
die Farbigkeit des Wassers, und im Blau der Donau spiegeln sich die Wolken.
Alexandra Matzner

In her paintings, Moje Menhardt dwells both on associations and her own biography.
The Hamburg-born artist painted the series "Danube Paintings" from 2000 to 2002 in
her open-air studio at the ruin in Weitenegg. Situated on a rock where the Weitenbach
flows into the Danube, there are views from the fortress as far as Melk Abbey. Moje
Menhardt spent a lot of time at this ruin as a child. The Danube, with its colour – or
rather colours – and sounds, inspires the artist to create abstract pictures that draw
their strength from the pure colours and brushwork. She always works on many
paintings at the same time, puts a picture aside for a while and then focuses on it
again weeks or months later.

In Menhardt's "Danube Paintings" one can appreciate how nature is transformed into
art. It is the Danube's colour atmospheres, changing with the wind and weather, which
create this harmonious palette. The water is blue when there is an east wind and
brown when the river is in flood. Meditative and tranquil pictorial spaces alternate
with textual, gestural brushwork. The sky "reacts" to the water's colours and the
clouds are reflected in the blue Danube. Alexandra Matzner

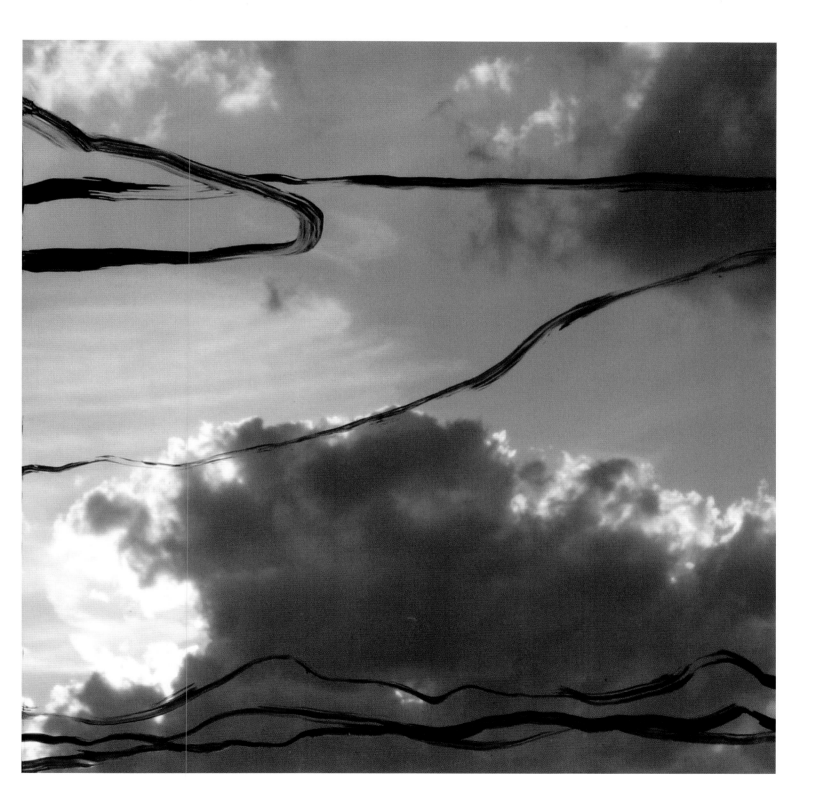

Für die Vögel For the Birds, 2008
Holzfaserplatte, Öl auf Glas wood fiber plate, oil on glass, 139 cm, Ø 55 cm

Hubert Roithner

Air, 2002
Acryl auf Segelleinen Acrylic on duck canvas, 220 x 190 cm

Die Bilder von Hubert Roithner sind immer von der Natur inspiriert – sowohl in den Eigenschaften der eingesetzten Materialien als auch in den Motiven. Roithners Gemälde spüren oftmals der Luftfeuchtigkeit, der Atmosphäre nach. Sie oszillieren zwischen einem Verfließen und Verfestigen der Farbmaterie.

Der Arbeitsvorgang lässt sich am besten als ein Einsumpfen beschreiben: Zuerst löst Hubert Roithner Pigmente im Wasser, um sie dann in sehr wässriger Konsistenz auf das am Boden liegende Trägermaterial aufzubringen. Es bleiben die färbigen Lösungen stehen, verrinnen, vermengen sich, werden vom Künstler mit Bedacht in verschiedene Richtungen gelenkt. Beim Gestalten bewegt sich Roithner um die Bilder, bearbeitet sie von allen Seiten. Auf diese Weise entstehen abstrakte Kompositionen, die mehr als Metaphern denn als konkrete, anschauliche Seherlebnisse wirken sollen. Roithners Bilder wollen Assoziationen auslösen, wobei der Bildtitel – hier „Air" – nicht als Bestimmung des Motivs, sondern aufgrund des Klanges und der mit dem Begriff verbundenen Vorstellung dem Bild zugeteilt wird. Bewusst vermeidet der Künstler allzu eindeutige Referenzen, die Bildlichkeit seiner Malerei fußt völlig auf der Vorstellungskraft der BetrachterInnen. Alexandra Matzner

Hubert Roithner's pictures are always inspired from nature – both in terms of the characteristics of the materials and the subjects. Roithner's paintings often seek to capture the humidity or the atmosphere. They oscillate between the paint flowing, merging and converging.

The process behind his work can be best described as slaking. First of all Hubert Roithner dissolves pigments in water and then applies them in a very watery consistency to the support on the floor. The coloured solutions trickle and merge and are carefully guided in different directions by the artist. When composing his pictures, Roithner moves around them and works on them from all sides. In this way he creates abstract compositions that should be seen more as metaphors than definite visual experiences. Roithner's pictures aim to release associations in the observer. The picture title – in this case "Air" – does not define the motif but is chosen on account of the sound and the ideas it evokes. The artist deliberately avoids references that are too obvious; his painting's imagery is based entirely on the viewer's powers of imagination. Alexandra Matzner

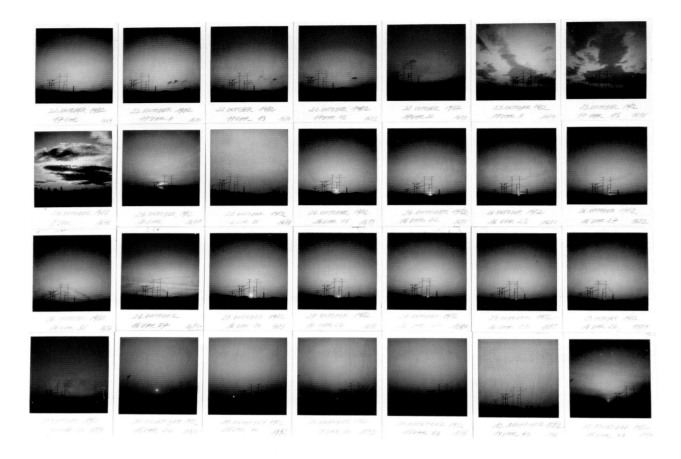

Trude Rind

Himmel Heaven, 1983
Polaroids auf Karton polaroid photographs on cardboard, 44 x 63 cm
Himmel Heaven, 20.10.–15.11.1982
Polaroids auf Karton polaroid photographs on cardboard, 44 x 62 cm

Das Besondere an Polaroids besteht darin, dass sie Unikate sind und das Ergebnis kurz nach dem Druck auf den Auslöser vorliegt, also keine Manipulationen nötig und möglich sind, um ein Bild hervorzubringen. Auch ist es dann zu spät, um auf eine positive Darstellung zu verzichten: Jede Aufnahme gerät zum Abzug. Und während seiner Fertigstellung kann auch kein neues Motiv festgehalten werden. Der erste Eindruck wird also gewissermaßen in Schwebe gehalten, bis er als Bild vorliegt.

So hat es auch Trude Rind gesehen, der es immer um die Atmosphäre – in der zweifachen Bedeutung des Wortes – ging. Die allermeisten Aufnahmen sind vom gleichen Standpunkt aus entstanden, dem Haus in Gersthof, die Kamera wurde stets in dieselbe Richtung gehalten, zu jedweder Tageszeit, die genaue Uhrzeit auf dem Abzug notiert, gelegentlich ergänzt um das, was zugleich unter dem Himmel geschieht, zum Beispiel: „21. August 1984 19 Uhr 31 Barbara in Wien". Ein Diarium himmlischer Bilder.

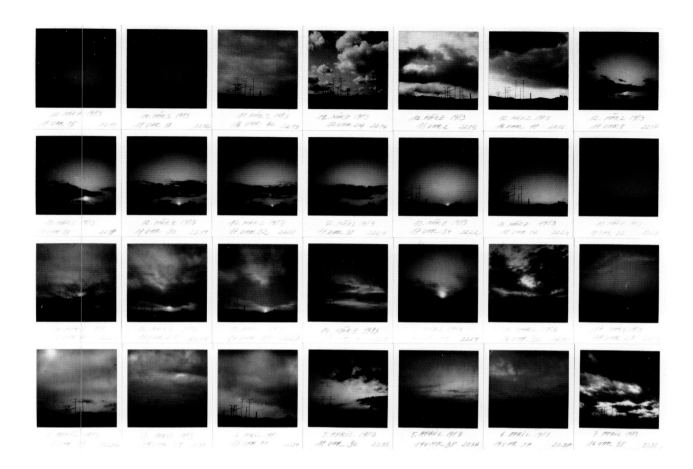

Sie habe zwischen 1980 und 1986 100.000mal den Himmel fotografiert, nimmt die Künstlerin an, und das Projekt habe sie nur deshalb abbrechen müssen, weil die Filme vom Erzeuger nicht mehr geliefert wurden. Timm Starl

What is special about Polaroids is that they are unique and the result appears shortly after you press the shutter release button. Creating an image therefore doesn't require, or even permit, any manipulation. It is also too late to avoid producing a positive image as every photo taken appears as a print. And while this is being produced, one cannot take a picture of another motif. In a way the first impression is held in the balance until it appears as a picture.

This is how Trude Rind sees it, an artist who has always been concerned with atmosphere – in both senses of the word. She took most of the photographs from the same place, the house in Gersthof, always pointing the camera in the same direction. There are shots from every time of day and the artist noted the exact time on the print, occasionally with a comment about what was happening beneath the skies, for example "21 August 1984 19.31 Barbara in Vienna". It is a diary of celestial pictures.

Trude Rind estimates that between 1980 and 1986 she photographed the sky 100,000 times and she only discontinued the project because the films were no longer available from the manufacturer. Timm Starl

Meina Schellander

Wolken (Zeit-Himmel-Anteil)/Innere Frequenz 143
Clouds (A Share of Time and Sky) / Inner Frequency 143, **2006**
Farbfoto und Zeichnung auf Aluminium kaschiert mit Acrylglasabdeckung
Colour photograph and two-part drawing, mounted on aluminum, acrylic glass covering, 61 x 101 x 5,6 cm
Leihgabe der Künstlerin loan of the artist

In einer Auseinandersetzung des „Innen und Außen" sowie in einer kritischen
Reflexion ihrer Umwelt entwickelt Meina Schellander seit den 1970er Jahren ihre
unverwechselbare Formensprache. Neben dem skulpturalen Werk bilden Foto-
grafie und Zeichnung einen weiteren Schwerpunkt ihres Œuvre. Seit 2001 ent-
steht die Fotoserie „Zeit-Land-Anteil", die Meina Schellander mit Zeichnungen,
den „Inneren Frequenzen", ergänzt. Aus einer inneren Mitte heraus vereint sie
darin, was sie in ihrem Leben sieht, aufnimmt, wonach sie forscht und woran sie
sich reibt. Parallel dazu reagiert Meina Schellander seit 2006 ebenso zeit- und
persönlichkeitsbezogen auf die Wolkenfotografien der Serie „Zeit-Himmel-
Anteil". Serielle, lineare Schichtungen auf geleimtem Papier kontrastieren mit
dem jeweiligen Wolkenbild oder verdichten, verwandeln seine Struktur und
führen sie in der Zeichnung fort. Stets ist das äußere Bild, die Fotografie der
Auslöser der „Inneren Frequenz". „Dabei entsteht Balance ebenso wie Dissonanz,
je nachdem, was mir mein Denken während des Arbeitsprozesses freilegt. Selten
lasse ich ein unmittelbares Erscheinungsbild zu, meist drängt es mich dazu,
kritische und ironische Distanz herzustellen." Silvie Aigner

Since the 1970s, Meina Schellander has developed her own unmistakeable language
of forms in order to examine "inside and outside" and as a critical reflection of her
environment. Besides her sculptural work, she also focuses on photography and
drawing in her œuvre. Since 2001 she has been working on the photo series "A Share
of Time and Land", adding drawings, the "inner frequencies", to these images. Out of
an innermost centre she combines what she sees and absorbs in life, what she's
looking for and what preoccupies her. In parallel with this project, since 2006 Meina
Schellander has been working on the series "A Share of Time and Sky". Her reactions
to the cloud photographs in this series also reflect personality and time. Sequences of
linear layers on pasted paper contrast with the cloud picture or they compact and
transform the cloud's structure and continue it in the drawing. The outward
appearance of the photograph always triggers the "inner frequency". "In this way both
balance and dissonance emerge depending on what my thoughts uncover during the
work process. I rarely permit a direct image; usually it compels me to establish a
critical and ironic distance." Silvie Aigner

Eva Schlegel

O.T. Untitled, **1998**
Acryl auf Holz acrylic on wood, 88 x 120 cm

In Eva Schlegels Œuvre nehmen Wolkenbilder eine eigenständige Position ein.
So wie bei den Bildtextarbeiten auf Glas steht auch hier der Raum, allerdings
der immaterielle Raum im Zentrum des Interesses. Das Phänomen Wolke
repräsentiert etwas Sichtbares, das man nicht greifen und nicht wirklich berühren
kann. Ausgangspunkt für Schlegels Wolkenbilder sind einfache, schnelle Foto-
grafien von Wolkenformationen, die die Künstlerin bei jeder sich bietenden
Gelegenheit anfertigt. Das Foto wird anschließend via Xerokopie auf das
Bildformat vergrößert und mittels Trichloräthylen auf Kreidegrund übertragen.
Die so entstandene Transformation ins Malerische oder Zeichnerische wird mit
bis zu 20 Schichten transparentem, mit Ölfarbe gemischtem Lack übermalt. Das
Bild erscheint dadurch als luzider, glänzender Farbraum, in dem das Motiv wie in
einen Schleier gehüllt ist. Das Interesse an der Form der Wolke, an deren
amorpher Erscheinung an der Grenze zur Abstraktion bildet die Basis für diese
speziellen Wolkenbilder. Schlegel versucht durch ihr schichtweises Arbeiten an
unterschiedlichen Bildzuständen nicht romantische oder sentimentale Qualitäten
hervorzuheben, sondern evoziert in den BetrachterInnen neue und offene Ebenen
der Wahrnehmung. Michaela Nagl

Cloud pictures occupy an independent position in Eva Schlegel's œuvre. As in her
works combining image and text on glass, space is the focus of interest, although in
this case the space is immaterial. A cloud is a phenomenon that is visible yet it cannot
be touched or grasped. As the first stage in her cloud pictures, Schlegel takes quick
photographs of cloud formations when the opportunity arises. She then xeroxes the
photo, enlarging it into a picture format, and transfers this onto a chalk ground using
trichloroethylene. After the image has been transformed into the medium of painting
or drawing, she paints over it with up to twenty layers of varnish mixed with oil paint.
This makes the picture seem like a lucid, glowing colour space, veiling the subject in
mist. These special cloud pictures are based on the interest in a cloud's amorphous
appearance that borders on the abstract. By working in layers and creating different
pictorial states, Schlegel does not aim to emphasize romantic or sentimental qualities
but to open up and evoke new levels in viewers' perception. Michaela Nagl

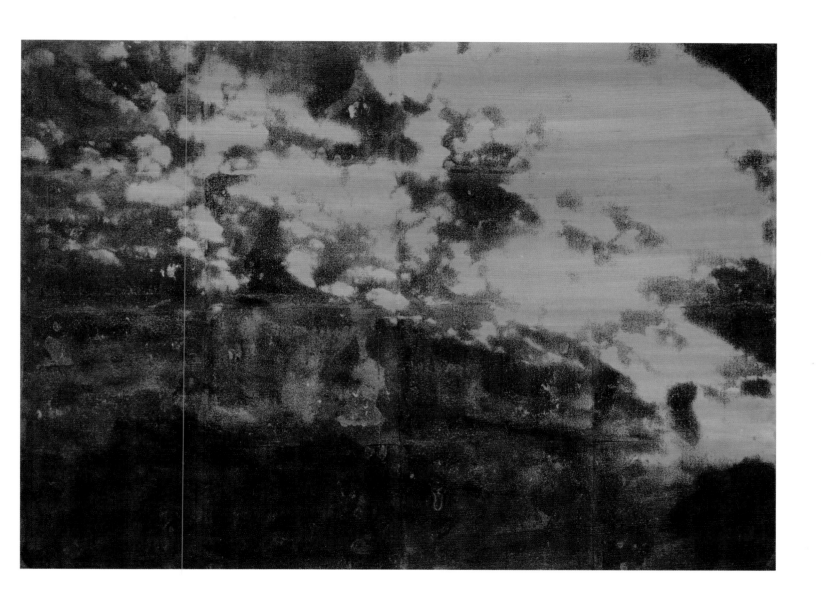

Josef Schwaiger

CMYKOG_Morph, 2002

Alkydharz und Silikon auf Aluminium alkyd resin and silicone on aluminum, je each **40 x 30 cm**

Josef Schwaiger nimmt eine konzeptionell analytische Position im Kontext der Ausstellung *stark bewölkt* ein. Sein Bezug zum wolkenverhangenen Himmel liegt nicht im naturalistisch Mimetischen, sondern im Prozesshaften, im ständigen Wandel des Organismus Malerei. Der Werdungsvorgang der vorliegenden Bilderserie erstreckt sich über einen langen Zeitraum von etwa einem halben Jahr. In eine Wanne, die von Metallschienen in sechs Waben geteilt wird, schüttet Schwaiger die Primärfarben. Im nächsten Arbeitsschritt werden die Trennwände entfernt und die in noch strengen Streifen gegliederte Oberfläche der Acrylharzfarbe mit einer Aluminiumplatte in Berührung gebracht. Dieses Abklatschverfahren wird nun in gleichmäßigen Perioden fortgesetzt. Dabei wird die Genese des Bildes in Einzelschritten dokumentiert; die unterschiedlichen Viskositäten und spezifischen Gewichte der Farbpigmente erzielen malerische Vermischungen, die sich in letzter Konsequenz der Monochromie annähern. So tauchen in den ersten Bildkadern die schwereren Farben optisch unter, bleiben materiell jedoch länger im Farbwannenbad existent und prägen in ihrer koloristischen Erscheinung die letzten Bilder. Florian Steininger

Josef Schwaiger takes up a conceptual, analytical position in the context of the exhibition *clouds up high*. His connection with a cloudy sky is not naturalistic or mimetic but processual and this is reflected in his approach to painting as a constantly changing organism. The evolution of this series spanned a long period of about half a year. Schwaiger poured the primary colours into a tub divided into six compartments by metal partitions. The next step was to remove the partitions and to bring an aluminium sheet into contact with the surface where the acrylic resin paint was still divided into clear stripes. This transferring technique was then repeated at regular intervals. In this way, the genesis of the picture was documented in separate stages. The different viscosities and specific weights of the colour pigments created mixtures that ultimately almost became monochrome. Thus, in the first images, the heavy pigments have receded optically. However, they remained in the tub for longer and dictated the colours of the last pictures. Florian Steininger

Hubert Sielecki

Levitation, 2007
Video, 3:00 min, Leihgabe des Künstlers loan of the artist

Die filmische Sequenz „Levitation" von Hubert Sielecki zeigt eine klassische
„Schäfchenwolke" (Altocumulus) vor blauem Himmel und – auf die Dauer des
Animationsfilms verdichtet – deren permanente optische Wandlung bis hin zu
ihrer vollkommenen Auflösung. Wolken sind in ständiger Bewegung und
Veränderung begriffen. Für ihre Entstehung ist die Sonne verantwortlich, die als
Energiequelle den Wasserkreislauf in Gang hält und Wasser in Wasserdampf
umwandelt. Er kondensiert in der Luft und bildet jene Milliarden winziger
Wassertröpfchen und Eiskristalle, aus denen wiederum Wolken bestehen. Für uns
Menschen erscheinen sie als am Himmel schwerelos dahinziehende Gebilde –
das Phänomen der Levitation, des Schwebens (lat. levitas = Leichtigkeit), ist auch
titelgebend. „Wenn der Körper ein wenig leicht wird …" bildet den Anfang der
sprachlichen Untermalung des Films. Die Prosa endet mit dem Wort „licht", das,
für das Leben auf der Erde wesentlich, durch die Sonne gegeben wird. Gerade
bei wolkenlosem, blauem Himmel.

„Levitation" ist der letzte von insgesamt fünf Teilen der Animationsfilm-Serie
„Sehen", die 2007 produziert wurde. Sie entstand in Zusammenarbeit mit
Gerhard Rühm, Autor der jeweiligen Sprechtexte. Markus Schön

The film sequence "Levitation" by Hubert Sielecki shows a classic fleecy cloud
(altocumulus) against a blue sky. It traces the cloud's constant optical changes until it
finally disperses – all compressed into the length of an animation film. Clouds are in a
state of constant motion and flux. The sun is actually behind their creation, acting as
the source of energy that drives the water cycle and changes water into vapour. This
condenses in the air forming a mass of minuscule water droplets and frozen crystals
that in turn create clouds. To people, clouds look like weightless, scudding figures.
This phenomenon of levitation and floating is also reflected in the title (in Latin levitas
= lightness). "When the body becomes a little lighter …" is how the background text
to the film begins. The prose ends with the word "light", essential for life on earth,
which comes from the sun. This is especially apparent in a cloudless, blue sky.

"Levitation" is the last of five parts in the animation film series "Seeing" that was
produced in 2007. The artist created this in cooperation with Gerhard Rühm, who was
the author of the spoken texts. Markus Schön

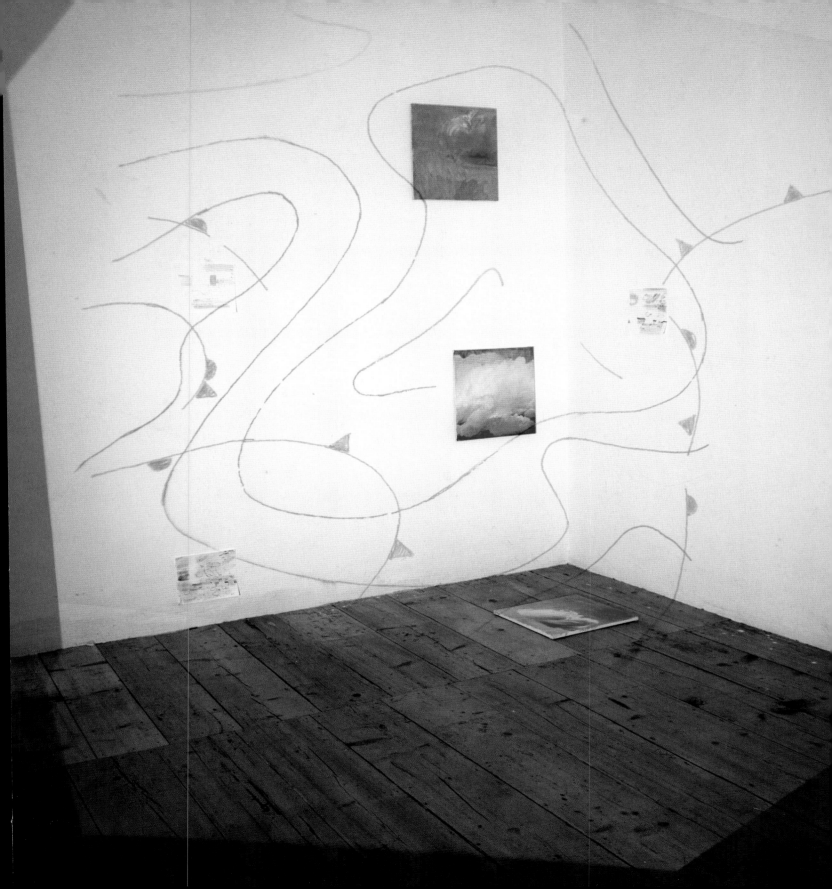

Helmut Swoboda

Dachstein, 2001

Eitempera und Wachsemulsion auf Leinwand egg tempera and wax emulsion on canvas, 150 x 140 cm

„An euch Dachstein-Wolken / segelnde Wolken, luftige Schiffe! schicket euch an in Lichtgestalten hinüberzuwechseln, und wolltet / doch, aus Überlebensgründen, euren / vergänglichen Himmelserscheinungen / eine Leibesbeschaffenheit, dauerhafter als Eis und Erz, / da drüben gewinnen …"

Der Sammelband „Dachsteinwolken" mit Gedichten von Julian Schutting und Offsetlithografien von Helmut Swoboda vereint die beiden Amstettener vor derselben Landschaft: Sie erweisen dem Dachstein mit dem Gosausee ihre Referenz.

Bereits seit 2000 beschäftigt sich Helmut Swoboda mit der Dachsteinregion. Besonders fasziniert ist er von der pittoresken Spiegelung des Gebirgsmassivs im See. Im Gegensatz zu den vielen Malern des 19. Jahrhunderts interessiert sich Swoboda nicht für die smaragdene Farbigkeit des Sees (wie Franz Steinfeld) oder die schneebedeckten Abhänge und Felsformationen (wie Ferdinand Georg Waldmüller), sondern für die Möglichkeiten malerischen Agierens. Wenige Anhaltspunkte lassen das Motiv noch erkennen, denn das Gebirge wirkt wie von Wolken eingehüllt. Das Schwebende abstrakter Kompositionen findet hier eine Entsprechung im optischen Phänomen der Spiegelung. Das Bild changiert zwischen Figuration und Abstraktion und wird so ganz Malerei. Alexandra Matzner

"To you Dachstein clouds / sailing clouds, airy ships! ready yourselves / to transform into figures of light, and though / you wanted, for survival, to wrest / from your fleeting heavenly appearances / a bodily form / more enduring than ice and ore …"

The anthology "Dachsteinwolken" (Dachstein Clouds), with poems by Julian Schutting and offset lithographs by Helmut Swoboda, unites the writer and artist from Amstetten in their reverence for the Dachstein and Lake Gosau.

Helmut Swoboda has been interested in the Dachstein region ever since the year 2000 and is particularly fascinated by the picturesque reflection of the mountain in the lake. In contrast to many nineteenth-century painters, Swoboda is not interested in the emerald green colour of the lake (like Franz Steinfeld) or the snow-covered slopes and rock formations (like Ferdinand Georg Waldmüller), but in the opportunities it offers for painting. The subject can only be identified from a few remaining features because the mountains seem to be shrouded in clouds. A floating, abstract composition is echoed in the optical phenomenon of the reflection. The picture oscillates between figurative and abstract art and is thus transformed into total painting. Alexandra Matzner

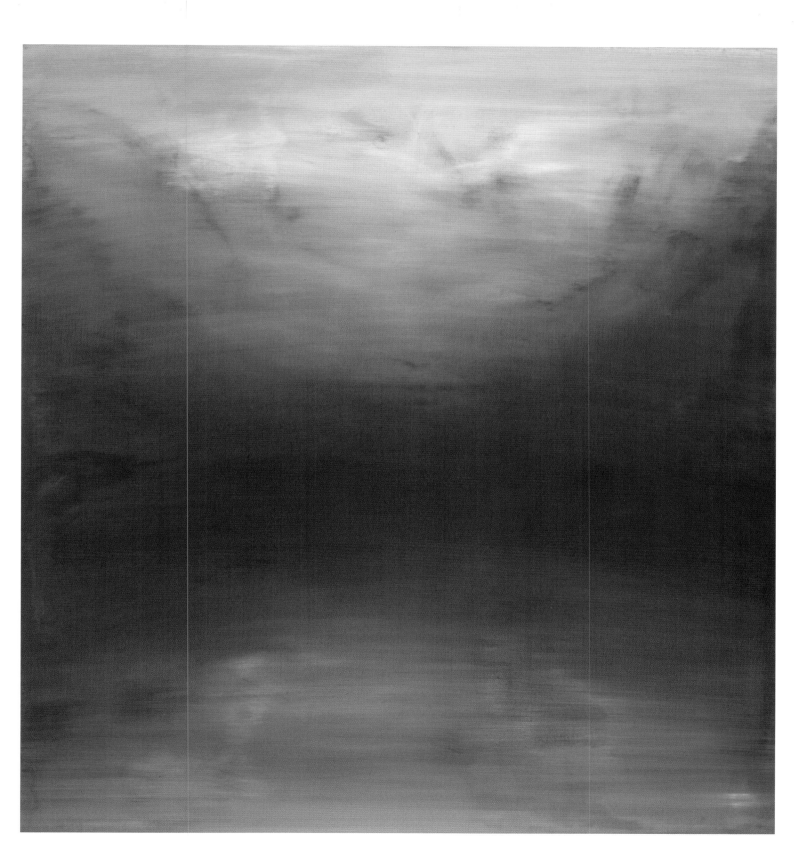

Ida Szigethy

Wolkenschachtel, 1971
Öl auf Karton oil on cardboard, 50 x 40 cm
Leihgabe der Artothek des Bundes loan of the Artothek of the Federal Ministry

Die Szene wirkt surreal und doch bekannt. Geblümte Tapeten, blauer Himmel, Ruhe, vielleicht ist nur das Ticken einer Uhr im Wohnzimmer zu hören – nichts passiert. Möge doch etwas passieren. Möge sich doch die Schachtel auf dem Tisch öffnen und kleine Wolken aus dem scheinbar bodenlosen Inneren emporsteigen lassen, die ihren Weg ins Freie suchen: Wolken, Nomaden des Himmels, privilegierte Wesen, die immer reisen können, wohin sie wollen, über Grenzen, Einreisebestimmungen und Ozeane hinweg.

Das Reisen nimmt im Leben und künstlerischen Schaffen von Ida Szigethy eine zentrale Rolle ein, sei es in tatsächlichen Fernreisen rund um den Globus oder aber in sehnsüchtigen Phantasien. Die „Wolkenschachtel" (1971) zählt zum Frühwerk der autodidaktischen Malerin und fällt damit in jene Zeit, in der sie auch als Kinderbuch-Illustratorin arbeitete. Kindlich oder gar naiv? „Ich halte nichts davon, Ida Szigethys Bilder naiv zu nennen", schreibt Gerhard Roth 1973. Und wenn schon. Die aktuellen Arbeiten der Malerin, farbenprächtige Reiseberichte aus den Tropen, zuletzt präsentiert in Paris (2005), befänden sich in bester Gesellschaft mit Henri Rousseau und anderen namhaften Vertretern der französischen Naiven. Martina Griesser-Stermscheg

The scene seems surreal yet familiar. Floral wallpaper, blue sky, peace – perhaps all that can be heard is the ticking of a clock in the sitting room. Nothing is happening. If only something would happen. If only the casket on the table would open and out of its seemingly bottomless interior small clouds float up, seeking their way into the open. Clouds that are nomads of the sky, privileged beings that can always travel wherever they please, regardless of borders, entry permits and oceans.

In the life and art of Ida Szigethy, travel holds a central role, both in terms of actually travelling around the world and in wistful fantasies. The "Cloud Casket" (1971) is an early work by this self-taught artist and she created it when she was working as a children's book illustrator. Is it childlike or even naive? "I really don't think that Ida Szigethy's pictures should be called naive", Gerhard Roth wrote in 1973. And even if they are, the painter's current works – colourful tales of travels from the tropics, last presented in Paris in 2005 – would be in the best of company with Henri Rousseau and other famous representatives of French naive art. Martina Griesser-Stermscheg

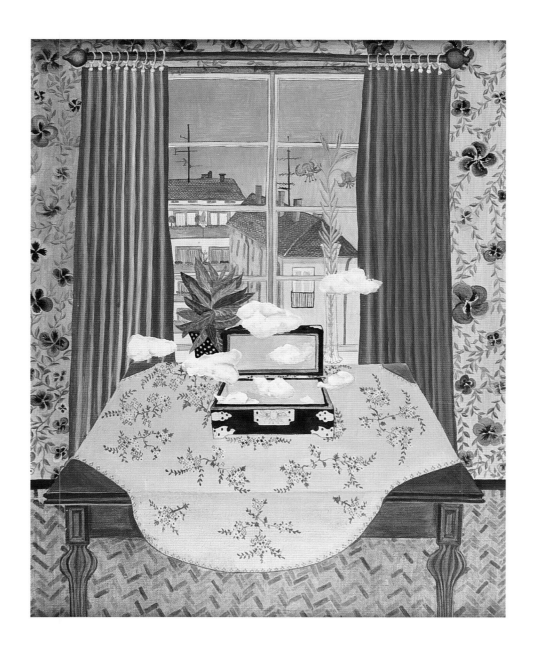

Lea Titz

Jupiter, 2006

Farbfoto auf Aluminium colour photograph on aluminum, 91 x 90,8 cm

Thema dieser Arbeit ist der antike Mythos um ein außereheliches Abenteuer Jupiters mit Io. Zwar floh Io, wurde allerdings von dunklem Nebelgewölk, welches der mächtige Gott entstehen ließ, aufgehalten und von Jupiter vergewaltigt.

Inspirierte die Geschichte Künstler früherer Epochen, allen voran Correggio, zur atmosphärischen Darstellung einer Verschmelzung von nackter Weiblichkeit und körperloser Wolke, tritt Jupiter bei Lea Titz wieder personifiziert auf. In einer weiten, gesichtslosen Landschaft positioniert die Künstlerin einen männlichen Körper, der bis zur Taille, die genau auf der Horizontlinie liegt, mit einer mit Wolken bedruckten Plane verhüllt ist. Die Erscheinung und Intention des Gottes wird dadurch konterkariert, denn er selbst ist seiner Sicht und Bewegungsfreiheit beraubt. Die im Mythos erzählte Täuschung der Gemahlin Jupiters durch die Tarnung während seines Liebesabenteuers mit einer Wolke wird zusätzlich ironisiert, stimmt doch weder die Farbe der Hose mit dem Boden der Landschaft noch die Himmelsstimmung mit dem Wolkendruck der Plane überein.

Lea Titz verarbeitet die Begegnung Jupiters mit Io durch eine Entmythifizierung der Gottesgestalt mithilfe ironischer Andeutungen und Betonung des skurrilen Moments. Sie negiert bewusst sowohl das Romantisch-Luftige als auch die vermeintliche Harmlosigkeit des Zusammentreffens. Johannes Karel

This work is based on the classical myth about Jupiter's adulteress adventures with Io. Although Io fled, she was stopped by a dark cloud conjured up by the powerful god who then raped her.

In earlier epochs this story inspired artists to focus on the atmospheric merging of the naked female body with the incorporeal cloud, Correggio being the most prominent example. By contrast, in Lea Titz's work Jupiter appears as a person. In a wide, featureless landscape the artist placed a male body covered up to the waist with a tarpaulin printed with clouds, the base of which is aligned exactly with the horizon. This foils the god's appearance and intentions as he is deprived of his sight and cannot move. The deception of Jupiter's wife in the myth, by disguising his amorous escapade with a cloud, is therefore given an ironic slant in this picture. The colour of the trousers does not match the ground and the sky is not the same as the cloud-printed tarpaulin.

Lea Titz tackles this meeting of Jupiter and Io by demystifying the god using ironic touches and emphasizing the bizarreness of the scene. In this way she deliberately negates the romantic "waftiness" and also the alleged harmlessness of this encounter. Johannes Karel

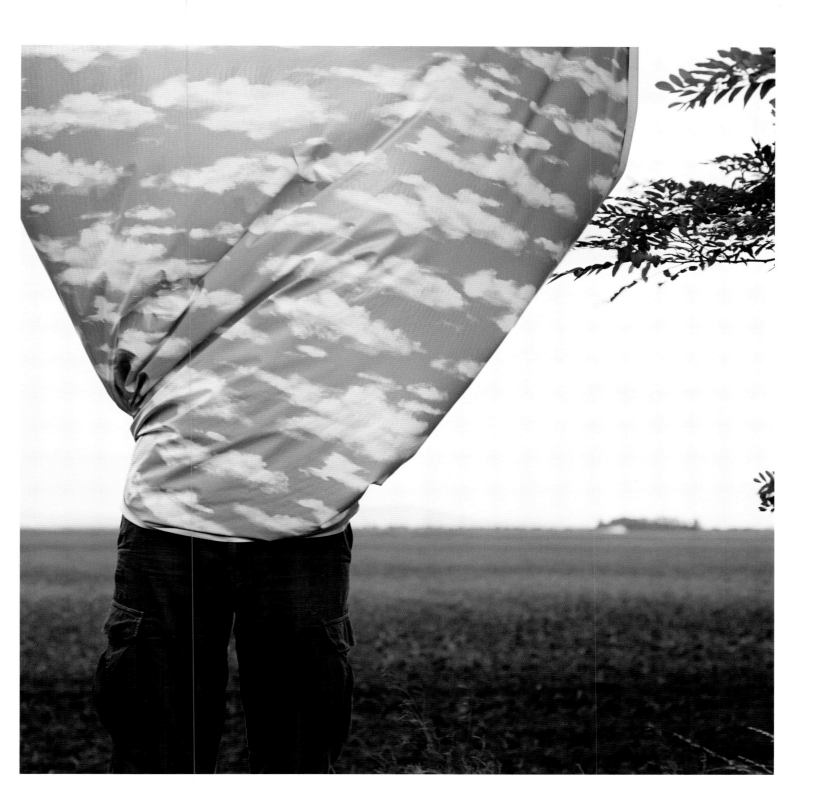

Jochen Traar

Man Made Skies, 2001

Computerbearbeitetes Foto auf Leinwand computer processed photograph on canvas, **120 x 180 cm**

Die Fotoserie „Man Made Skies" ist 1996 an verschiedenen Orten in Los Angeles entstanden und umfasst rund 600 Teile. Aufgenommen wurden Kondensstreifen, die Flugzeuge bei bestimmten atmosphärischen Konstellationen am Himmel hinter sich lassen. Bei diesen Erscheinungen handelt es sich um Spuren, die eine Maschine in der Luft erzeugt, gewissermaßen technische Zeichnungen mittels weißem Dampf auf blauem Grund. Je nach Verkehrsaufkommen treten sie einzeln auf oder kreuzen sich. Je nach der Luftströmung verändern sie ihre Gestalt und verschwinden nach einiger Zeit, wobei manche in der Phase der Auflösung wie Wolken aussehen.

Dieser Metamorphose gebietet die Fotografie Einhalt, verfertigt ein Bild, übersetzt das Natürliche in ein Künstliches. Doch Jochen Traar führt den Prozess virtuell weiter, indem er die Aufnahme am Computer bearbeitet. So bändigt er den Zufall, der jedes fotografische Produkt auszeichnet, und erhöht die Abstraktion. Zum Inventar dieser Bilder gehören: das Atmosphärische, das Fotografische, das Digitale – ein Medienmix besonderer Art. Doch letzten Endes sind Himmel und Kondensstreifen eine Kreation des Künstlers. Timm Starl

The photo series "Man Made Skies" was created in 1996 at various locations in Los Angeles and comprises approximately 600 photos. Traar took photos of contrails left behind by aeroplanes in certain atmospheric constellations in the sky. These are trails made by a machine in the air and in one way can be seen as technical drawings using white vapour on a blue background. Depending on the air traffic, they can appear as a single trail or they can cross each other. Depending on the air currents, their forms alter and after a time they disappear. Some contrails look like clouds during this phase when they disperse.

This metamorphosis is frozen by photography, which produces an image and translates something natural into something artificial. Jochen Traar continues this process in a virtual environment by manipulating the photograph on the computer. This holds in check the element of coincidence, which determines every photographic product, and increases the abstraction. These pictures are made up of atmospheric, photographic and digital components – a very distinctive mix of media. Yet ultimately the sky and the contrails are a creation by the artist. Timm Starl

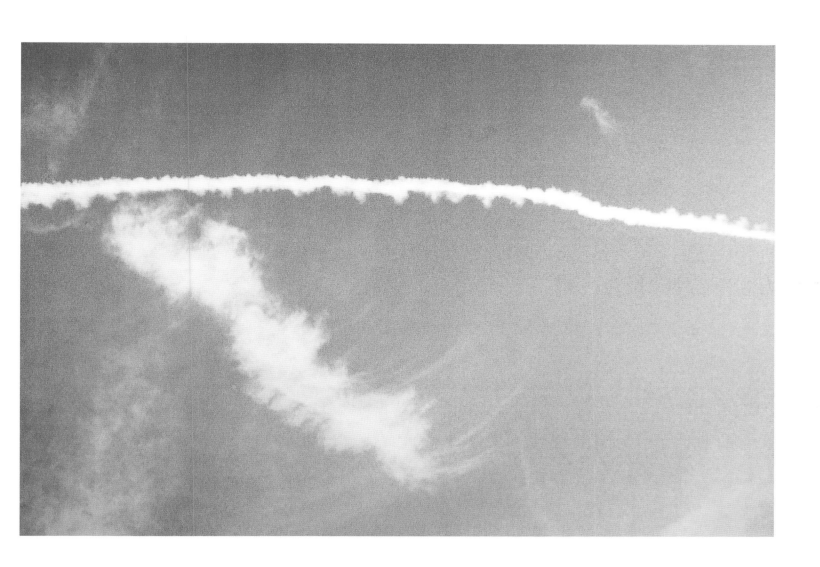

Werner Trinkl

Beobachtung Observation, 1976/77
Öl auf Hartfaserplatte oil on wood fiber plate, 40 x 30,2 cm

Werner Trinkl, der keine künstlerisch-akademische Ausbildung absolvierte, schulte sich autodidaktisch und durch zahlreiche künstlerische Kurse. Das 1976/77 entstandene Bild „Beobachtung" spiegelt sein Interesse an der naturalistischen Wiedergabe von Bildgegenständen und Erscheinungen in der Natur wider. Zugleich zeigt es sein Vermögen, fantasievolle und kreative Themen darzustellen, die voller allegorischer und symbolischer Andeutungen sind.

Vor dem Hintergrund einer Landschaft mit dunkelblauem Wolkenhimmel, stilisierten Baumskeletten und Felsblöcken ragt eine überdimensionierte linke Hand aus dem Grün des flachen Terrains. Ihre Finger halten ein durchsichtiges Gebilde in Kugelform, das von Strahlen durchbrochen wird. In seinem Inneren ist eine männliche Figur erkennbar, die im geschlossenen Raum zu schweben scheint – ein Eindruck, der durch die untersichtige Darstellung („Sotto in su"-Prinzip) gesteigert wird. Die Figur ist nackt, nur der Schambereich ist von einem Tuch bedeckt. Eine Reihe von blauen Kugeln – sie finden sich sowohl im Geäst der Bäume als auch auf dem Boden liegend – sowie der Kopf mit Kappe im Vordergrund (eine Darstellung im Prinzip eines „Verlorenen Profils") tragen zusätzlich zum symbolhaften Charakter der Bildthematik bei; die Lesbarkeit von Trinkls Arbeit wird mystisch verdeckt: gleich dem Himmel mit seinen Wolken-formationen. Markus Schön

Werner Trinkl did not complete an academic degree in art but taught himself and attended many art courses. His painting "Observation" of 1976/77 reflects his interest in a naturalistic representation of objects and appearances in nature. At the same time it shows his ability to depict imaginative and creative subjects that are full of allegorical and symbolic allusions.

This picture is set in a landscape with a dark blue cloudy sky, stylized tree skeletons and boulders. Against this background a larger-than-life-sized left hand thrusts upwards out of the flat green ground holding a round, transparent form that is perforated by rays. Inside this ball we can detect a male figure who seems to be floating in an enclosed space – an impression heightened by looking up on the scene from below (sotto in su-principle). This figure is naked apart from a cloth across his loins. A number of blue balls are distributed among the trees' branches and on the ground. Together with the head wearing a hat in the foreground – depicted in profil perdu – these add to the symbolic character of the subject. The legibility of Trinkl's painting is veiled in mysticism – like the sky shrouded in cloud formations. Markus Schön

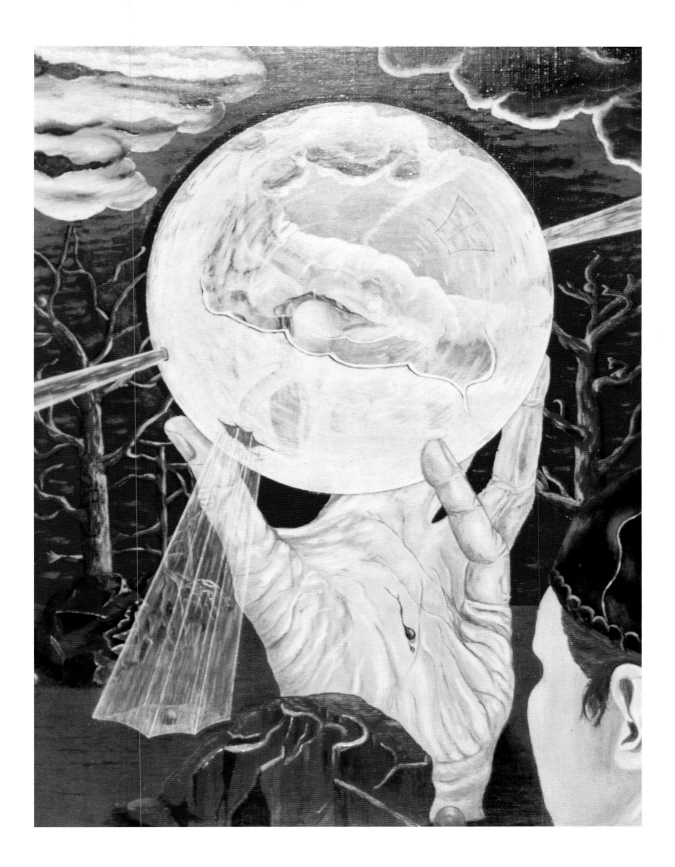

Simon Wachsmuth

O.T. Untitled, 2002
Ölkreide auf Papier oil crayon on paper, 66 x 101 x 5 cm

Die Kunst von Simon Wachsmuth spiegelt die selektiven Konstruktions- und
Projektionsmechanismen sowie narrativen Verkürzungen bei der Produktion und
Repräsentation von Natur, Geschichte und Wissen wider. Durch sein prozessuales
Vorgehen und die visuelle Reduzierung wird Natur als kulturell überladenes oder
erst erschaffenes Konstrukt präsentiert, das gesellschaftlich immer wieder neu
ausgehandelt wird. In einer Serie von Arbeiten mit Ölkreide auf Papier stilisiert
Wachsmuth das kunsthistorisch vielfach besetzte Motiv der Wolke: Die diffuse,
amorphe und flüchtige Ansammlung von schwebenden Wassertröpfchen wird in
klar abgegrenzte Formen und Flächen in verschiedenen Grauabstufungen
übersetzt. Die zwangsläufige Reduktion natürlicher Kontingenz und Instabilität
durch die Sparsamkeit und Effizienz beim Einsatz der Mittel steht dabei für
unvermeidliche und durch die jeweiligen Technologien historisch spezifische
Verkürzungen von wissenschaftlichem Denken. Romantische Konnotationen von
ästhetischer Sinnlichkeit, Melancholie oder Essentialität stehen im Spannungs-
verhältnis zur Monotonie und Positiv/Negativ-Setzung eines gesellschaftlich
konstruierten Zeichensystems. Elisabeth Fritz

Simon Wachsmuth's art demonstrates selective construction and projection
mechanisms and narrative simplifications in his production and representation of
nature, history and knowledge. Through his processual approach and visual
simplification, he presents nature as a construct, loaded with cultural meaning or
newly created, and a subject that society is always re-negotiating. In a series of works
using oil crayon on paper, Wachsmuth stylizes the subject of clouds with its long art-
historical tradition. He translates the indistinct, amorphous and fleeting mass of
floating water droplets into clearly defined forms and surfaces in different gradations
of grey. This unavoidable reduction of natural contingency and instability through this
economical, efficient approach reflects how throughout history, technology has always
simplified scientific thought in its own specific way. Romantic connotations of
aesthetic sensuality, melancholy or essentiality are thus placed in tension with the
monotony and positive/negative pigeon-holing of a socially constructed system of
signs. Elisabeth Fritz

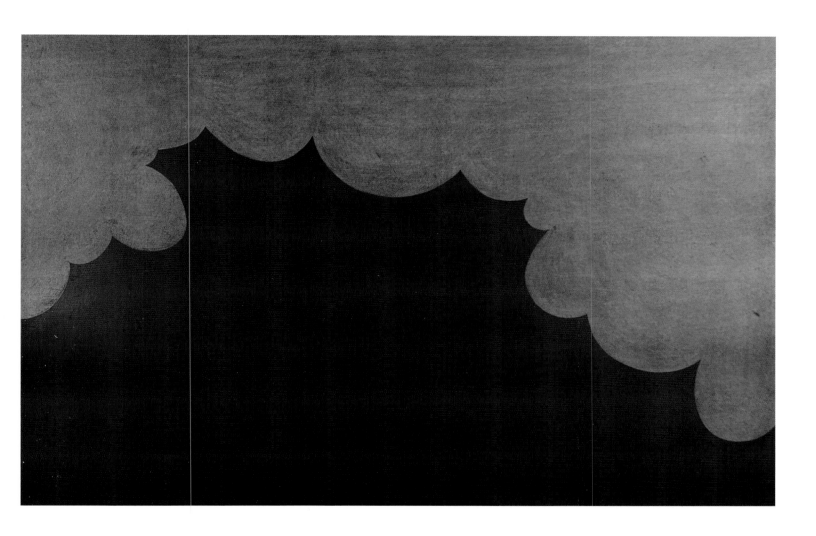

Franz Wacik

Wolken Clouds, 1930–1938
Pastell auf Papier pastel on paper, 25 x 32 cm

Dieses Studienblatt von Franz Wacik zeigt eine detailgetreue, naturalistische Wiedergabe einer sogenannten Cumulus-Wolke. Der hauptsächlich als Grafiker arbeitende Secessionist – er wurde am 13. April 1910 in die Künstlervereinigung aufgenommen – beschreibt die Masse der Wolke als sich aufbauschendes Naturphänomen und weich abgestuftes Seherlebnis mit feinen, zeichnerischen Nuancen. Das undatierte Blatt diente ihm wohl als Entwurf und auch als „Fingerübung".

Der bei Alfred Roller an der Kunstgewerbeschule (1901–1902) und in der Folge bei Christian Griepenkerl (1902–1906), Franz Rumpler (1906–1907) und Heinrich Lefler (1907–1908) an der Akademie der bildenden Künste ausgebildete Künstler spezialisierte sich bereits früh auf Illustrationsgrafik und Karikatur. In den 1920er und 1930er Jahren trat er besonders als Illustrator von unzähligen Publikationen im didaktischen Bereich hervor. Kinderbücher und Märchen, aber auch Biografien und Schulbücher zählten zu seinen Hauptaufgaben. Alexandra Matzner

This study by Franz Wacik shows a detailed, naturalistic depiction of a cumulus cloud. A Secessionist who was admitted to the association on 13 April 1910, Wacik worked mainly as a graphic artist. In this work he renders the mass of cloud as a billowing phenomenon in nature and a visual experience and uses soft gradations with delicately drawn nuances. This undated work must have been a sketch or a "finger exercise" for the artist.

The artist trained with Alfred Roller at the College of Arts and Crafts (1901–1902) and then studied at the Academy of Fine Arts with Christian Griepenkerl (1902–1906), Franz Rumpler (1906–1907) and Heinrich Lefler (1907–1908). At an early stage he specialized in illustration and caricatures. In the 1920s and 1930s he made his name as an illustrator of countless educational publications and worked on children's books and fairy tales as well as biographies and schoolbooks. Alexandra Matzner

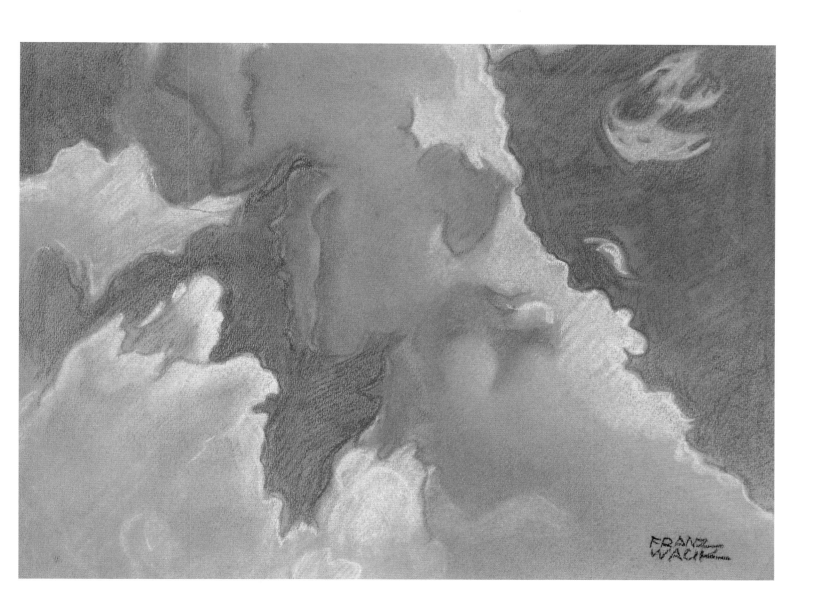

Martin Walde

Die Daten rufen nur vage Vorstellungen hervor
The Data Just Cause Vague Ideas, 1990
Filzstift auf Papier felt pen on paper, 49 x 70 cm

Die vorliegende Arbeit Martin Waldes entstammt der Serie „ABC Worlds",
einer Reihe von Zeichnungen, die zwischen 1986 und 1990 entstand.

„ABC Worlds" ist inspiriert von Spruchbildern, die häufig die Wände von Büros
zieren. Die Serie hat algorithmischen Charakter, alle Zeichnungen sind anti-
narrativ, auch wenn die Betrachtung eine zeitliche Ebene implizieren will. Walde
geht vom Comicstrip aus, wo der Blick von einem Gegenstand zum anderen
wandert, um die Zusammenhänge zu filtern, bei ihm jedoch spielen Zeit und
Kausalitäten keine Rolle. Im Vordergrund stehen die Diskontinuitäten im Raum
als Manifestation einer diskontinuierlichen Welt.

Die vorliegende Arbeit hat ikonografischen Charakter, die Anordnung der Linien
könnte einem Holzschnitt entsprechen. Das Nebeneinander von Kralle, Wolken
und Text lässt eine Interpretationslücke für den Betrachter. Das Vage könnte
bedrohlich sein, die Wolke ein Verweis auf Daten, die das Büro hortet.

Das Bildungsgesetz der Serie „ABC Worlds" besagt, dass im Idealfall sieben gleiche
Varianten eines Bildes entstehen. Nicht das Motiv, sondern die feinen Differenzen
bilden dabei das künstlerische Hauptinteresse. Wo das Bildungsgesetz nicht
eingehalten wurde, kam das Gesetz der Inkonsequenz und Irrelevanz zum Tragen.

Das Medium Zeichnung diente Martin Walde lange Zeit als Storyboard für sein
späteres künstlerisches Schaffen. Für ihn hat die Zeichnung weniger den
Charakter der Identitätsfindung als jenen eines intermediären Mittels. Der
Künstler entwickelte damit ein Vokabular, das er nachhaltig in seinem
fortlaufenden Werk nutzen kann. Erwin Uhrmann

This work by Martin Walde is from the series "ABC Worlds", a sequence of drawings
the artist created between 1986 and 1990.

"ABC Worlds" is inspired by images with slogans that often decorate office walls. The
series has an algorithmic character; all of the drawings are anti-narrative, even though
viewing them implies a certain time frame. Walde bases this on comic strips in which
the viewer's eyes flit from one subject to the next to find out how they are connected.
However, time and the relation of causalities hold no significance for the artist. He
actually places an emphasis on the discontinuities that manifest a discontinuous world.

This work has an iconographic character and the composition of the lines resembles a
woodcut. The juxtaposition of claw, clouds and text leaves a great deal open to inter-
pretation for the viewer. The "vagueness" referred to in the text could be interpreted as
threatening and the cloud could be seen as a reference to "data" stored by the office.

The compositional rule of the series "ABC Worlds" states that ideally there should be
seven variations of a picture. The artistic focus is not the motif but the subtle
differences between the images. In cases where the compositional rule was not
obeyed, the rule of inconsistency and irrelevance entered into effect.

Martin Walde used the medium of drawing for a long time as a storyboard for his later
art. For him drawing was less about finding his identity and more an intermediary
method. The artist developed a vocabulary with this that he could then use as a lasting
resource in his subsequent work. Erwin Uhrmann

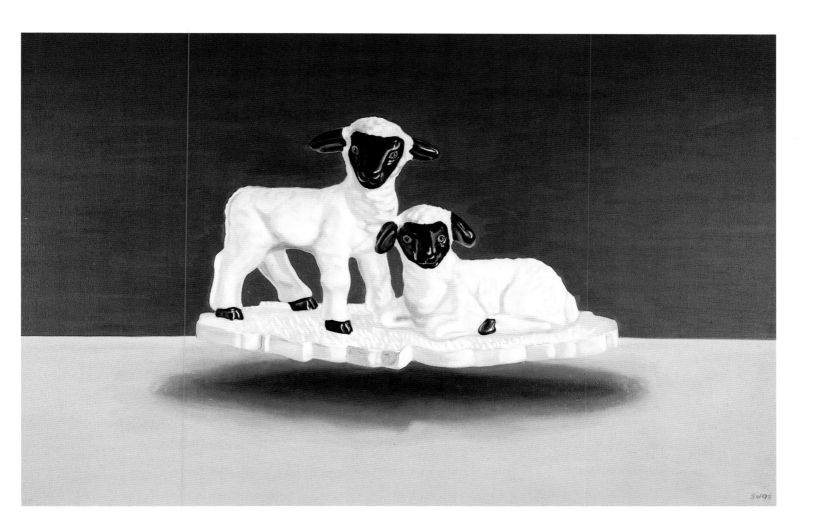

Jana Wisniewski

Fotomärchenbuch Fairytale Photo Book, 1980
Schwarzweißfotos in Buchform black and white photographs in book size, 24 x 30,5 cm

„Eine Schwalbe bringt noch keinen Sommer und eine zufällige Wolke noch kein
Stimmungsbild", belehrte uns 1955 der „Fotorat" in Heft Nr. 32 mit dem Titel
„Wolken ins Bild". – Wie um das konterkarierend zu illustrieren, hebt Jana
Wisniewskis Fotomärchenbuch in „grimmigem", bedeutungsschwangerem
Tonfall an: „Die sieben Raben flogen ...", lesen wir eingangs, über fünf foto-
grafierten Studien maniert gedrehter Hände – als opener, als deiktische
Gesten und gleichwohl Akteure in einem Schatten(theater)spiel.

Nichts anderes ist Fotografie, und über ihre Bilder werden wir durch Wien
geführt; als Stadt, in der „ein glücklicher Menschenfresser" lebt, und die sich
ziemlich fantastisch gibt. Wie ein Rebus wirken die meisten der 32 Motive, die
sich zum Leporello fügen, und dieses, hochkant gestellt und entsprechend
arrangiert, mutet wiederum fast an wie ein Labyrinth. Eigene Aufnahmen finden
sich collagiert, zerrissen, mit Text kombiniert und neuerlich abgelichtet, um
Dreidimensionalität am planen Papier zu simulieren. Eine Paraphrase auf
Märchen, gewiss; auf ihre handfeste Ethik, ihre schwarzweißen Bilder. So rückt
stimmungsunterstützend eine dräuende Wolke ein, durch die Sonne von hinten
mit Licht umbändert. Ulrike Matzer

"A swallow doesn't make it summer and a random cloud doesn't make an atmospheric
picture" are the cautioning words in issue 32 of the journal "Fotorat" in 1955, published
with the title "Wolken ins Bild" (Clouds in the Picture). As if to illustrate exactly the
opposite, Jana Wisniewski's Fairytale Photo Book starts off with a "grim" and grave
tone: "The seven ravens flew ...". We read this at the beginning above five photo-
graphed studies of mannered, turned hands – acting as an opener, as deictic gestures
and also performers in a shadow play.

Photography is no different from this and her pictures guide us through Vienna, a city
where a "happy cannibal lives" and which presents itself as a pretty fantastic place.
Most of the thirty-two motifs seem like puzzles, which have been compiled into a
concertina book and this in turn, placed on end and arranged accordingly, could almost
resemble a labyrinth. Some of the images have been collaged, torn, combined with
text and photographed again to simulate a three-dimensional effect on the flat paper.
It is a paraphrase of fairy tales, no doubt, and of their stern ethics and black-and-white
images. In this picture the atmosphere is enhanced by a threatening cloud, the sun
illuminating it from behind, encircling it with light. Ulrike Matzer

Robert Zeppel-Sperl

Die Innenseite der Aussenseite The Inside of the Outside, 1970
Farblithographie auf Papier colour lithography on paper, 50 x 65 cm

Was wäre, so scheint Robert Zeppel-Sperl in diesem Bild zu überlegen, wenn sich
der Himmel nicht über einem mehr oder weniger gerade verlaufenden Horizont
ausspannte, also die Kugel ihre kugelige Form aufgäbe, um gleichsam den
Himmel zu umarmen? Was wäre, wenn im Zentrum dieses Himmels eine gött-
liche Figur säße, von Wolken und Energie umgeben? Und was wäre, wenn diese
göttliche Figur, das Menschenpaar beobachtend, erschreckte? Dann – so mag
man darauf antworten – wäre es wohl nicht nur ein Bild einer theozentrischen
Weltauffassung, sondern auch eines, in dem Gott der Menschheit gewahr wird.

Der Maler Zeppel-Sperl ist heute bekannt für seine poppigen, üppig ornamen-
tierten, phantasievollen Bilder, in denen er Anregungen der Wiener Phantastischen
Realisten, von revolutionären Beatles-Covers, aber auch von Hieronymus Bosch
verarbeitete. In vielen seiner um 1970 entstandenen Bilder finden sich himm-
lische Gestalten, die von Wolken umkreist werden. Das Göttliche erschien bereits
den alten Griechen in Form einer Wolke, in den Bildern Zeppel-Sperls sind sie
Trennung, aber auch Verbindung zwischen Mensch und Gott. Die Wolke ist hier
nicht Wetterphänomen oder Landschaftselement, sondern wird verwandelt zur
Bühne der Gottesschau. Alexandra Matzner

What would it be like, Robert Zeppel-Sperl seems to be musing in this picture, if the
sky no longer stretched across a virtually straight horizon? If the globe in fact
relinquished its globular form as if to embrace the sky? What would it be like if at the
sky's centre there was a divine figure, surrounded by clouds and energy? And what
would happen if this divine being, watching the two people, had a fright? Then – one
could answer – it wouldn't only be a picture of a theocentric view of the world but an
image in which God was also aware of humanity.

The painter Zeppel-Sperl is known today for his psychedelic, richly decorated,
imaginative pictures in which he absorbed inspiration from the Viennese Fantastic
Realists, revolutionary Beatles' covers, and also Hieronymus Bosch's imagery. Divine
figures surrounded by clouds can be found in many of his pictures dating from around
1970. Divinity appeared in the form of a cloud as far back as the ancient Greeks. In the
pictures by Zeppel-Sperl, however, clouds formed a division and also a connection
between humanity and God. Here the cloud is not a product of the weather or an
element in the landscape but is transformed into a stage for this divine vision.
Alexandra Matzner

David Ziegelman, alias Philipp Preuss

Himmel über Berlin, Regie: Philipp Preuss
Sky above Berlin, directed by Philipp Preuss, 2000
Danchlor auf Denim Danchlor on denim , je each 130 x 190 cm

Was macht eine Wolke zu einer Wolke? Oder genauer, welches indexikalische
Zeichen kann noch als Wolke wahrgenommen werden? Philipp Preuss, alias
David Ziegelman, zeigt, dass Wolken auch Fehlstellen im Himmelsblau sein
können. Sein dreiteiliges Bild „Himmel über Berlin" wirkt wie ein Fensterausblick.
Die ausgefransten weißen Flecken auf dem Blau entstanden durch Bleichen von
blauem Denimstoff mittels Danchlor. Der Malerei, einem additiven Vorgang,
stellt Ziegelman hier den Prozess des Wegnehmens und des Zufalls entgegen.

Der Regisseur Philipp Preuss lässt seine Kunstfigur David Ziegelman über Berlin
resümieren: „Ich hatte von Berlin aus der Ferne 2000 Vorstellungen im Kopf. Da
war der Reichspalast, da waren Skins, da war der wunderbare Wenders-Film und
ganz viele Erinnerungsgedanken in Schwarz-Weiß aus Erzählungen meiner Ver-
wandten. Und dann war ich plötzlich da und ein Supermarkt und eine Boutique
waren um die Ecke." Mit Hilfe der fiktiven Figur mischt sich Preuss auch in die
deutsche Diskussion rund um das Holocaust-Mahnmal und Gedenkstätten in
Berlin. „Himmel über Berlin" entpuppt sich so nicht nur als eine Verneigung vor
Wim Wenders gleichnamigem Film, sondern auch als Reflexion über historisches
Erbe, über Kommerzialisierung von Bild- und Materialcodes, aber auch über die
Freiheit, diese beliebig umzudeuten. Alexandra Matzner

What exactly is it that makes a cloud a cloud? Or more precisely, which indexical sign
can be perceived as a cloud? Philipp Preuss, alias David Ziegelman, shows that clouds
can also be gaps in the sky. His three-part picture "Sky above Berlin" is like a view
from a window. He created the frayed white areas on the blue background by
bleaching blue denim with Danchlor. Ziegelman is contrasting painting, a process of
addition, with this method of removing and element of coincidence.

The director Philipp Preuss gave the following words to his art persona David
Ziegelman to sum up his thoughts about Berlin: "From a distance I had 2000 ideas in
my head about what Berlin would be like. There was the Reichspalast, there were the
skinheads, there was that wonderful Wenders' film and many memories in black-and-
white from relatives' stories. Then suddenly I was there and a supermarket and a
boutique were around the corner." With the help of this fictional character, Preuss
became involved in the discussion in Germany about Berlin's Holocaust Memorial.
"Sky above Berlin" emerges not only as a mark of respect to Wim Wenders' film
("Wings of Desire") of that name but also reflects on the historical heritage and the
commercialization of pictorial and material codes – as well as our freedom to
reinterpret these as we wish. Alexandra Matzner

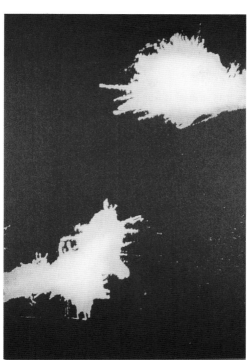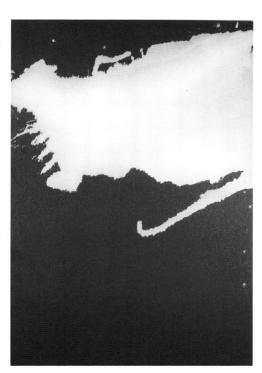

Wenn nicht anders angegeben, befinden sich alle hier angeführten Kunstwerke in der Sammlung der Kulturabteilung der Stadt Wien MUSA und weisen einen Bezug zur vorliegenden Thematik auf. Blau gedruckte Signaturen kennzeichnen Werke in der Ausstellung.

Unless otherwise stated all works of art in the catalogue form part of the Collection of the Department for Cultural Affairs of the City of Vienna MUSA and have a relation to the subject at hand. All references printed in blue indicate works of art that actually form part of the exhibition.

Angeli Eduard, * 1942 in Wien in Vienna, **lebt in Wien** lives in Vienna

O.T. Untitled, 2005
Farblithographie auf Papier colour lithography on paper
58,8 x 75,6 cm

..

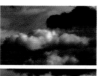
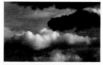

Appelt Siegrun, * 1965 in Bludenz / A, **lebt in Wien** lives in Vienna

Clouds, 1996
Dia-Installation slide installation
Größe variabel size variable

..

Arnoldi Henrique de, * 1905 in Brasilien in Brasil † 1979 in Wien in Vienna

Ein Blick auf Wien von der Himmelsstrasse View on Vienna from Himmelsstrasse,1970
Öl auf Holzfaserplatte oil on wood fiber plate
41,5 x 55 cm

..

B. Ona, * 1957 in Wien in Vienna, **lebt in Wien** lives in Vienna

Nordlicht Northern Lights, 1992
Acryl auf Leinwand
acrylic on canvas
200 x 200 cm

Triadic Memories, 1997
Acryl auf Leinwand
acrylic on canvas
200 x 180 cm

Wrappings, 1995/2005
Farbfotos colour photographs
je each 42,3 x 32,6 cm

..

Bachler Hildegund, * 1959
in Salzburg / A, lebt in Wien
lives in Vienna

Touching the sky
(Agnolo Bronzino), 1997
Farbfoto auf Papier
colour photograph on paper
47 x 84 cm

Baldasti Gerhard, * 1955
in Güssing / A, lebt in Wien
lives in Vienna

O.T. Untitled, 1996
Öl auf Leinwand oil on canvas
220 x 170 cm

Bartrix-Ziegler Barbara, * 1943
in Neutitschein / CZ † 1989
in Wien in Vienna

Geistiges Menschenleben
Mental Human Life, 1975
Acryl und Aquarell
acrylic and watercolour
67,8 x 95,7 cm

Bauer Jürgen, * 1969 in Schwaz / A,
lebt in Wien lives in Vienna

Wolke 7 Cloud 7, 2006
Druck auf Papiertragetasche
print on paper bag
36 x 22 cm

Bechtold Astrid, * 1969 in Rank-
weil / A, lebt in Wien lives in Vienna

O.T. Untitled, 2001
Doppelbelichtete Farbfotos auf
Aluminium double exposed
colour photographs on aluminum
30 x 150 cm

Bergler Fritz, * 1955
in St. Lorenzen im Mürztal / A,
lebt in Wien lives in Vienna

Himmel Heaven, 2004
Öl, Paraffin auf Karton
oil, paraffin on cardboard
je each 61 x 46,5 cm

Beschorner Lieselott, * 1927
in Wien in Vienna, lebt in Wien
lives in Vienna

Komposition Composition, 1961
Tempera auf Papier tempera on paper
34,2 x 29,7 cm

Blaskovic Aimée, * 1974 in Wien in
Vienna, lebt in Wien lives in Vienna

Luft Air, 1998
Polaroidfotos, Plexiglas,
Aluminium polaroid photographs,
plexiglass, aluminum
je each 10,1 x 10,3 x 3,5 cm

Bodnar Eva, * 1952 in Budapest / H,
lebt in Wien lives in Vienna

O.T. Untitled, 1986
Öl auf Leinwand oil on canvas
120 x 100 cm

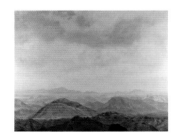

Braunsteiner Paul, * 1948
in Gmünd / A, lebt in Wien
lives in Vienna

Gelber Sandberg
Yellow Sand Hill, 1998
Öl, Alkyd auf Hartfaserplatte
oil, alkyd resin on wood fiber plate
125 x 140 cm

Breuss Elisabeth, * 1965
in Dornbirn / A, lebt in Wien
lives in Vienna

O.T. Untitled, 1994
Graphitzeichnung und Magnet-
felder mit Eisenstaub auf Japan-
papier graphite and magnetic fields
with iron dust on japanese paper
300 x 300 cm

Buchta Wolfgang, * 1958
in Wien in Vienna, lebt in Wien lives
in Vienna

O.T. Untitled, 1987
Aquarell auf Papier
watercolour on paper
100 x 70 cm

...

Choung-Fux Eva, * 1935 in Wien in
Vienna, lebt in Wien lives in Vienna

Nebelbild Mist Picture, 2004
Hochdruck auf Japanbütten letter-
press on Japanese handmade paper
52,5 x 25 cm

...

Cmelka Helga, * 1952 in Mödling / A,
lebt in lives in Brunn am
Gebirge / A

Cumulus humilis – entstehen
mittags, Auflösung abends, meist
beständiges Schönwetter Cumulus
humilis – Fair Weather Clouds that
appear at Midday and disperse in
the Evening, 2008/2009
Verzinkter Eisendraht, Polyester-
gewebe galvanized iron wire,
polyester fabric, diverse various Ø
Leihgabe der Künstlerin
loan of the artist

...

Dotrel Peter, * 1942 in Wien
in Vienna, lebt in Wien lives in Vienna

Objekt Object, 1971
Öl und Acryl auf Leinwand
oil and acrylic on canvas
100 x 80 cm

...

Dreux Béatrice, * 1972 in
Versailles / FR, lebt in Wien
lives in Vienna

ciel // purpur 01–04, 2008
Farbfotos colour photographs
je each 30 x 53 cm
Leihgabe der Künstlerin
loan of the artist

...

Eberl Irma, * 1953 in Seeshaupt / D,
lebt in Wien lives in Vienna

O.T. Untitled, 1992
Acryl auf Leinwand
acrylic on canvas
150 x 142 cm

O.T. Untitled, 1992
Acryl auf Jute acrylic on jute
150 x 142 cm

...

Ecker Gottfried, * 1963 in Linz / A,
lebt in Wien lives in Vienna

Schädeldecken – lose Gedanken
Scullcaps – Loose Thoughts, 1994
Farbstift auf Papier
colour pencil on paper
je each Ø 79 cm
Leihgabe des Künstlers
loan of the artist

O. T. Untitled, 1998
Holz, Papier, Ölfarbe
wood, paper, oil
35 x 120 cm
Privatbesitz
private ownership

...

Ecker Pamela, * 1974
in Schärding / A, lebt in Wien
lives in Vienna

Aus der Serie „Lichtfinsternisse"
from the series "Light Darkness",
2000
Farbradierungen auf Papier
colour etchings on paper
40 x 30 cm

...

Engelhardt Khy, * 1948 in
Duderstadt / D, lebt in Wien
lives in Vienna

Ufos über Simmering
Ufos over Simmering, 1996
Video, 18:15 min

...

207

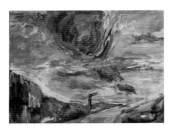

Fieglhuber-Gutscher Marianne,
* 1886 in Wien in Vienna
† 1978 in Graz / A

Rote Wolke Red Cloud, 1955
Tempera auf Papier
tempera on paper
48,5 x 62,5 cm

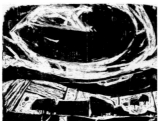

Fladerer Herbert, * 1913 in Wien
in Vienna † 1981 in Wernstein / A

Große Wolke Big Cloud, 1956
Holzschnitt auf Papier
woodcut on paper
43,7 x 57,9 cm

Fleischmann Norbert, * 1951
in Wien in Vienna, lebt in lives in
Gföhl / A

Nur ein wenig kalt
Only a bit cold, 1985
Mischtechnik auf Homogenplatte
mixed media on homogeneous plate
61 x 100 cm

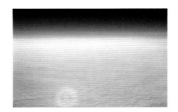

Fodor Gyula, * 1953 in Dorog / H,
lebt in Wien lives in Vienna

O.T. (Donautal mit geschlossener
Wolkendecke) Untitled (Danube
Valley with Closed Cloud Cover), 2006
C-Print auf Aluminium
C-print on aluminum
90 x 120 cm

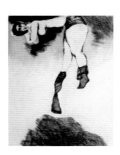

Frohner Adolf, * 1934
in Großinzersdorf / A † 2007
in Wien in Vienna

Die Todeswolke
The Death Cloud, 1973–1974
Radierung auf Papier
etching on paper
76,2 x 56,4 cm

Gappmayr Heinz, * 1925
in Innsbruck / A, lebt in lives in
Innsbruck / A

vertikal vertical, 1979
Schwarzweißfoto
black and white photograph
60 x 50,2 cm

Gauss Brigitte, * 1953
in Grieskirchen / A, lebt in Wien
lives in Vienna

Windhund in den Wolken
Greyhound in the Clouds, 1984
Bleistift, Pastel auf Papier
pencil, pastel on paper
29,6 x 41,9 cm

Gottfried Markus Maria, * 1971
in Wien in Vienna, lebt in Wien
lives in Vienna

Manuela zerschlägt ein Glas
Manuela Breaks a Glass, 1999
Siebdruck auf Papier
screenprint on paper
68 x 50 cm

Yvonne, 1999
Siebdruck auf Papier
screenprint on paper
68 x 50 cm

Fritz, 1999
Siebdruck auf Papier
screenprint on paper
68 x 50 cm

Gross Gertraud, * 1923 in Teschen
/ PL, lebt in Wien lives in Vienna

Gewitterbäume Trees of Thunder
undatiert undated
Öl auf Leinwand oil on canvas
65 x 80 cm

Grossmann Silvia, * 1957
in Zürich / CH, lebt in Wien
lives in Vienna

Westwärts 5–8 Westwards 5–8, 2006
Schwarzweißfotos auf Baryt black
and white photographs on barite
je each 39,5 x 55,3 cm

Härtel Hermann, * 1943
in Korneuburg / A, lebt in Wien
lives in Vienna

Die Schneewolke
The Snow Cloud, 1977
Aquarell auf Papier
watercolour on paper
22 x 32,5 cm

Hauer-Fruhmann Christa, * 1925
in Wien in Vienna, lebt in
lives in Lengenfeld / A

blau-grün blue-green, 1964
Aquarell auf Papier
watercolour on paper
30 x 44 cm

...

Haug Egon, * 1923 in Kežmarok / H,
lebt in Wien lives in Vienna

Aufgehender Mond
Rising Moon, 1961
Aquarell auf Papier
watercolour on paper
33,4 x 48,4 cm

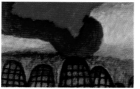

Strohtristen und rotblaue Wolke
Haystacks and red-blue Cloud, 1974
Öl auf Leinwand oil on canvas
70 x 80 cm

Getreidefelder Cornfields,
undatiert undated
Aquarell auf Papier
watercolour on paper
36,5 x 53 cm

...

Hausner Rudolf, * 1914 in Wien
in Vienna † 1995 in Wien in Vienna

Adam und sein Maschinist
Adam and his Machinist, 1974
Lithographie auf Papier
lithography on paper
79,5 x 64,7 cm

...

Hazai Susan, * 1899 in Varasdin / H
† 1985 in Wien in Vienna

Organisches Werden
Organic Progression 1966
Kugelschreiber auf Papier
ballpen on paper
34 x 28,9 cm

Heer Joseph, * 1954 in Wien in
Vienna, lebt in Wien lives in Vienna

O.T. Untitled, 2001
Mischtechnik auf Textil
mixed media on canvas
162 x 162 cm

...

Heindl Ursula, * 1959 in Wien in
Vienna, lebt in Wien lives in Vienna

O.T. Untitled, 1993
Öl auf Holz oil on wood
120 x 90 cm

O.T. Untitled, 1987
Öl auf Leinwand oil on canvas
110 x 100 cm

...

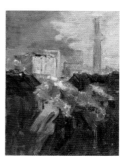

Helfert Wilhelm, * 1922 in Baum-
garten / A † 1991 in Wien in Vienna

Adalbert-Stifter-Strasse, Herbst
Adalbert-Stifter-Street, Autumn, 1973
Öl auf Leinwand oil on canvas
80 x 60 cm

...

Heller Rudolf, * 1966 in Innsbruck /
A, lebt in Wien lives in Vienna

Von A nach B From A to B, 1996
Kunstharz und Fackelruss auf
Molino synthetic resin and torch
soot on molino
zweiteilig, je
two-part, each 115 x 115 cm

...

Hikade Karl, * 1942 in Wien in
Vienna, lebt in Wien lives in Vienna

Sky, 1972
Eitempera, Acryl auf Molino
egg tempera, acrylic on molino
110 x 115 cm

4 Sky piece, 1977
Pastell, Papier auf Karton
pastel, paper on cardboard
54 x 80 cm

...

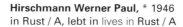

Hirschmann Werner Paul, * 1946
in Rust / A, lebt in lives in Rust / A

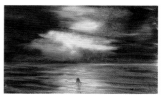

Abend am See
Evening at the Lake, 1976
Öl auf Holzfaserplatte
oil on wood fiber plate
19,5 x 32,5 cm

...

Hofer Albert, * 1945 in Kufstein / A, lebt in Wien, Innsbruck und Venedig / I lives in Vienna, Innsbruck / A and Venice / I

Verborgene Person
Hidden Person, 1974
Acryl und Gouache auf Papier
acrylic and gouache on paper
88 x 60 cm

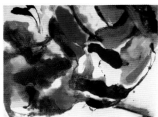

Hollegha Wolfgang, * 1929 in Klagenfurt / A, lebt in lives in Semriach / A

Variationen über ein Wurzelstück
Variations on a Root, 1971
Öl auf Leinwand oil on canvas
100 x 130 cm

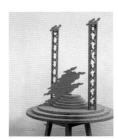

Höllwarth Gottfried, * 1945 in Salzburg / A, lebt in Wien und Hainfeld / A lives in Vienna and Hainfeld / A

Grüner Wolkensitz (Modell)
Green Cloud Seat (Model), 1980
Holz, Holzfaserplatte wood, wood fiber plate
81 x 76 x 76 cm
Leihgabe des Künstlers
loan of the artist

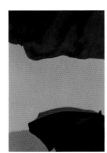

Eva Holter, * 1952 in Budapest / H, lebt in Wien lives in Vienna

O.T. 2 Untitled 2, 1982
Farbfoto colour photograph
25,3 x 20,2 cm

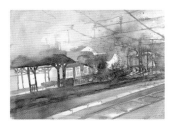

Horak Helmut, * 1947 in Fritzlar / D, lebt in Wien lives in Vienna

Bahnhof Penzing
Train station Penzing, 1991
Aquarell auf Papier
watercolour on paper
36 x 48 cm

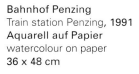

Huber Eva, * 1953 in Wien in Vienna, lebt in Wien lives in Vienna

O.T. Untitled, 1985
Mischtechnik auf Papier
mixed media on paper
32 x 46 cm

Huber Lisa, * 1959 Afritz / A, lebt in Wien lives in Vienna

Von Plage und Strafe Gottes, aus der Serie „Das Narrenschiff"
Of God's Plagues and Punishments, from the series "The Ship of Fools"
2001
Farbholzschnitt mit Acryl-Unter-malung auf Papier woodcut with arcrylic underpainting on paper
Druckplatte printing plate
39,7 x 30,7 cm

Hubmann Franz, * 1914 in Ebreichsdorf / A † 2007 in Wien in Vienna

Der Westbahnhof in Wien Train Station Vienna Westbahnhof, 1947
Schwarzweißfoto black and white photograph
30 x 24 cm

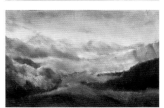

Hutar Gerhard, * 1943 in Wien in Vienna, lebt in Wien lives in Vienna

Landschaften mit Einschnitten
Blots on the Landscape, 1976
Mischtechnik auf Papier
mixed media on paper
83,5 x 105 cm

Jackson Lydia, * 1933 in Wien in Vienna, lebt in lives in Salzburg / A

Im Drautal In the Drau Valley, 1978
Pastellkreide auf Papier pastel chalk on paper
33,5 x 49,5 cm

Jaschke Gerhard, * 1949 in Wien in Vienna, lebt in Wien lives in Vienna

Austria forever, 2002
Collage auf Papier collage on paper
41,5 x 31,5 cm

Jelic Sanja, * 1973 in Siroki Brijeg / BIH, lebt in Wien lives in Vienna

Wien intern Vienna internal, 1999
Farbfoto-Collage auf Papier
colour photograph collage on paper
70 x 100 cm

Jöchl Hans, * 1939
in St. Sebastian / A
† 2003 in Wien in Vienna

Wolkenbild Cloud Picture, 1985
Farbstift auf Papier
colour pencil on paper
94,5 x 71 cm

Wolkenbild Cloud Picture, 1980
Acryl auf Holzfaserplatte
acrylic on wood fiber plate
67 x 85,5 cm

Wolkenbild Cloud Picture, 1993
Zeichnung auf Papier
drawing on paper
70 x 94 cm

...

Kabas Robert, * 1952 in
Purgstall / A, lebt in Wien
lives in Vienna

Dunkles Gewässer Dark Waters,
1991
Acryl auf Leinwand acrylic on canvas
4-teilig four-part, 74 x 114 cm

...

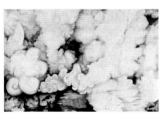

Kampfer August, * 1950 in Wien in
Vienna, lebt in Wien lives in Vienna

O.T. Untitled, 1969
Bleistiftzeichnung auf Papier
pencil drawing on paper
21 x 29 cm

...

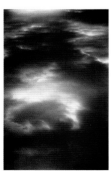

Kempinger Herwig, * 1957
in Steyr / A, lebt in Wien
lives in Vienna

070499-300699, 1999
Computerfotografie auf Acrylglas
und Aluminium computer photo-
graph on acrylic glass and aluminum
200 x 130 cm

...

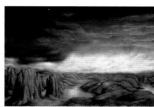

Kies Helmut, * 1933 in Wien in
Vienna, lebt in Wien lives in Vienna

Landschaft mit aufsteigendem
Gewitter Landscape with
Approaching Thunderstorm, 1961
Öl auf Paneel oil on panel
27 x 40 cm

Stadtbild von Wien
View of the City of Vienna, 1960
Tusche auf Papier ink on paper
24,9 x 34,8 cm

Der Meiler The Kiln, 1971
Radierung auf Papier
etching on paper
38 x 53 cm

...

Klein Eva, * 1959 in Linz / A,
lebt in Wien lives in Vienna

Sinnlich-t Objekt
Sinnlich-t object, 1986
Plexiglaskasten, Blinklämpchen,
Niederspannung plexiglass box,
blinking lights, low voltage
42 x 60 x 10 cm

...

Klinkan Alfred, * 1950 in Juden-
burg / A † 1994 in Wien in Vienna

Tradition der Wolke
Tradition of the Cloud, 1985
Siebdruck auf Papier
screenprint on paper
49,9 x 65,6 cm

...

Klučarić Claudia, * 1968 in Graz / A,
lebt in lives in Unterrohrbach / A

Drüber, unwissendes Blau,
der Himmel (nach Christa Wolf,
Kein Ort. Nirgends) The Unknowing
Blue of the Sky Above (after Christa
Wolf, No Place on Earth), 1995
Bleistift und Buntstift auf Papier
pencil and coloured pencil on paper
35,1 x 49,7 cm

...

Kodera Peter, * 1937 in Wien
in Vienna, lebt in Wien lives in Vienna

Inseln Islands, 1963
Kunstharz, Sand auf Holzplatte
synthetic resin, sand on wood panel
85 x 130 cm

Koller Bernd, * 1971
in Schwarzach / A, lebt in Wien
lives in Vienna

Die Wolken The Clouds, 2000
Bleistift, Aquarell auf Papier
pencil, watercolour on paper
28 x 38,5 cm

Kriebaum Rudolf, * 1942 in Wien
in Vienna, lebt in Wien lives in
Vienna

Strahlende Welt Bright World, 2000
Farbradierung auf Papier
colour etching on paper
27 x 32,7 cm

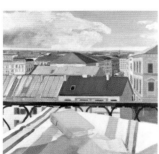

Krön Markus, * 1970 in Salzburg /
A, lebt in Wien lives in Vienna

Hernals, 1994
Öl auf Leinwand oil on canvas
70 x 70 cm

Die letzten Baugründe
The Last Building Sites, 2003
Öl auf Leinwand oil on canvas
140 x 240 cm

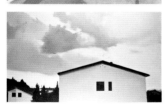

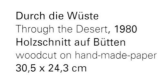

Kronheim Auguste, * 1937 in
Amsterdam, lebt in Wien
lives in Vienna

Durch die Wüste
Through the Desert, 1980
Holzschnitt auf Bütten
woodcut on hand-made-paper
30,5 x 24,3 cm

Shang-Shung, Himmelsreisen –
„Mein Weg ist der Saum einer
purpurnen Wolke" Shang-Shung,
Sky Voyage – "My Way is the Marge
of a Purple Cloud", 1992
Holzschnitte auf Bütten
woodcuts on hand-made-paper
24,2 x 36 cm

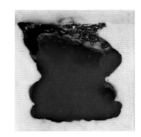

Krumpel Helmut, * 1941 in Wien
in Vienna, lebt in lives in Texing / A

Rote Mauer Red Wall, 1972
Gouache auf Transparentpapier
gouache on transparent paper
66,4 x 33,5 cm

Kunitzberger Hanns, * 1955 in
Salzburg / A, lebt in Wien lives in
Vienna

A.M. (= Alter Mann)
A.M. (= Old Man), 1997
Öl auf Molino oil on molino
100 x 200 cm

Laber Gerhard, * 1941 in
Sieghartskirchen / A, lebt in Wien
lives in Vienna

Wolkenzieherin
Female pulling the Cloud, 1982
Buntstift auf Papier coloured pencil
on paper
44 x 60 cm

O.T. Untitled, 1983
Buntstiftzeichnung auf Papier
coloured pencil drawing on paper
30 x 40 cm

Laminger Peter, * 1955 in Villach / A,
lebt in Wien lives in Vienna

Stilleben Still Life, 1980
Gouache auf Papier
gouache on paper
24,9 x 38,9 cm

Lang Kurt, * 1940 in Innsbruck / A,
lebt in Wien lives in Vienna

Kurier Mai 1995, aus der
„Unendlichen Serie" Kurier May
1995 from „Endless Series", 1995
Zeitungen, Plexiglas (Opal 0,60)
newspapers, plexiglass (opal 0,60)
70 x 100 x 3,5 cm

Landschaft Landscape, 1984
Acryl auf Papier arcylic on paper
43,5 x 59 cm

..

Lebzelter Georg, * 1966 in Melk / A,
lebt in Wien lives in Vienna

Lichter Decimale, 1984
Farbradierung nach Foto
colour etching after photograph
49 x 34 cm

..

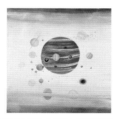

Lehmden Anton, * 1929 in Nitra / SK,
lebt in Wien lives in Vienna

Gestirne Luminaries,
undatiert undated
Aquarell auf Papier
watercolour on paper
25 x 25 cm

Skizze über Wien III
Study of Vienna III, 1960
Aquarell auf Papier
watercolour on paper
14,9 x 46,7 cm

Skizze für ein Wien-Bild II
Study for a Picture of Vienna II, 1960
Aquarell auf Papier watercolour on
paper
24 x 32,5 cm

Mondaufgang Moonrise, 1964
Öl auf Leinwand oil on canvas
91 x 250 cm

Sonnenuntergang Sunset, 1964
Öl auf Leinwand oil on canvas
91 x 250 cm

..

Leskoschek Axl, * 1889 in Graz / A
† 1976 in Wien in Vienna

Feuer vom Himmel
Fire from the Sky, 1964
Linolschnitt auf Papier
linocut on paper
30 x 39,9 cm

..

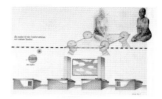

Lindinger Heinz, * 1940 in Wien in
Vienna, lebt in Wien lives in Vienna

Die Sache mit den vier Schorn-
steinen The Thing about the Four
Chimneys, 1971
Mischtechnik auf Papier
mixed media on paper
39,8 x 64 cm

..

Macheck Hellmuth, * 1924 in Wien
in Vienna, lebt in Wien lives in Vienna

Blick vom Bisamberg nach
Süd-Ost View of Bisamberg to
South-East, 1957
Federzeichnung auf Papier
pen drawing on paper
30 x 41 cm

..

Maderthaner Franziska, * 1962
in Wien in Vienna, lebt in Wien
lives in Vienna

O.T. Untitled, 1984-86
Gips und Öl auf Leinwand
gypsum and oil on canvas
56 x 63 cm

..

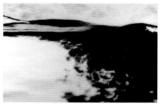

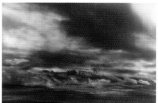

Maier Norman, * 1961 in Wien
in Vienna, lebt in Wien lives in Vienna

O.T. Untitled, 1999
Farbfoto colour photograph
89 x 134 cm

O.T. Untitled, 1999
C-Print hinter Diasec in Holzrahmen
C-print behind diasec in wood-frame
90 x 130 cm

..

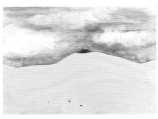

Maitz Petra, * 1962 in Wien
in Vienna, **lebt in Wien** lives in Vienna

Big mind, 1996
Öl auf Leinwand oil on canvas
42 x 61 cm

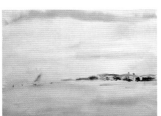

Mannhart Ruth, * 1920
in Stuttgart / D † 2004 in Wien
in Vienna

Bregenz, Blick auf Lindau
Bregenz, View of Lindau, 1956
Aquarell auf Papier
watercolour on paper
35,8 x 47,2 cm

Matejka-Felden, * 1901 in Dehlingen
/ FR † 1984 in Wien in Vienna

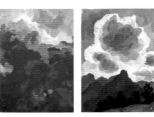

Wolken Clouds, 1970
Tempera auf Papier tempera on paper
62,8 x 43,5 cm

Blauer Berg und Wolkenstimmung
Blue Mountain and Cloud Atmosphere,
undatiert undated
Tempera auf Papier tempera on paper
60 x 43 cm

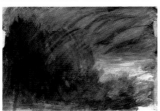

Gewitter Thunderstorm, 1979
Tempera auf Papier
tempera on paper
44 x 62,5 cm

Meierhofer Christine, * 1966
in München in Munich / D,
lebt in Wien lives in Vienna

Florian (Raum mit gestohlenem
Bild: C.D. Friedrich, Nebelschwaden,
1820) Florian (Room with stolen
picture: C.D. Friedrich, Wafting
Mist, 1820), **1997**
Inkjet-Print nach Computer-
Montage inkjet print of a
computer montage
65 x 100 cm

Mejchar Elfriede, * 1924 in Wien
in Vienna, **lebt in Wien** lives in Vienna

Rote Wolken Red Clouds, 1962
Foto in Baryt-, Splittingtonung
photograph in barite-, splitting tone
je each 25,4 x 23,5 cm

Menhardt Moje, * 1934 in
Hamburg / D, **lebt in Wien**
lives in Vienna

Donau-Ostwind-Wolken
Danube-Eastwind-Clouds, 2000–2002
Acryl auf Leinwand
acrylic on canvas
190 x 160 cm

Metykó Géza, * 1934 in Okony / H,
lebt in Wien lives in Vienna

Es war einmal
Once upon a time, 1974
Aquarell und Tempera
watercolour and tempera
75 x 106 cm

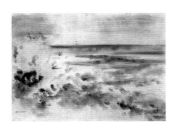

Moro Chris, * 1926 in Wien
in Vienna, **lebt in Wien**
lives in Vienna

Neusiedlersee Lake Neusiedl, 1979
Pastell auf Papier pastel on paper
30,5 x 42,5 cm

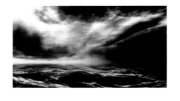

Monaco Julie, * 1973 in Wien in
Vienna, **lebt in Wien** lives in Vienna

cs_01/8, 2002
Lambdaprint auf Aluminium
lambda-print on aluminum
84 x 150 cm

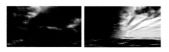

cs_02_0, 2006
C-Print
21 x 29,5 cm

cs_01_9, 2006
C-Print
21 x 29,5 cm

Müller Josh, * 1973 in Mainz / G,
lebt in Wien lives in Vienna

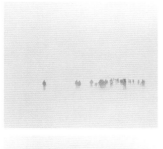

Somewhere, 2000
Konstruiertes Farbfoto
artificial colour photograph
112 x 150 cm

la construction du ciel
The construction of the Sky, 2001
DVD
5:40 min

Müller Karl, * 1947 in Klagenfurt / A,
lebt in Wien lives in Vienna

Schneeballschlacht im Mai
Snowball Battle in May, 1981
Batik auf Baumwolle batik on cotton
67,5 x 64,2 cm

..

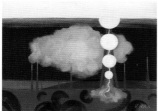

Müller Paul, * 1944 in Wien in
Vienna, lebt in Wien lives in Vienna

Impuls Impulse, 1980
Öl auf Leinwand oil on canvas
59,5 x 80 cm

..

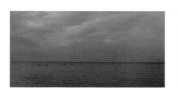

Neubauer Ruth, * 1980 in Steyr /
A, lebt in Wien lives in Vienna

It´s so real, 2002
Lambdaprints auf Kapaline
lambda-prints on kapaline
je each 70 x 115 cm

..

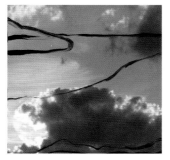

Nitzl Iris, * 1979 in Augsburg / D,
lebt in Wien lives in Vienna

Himmelsbeobachtung, Vogelflug,
30 min. Sky Oberservation,
Flight of Birds, 30 min., 2008
Farbfoto colour photograph
20 x 20 cm

Für die Vögel For the Birds, 2008
Holzfaserplatte, Öl auf Glas
wood fiber plate, oil on glass
139 cm, Ø 55 cm

..

Nubet Friedrich, * 1948 in Wien in
Vienna, lebt in Wien lives in Vienna

Ganz angenehm bewölkt
Quite pleasant cloudy, 1972
Siebdruck screenprint
46 x 65,5 cm

..

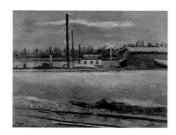

Paar Ernst, * 1906 in Graz / A
† 1986 in Wien in Vienna

Donaufähre Danube Ferry, 1936
Öl auf Leinwand oil on canvas
50 x 64 cm

..

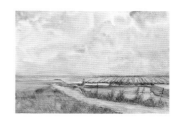

Passini Paul, * 1881 in Wien
in Vienna † 1956 in Wien in Vienna

Laaerberg, Weg nach Oberlaa
mit Flösserteich Laaerberg, Path to
Oberlaa and Flösserteich, 1955
Aquarell auf Papier
watercolour on paper
45 x 60 cm

..

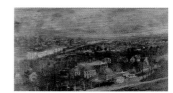

Pauser Sergius, * 1896 in Wien in
Vienna † 1970 in Klosterneuburg / A

Wiener Landschaft von der
Himmelhofwiese Viennese
Landscape of Himmelhofwiese, 1956
Öl auf Hartfaserplatte
oil on wood fiber plate
75 x 130 cm

..

Pfaffenbichler Hubert, * 1942 in
Ybbs / A † 2008 in Wien in Vienna

Hubert Pfaffenbichler
Blaue Wolke Blue Cloud,
undatiert undated
Siebdruck auf Papier
screenprint on paper
24,8 x 19,2 cm

..

Pick Robert, * 1911 in Wien in
Vienna † 2005 in Wien in Vienna

Garten Garden, 1964/65
Öl auf Leinwand oil on canvas
65 x 50 cm

..

Pisa Eva, * 1948 in Wien in Vienna,
lebt in lives in Perchtoldsdorf / A

Haute Couture, 1981
Mischtechnik auf Papier
mixed media on paper
29,4 x 20,9 cm

Pisk Michael Maria, * 1961
in Graz / A, lebt in Wien
lives in Vienna

Cracks & Distances
aus der Serie „Spur I"
aus dem Zyklus „Spurenbilder"
from the series "Trace" I from the
cycle "Trace Pictures", 1999
Spuren von Kasein auf Leinwand
traces of casein on canvas
100 x 100 cm

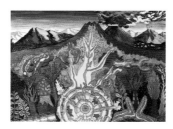

Pongratz Peter, * 1940 in
Eisenstadt / A, lebt in Wien
lives in Vienna

O.T. Untitled, 1975
Kunstdruck auf Bütten
art print on hand-made-paper
62 x 80 cm

Potuznik Heribert, * 1910 in Wien in
Vienna † 1984 in Großnondorf / A

Sommerabend Summer Evening,
undatiert undated
Monotypie auf Papier
monotype on paper
57,6 x 76,1 cm

Praetterhofer Hans, * 1943
in Wien in Vienna, lebt in Wien
lives in Vienna

Biomorphe Landschaft I
Biomorphic Landscape I, 1982
Aquarell auf Papier
watercolour on paper
33,5 x 51,7 cm

Praschl Stephan, * 1910 in Wien
in Vienna † 1994 in Wien in Vienna

Aus dem Steinfeld
From Steinfeld, 1955
Tempera auf Papier
tempera on paper
47,8 x 61,3 cm

Prelog Drago Julius, * 1939
in Cilli / SLO, lebt in Wien
lives in Vienna

Explosion Explosion, 1972
Öl auf Leinwand oil on canvas
150 x 130 cm

Prinz Isabel, * 1973 in Wien
in Vienna, lebt in Wien lives in Vienna

O.T. Untitled, 1996
Öl auf Leinwand oil on canvas
200 x 160 cm

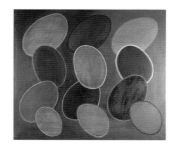

Rader-Soulek Grete, * 1920
in Wien in Vienna † 1997 in Wien
in Vienna

Grau Grey, 1975
Öl auf Leinwand oil on canvas
106 x 120 cm

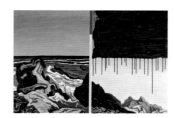

Rataitz Peter, * 1945 in Wolfsberg
/ A, lebt in Wien lives in Vienna

Korrektur I (Teilung IV) Correcture I
(Division IV), 1976
Acryl auf Leinwand
acrylic on canvas
100 x 140 cm

Ramaseder Josef, * 1956 in Linz / A,
lebt in Wien lives in Vienna

O.T. Untitled, 1993
Acryl und Wachs auf Leinwand
acrylic and wax on canvas
102 x 97 cm

Ratzenböck Wilhelm, * 1954 in
Linz / A, lebt in Wien lives in Vienna

Erscheinung am Weg
Phenomenon on the way, 1982
Aquarell auf Papier
watercolour on paper
43,4 x 60,5 cm

Rebhan Dominik, * 1929 in Feld-
bach / A, lebt in Wien lives in
Vienna

Wolken über dem Reisfeld
Clouds above a Rice Field, 1973
Aquarell auf Papier
watercolour on paper
64,8 x 49,7 cm

Reinbacher Rudolf, * 1920 in Wien
in Vienna † 2002 in Wien in Vienna

Lesbach bei Kals
Lesbach near Kals, 1987
Öl auf Spanplatte oil on chipboard
55 x 36 cm

Reiter-Raabe Andreas, * 1960
in Raab / A, lebt in Wien lives in
Vienna

O.T. Untitled, 1998
Acryl auf Leinwand
acrylic on canvas
110 x 90 cm

Reitmayer Walter, * 1927 in Wien
in Vienna † 1993 in Wien in Vienna

Landschaft mit Sonne
Landscape with Sun, 1972
Öl, Leinwand auf Holzfaserplatte
oil, canvas on wood fiber plate
23 x 52 cm

Rendl Richard, * 1946 in Wien in
Vienna, lebt in Wien lives in Vienna

Lichtzwang Light Compulsion, 1974
Acryl auf Papier acrylic on paper
62,5 x 77,5 cm

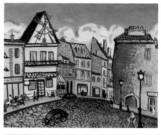

Richly Rudolf, * 1886
in Ödenburg / H † 1975 in Wien
in Vienna

Montmartre, 1954
Öl auf Holz oil on wood
41 x 49 cm

Landschaft mit Feldern
Landscape with Fields, 1959
Öl auf Leinwand oil on canvas
50 x 72 cm

Rind Trude, * 1944 in Wien in Vienna,
lebt in lives in Witzelsdorf / A

Himmel Heaven, 1983
Polaroids auf Karton
polaroid photographs on cardboard
44 x 63 cm

Himmel Heaven 22.10.–15.11.1982,
1982
Polaroids auf Karton
polaroid photographs on cardboard
44 x 62 cm

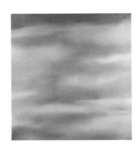

Roithner Hubert, * 1957 in Wien
in Vienna, **lebt in Wien**
lives in Vienna

Air, 2002
Acryl auf Segelleinen
Acrylic on duck canvas
220 x 190 cm

..

Rösch Rudolf, * 1948 in Wien in
Vienna, **lebt in Wien** lives in Vienna

Y/A 2235-2375, undatiert undated
Dispersion, Acryl auf Papier
dispersion, acrylic on paper
63 x 87 cm

..

Scheidl Roman, * 1949 in
Leopoldsdorf / A, **lebt in Wien**
lives in Vienna

Hauseinsturz
Collapse of a House, 1975
Farbradierung auf Papier
colour etching on paper
69,5 x 69,5 cm

..

Schellander Meina, * 1946 in
Klagenfurt / A, **lebt in Wien**
lives in Vienna

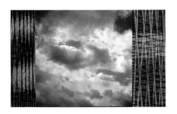

Wolken (Zeit-Himmel-Anteil) /
Innere Frequenz 143
Clouds (A Share of Time and Sky) /
Inner Frequency 143, 2006
Farbfoto und Zeichnung auf
Aluminium kaschiert mit Acryl-
glasabdeckung Colour photograph
and two-part drawing, mounted on
aluminum, acrylic glass covering
61 x 101 x 5,6 cm
Leihgabe der Künstlerin
loan of the artist

..

Schlegel Eva, * 1960 in Hall / A,
lebt in Wien lives in Vienna

O.T. Untitled, 1998
Acryl auf Holz acrylic on wood
88 x 120 cm

..

Schluderbacher Manfred, * 1964
in Bregenz / A, **lebt in Wien** lives in
Vienna

O.T. Untitled, 1999
Bleistift auf Papier pencil on paper
150 x 115 cm

..

Schmal Oskar, * 1904 in Brünn / CZ
† 1976 in Wien in Vienna

Italienische Landschaft Italian
Landscape, **undatiert** undated
Gouache auf Papier gouache on paper
32,1 x 34,6 cm

Aufsteigendes Gewitter, Normandie
Approaching Thunderstorm,
Normandy, 1967
Öl auf Leinwand oil on canvas
23,6 x 32 cm

..

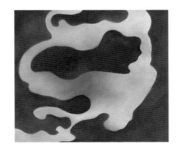

Schmid Peter Richard, * 1947
in Wien in Vienna, **lebt in Wien**
lives in Vienna

Abstraktion Abstraction, 1971
Öl auf Leinwand oil on canvas
57,5 x 50 cm

..

Schmid Hermann, * 1870
in Steyr / A † 1945 in Neumarkt
im Hausruckkreis / A

Blick über den Rudolfsheimer
Markt View of Rudolfsheim Market,
1924
Aquarell auf Karton
watercolour on cardboard
33,6 x 49,4 cm

..

Scholz Gerhard, * 1961 in Wien
in Vienna, **lebt in Wien** lives in
Vienna

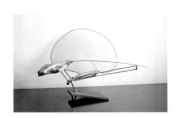

Konstruktion einer Landschaft
Construction of a Landscape, 1984
Stein, Metall, Tüll
stone, metal, net lace
60 x 60 x 25 cm

..

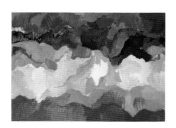

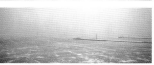

Schönhofer Rudolf, * 1946 in Wien
in Vienna, **lebt in Wien** lives in Vienna

Phrase I (Landschaft)
Phrase I (Landscape), 1970
Kunstharz, Acryl auf Textil
synthetic resin, acrylic on textile
61 x 85,5 cm
...

Schubert Sebastian, * 1980 in
Wien in Vienna, **lebt in Wien**
lives in Vienna

Nebel Fog, 2002
Lambdaprints auf Aluminium
lambda-prints on aluminum
je each 50 x 125 cm
...

Schulz Werner Wolfgang, * 1938
in Frankfurt / D, **lebt in Wien**
lives in Vienna

Bäume auf der Wolke
Trees on the Cloud, 1972
Buntstift auf Karton
pencil on cardboard
18 x 28 cm

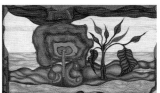

Der Himmel des blauen Pilzsteines
The Sky of the Blue Pilzstein, 1972
Buntstift auf Karton coloured pencil
on cardboard
25 x 17 cm
...

Schütt Gustav, * 1890 in Wien in
Vienna † 1968 in Laxenburg / A

Erinnerung an Gornostaj bei
Wladiwostok Memory of Gornostai
near Vladivostok, 1919
Tempera auf Papier
tempera on paper
32,3 x 49,9 cm

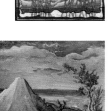

...

Schwarzer Ludwig, * 1912 in Wien
in Vienna † 1989 in Linz / A

Linz an der Wolke
Linz by the Cloud, 1961
Kugelschreiber auf Papier
ballpen on paper
30 x 20,9 cm
...

Schwaiger Josef, * 1962 in Linz / A,
lebt in Wien lives in Vienna

CMYKOG_Morph, 2002
Alkydharz und Silikon auf
Aluminium alkyd resin and
silicone on aluminum
je each 40 x 30 cm
...

Schwertberger DeEs, * 1942 in
Gresten / A, **lebt in Wien** lives in
Vienna

Ausdenken
To come up with Something, 1973
Ölkreide, Bleistift auf Papier
oil chalk, pencil on paper
73 x 102 cm
...

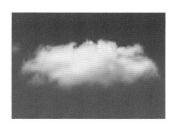

Sielecki Hubert, * 1945 in Rosen-
bach / A, **lebt in Wien** lives in Vienna

Levitation, 2007
Video, 3:00 min
Leihgabe des Künstlers
loan of the artist
...

Spiegel Michaela, * 1963 in Wien
in Vienna, **lebt in Wien** lives in Vienna

Timespacetripping, 1997
Öl auf Textil hinter gravierter
Plexiglasplatte oil on textile behind
engraved plexiglass
80 x 150 x 13 cm
...

Stecher Clemens, * 1968 in Wien in
Vienna, **lebt in Wien lives in** Vienna

Sonnenuntergang am Meer
Sunset at the Sea, 1999
Acryl auf Leinwand
acrylic on canvas
95 x 80 cm
...

Steckbauer Gottfried, * 1960 in
Prambachkirchen / A, **lebt in Wien**
lives in Vienna

Landschaft Landscape, 1981
Aquarell auf Papier
watercolour on paper
32,5 x 50 cm
...

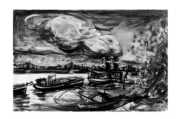

Steiner Heinz, * 1905 in Wien
in Vienna † 1974 in Wien in Vienna

Unterlauf der Donau bei Wien
Underflow of the Danube near Vienna,
undatiert undated
Aquarell auf Papier
watercolour on paper
42,7 x 63,1 cm

Stocker Esther, * 1974
in Schlanders / I, lebt in Wien
lives in Vienna

O.T. Untitled, 1997
Öl auf Molino oil on molino
130 x 180 cm

Sturm Gabriele, * 1968 in Lienz / A,
lebt in Wien lives in Vienna

Die Wolkenfängerin
The Cloud Catcher, 2009
Installation, Mixed Media
Variable Größen variable sizes

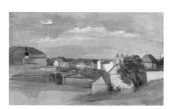

Susanka Leopold, * 1888,
weitere Daten unbekannt
further data unknown

Döbling, Blick gegen Gräf & Stift
Döbling, View of Gräf & Stift,
undatiert undated
Tempera auf Papier tempera on paper
50 x 65 cm

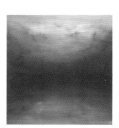

Swoboda Helmut, * 1958 in
Amstetten / A, lebt in lives in
Amstetten / A

Dachstein, 2001
Eitempera und Wachsemulsion auf
Leinwand egg tempera and
wax emulsion on canvas
150 x 140 cm

Szigethy Ida, * 1933 in Wien
in Vienna, lebt in Wien lives in Vienna

Wolkenschachtel Cloud Casket, 1971
Öl auf Karton oil on cardboard
50 x 40 cm
Leihgabe der Artothek des Bundes
loan of the Artothek of the Federal
Ministry

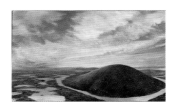

Tambour Wolfgang, * 1951
in Wien in Vienna, lebt in Wien
lives in Vienna

Symbolischer Hügel
Symbolic Hill, 1978
Öl auf Holz oil on wood
30 x 50 cm

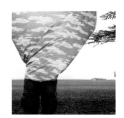

Titz Lea, * 1981 in Graz / A,
lebt in Wien lives in Vienna

Jupiter, 2006
Farbfoto auf Aluminium
colour photograph on aluminum
91 x 90,8 cm

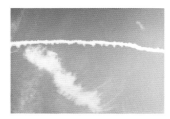

Traar Jochen, * 1960 in Essen / D,
lebt in Wien lives in Vienna

Man Made Skies, 2001
Computerbearbeitetes Foto auf
Leinwand computer processed
photograph on canvas
120 x 180 cm

Trinkl Werner, * 1950 in Wien
in Vienna † 2004 in Wien in Vienna

Beobachtung Observation, 1976/77
Öl auf Hartfaserplatte
oil on wood fiber plate
40 x 30,2 cm

Ulrich Wilhelm, * 1905 in Wien
in Vienna † 1977 in Wien in Vienna

Nussberg, letzter Schnee Nuss-
berg, last Snow, undatiert undated
Aquarell auf Papier
watercolour on paper
62 x 48 cm

Vesely Martin, * 1974 in Wien
in Vienna, lebt in Wien lives in Vienna

Staudamm Moserboden
Dam Moserboden, 2000
C-Print auf Dia-Sec, kaschiert auf
Eichenholz C-print on diasec,
laminated on oak wood
170 x 125 cm

Wachsmuth Simon, * 1964
in Hamburg / D, lebt in Wien
lives in Vienna

O.T. Untitled, 2002
Ölkreide auf Papier
oil crayon on paper
66 x 101 x 5 cm

Wacik Franz, * 1883 in Wien in
Vienna † 1938 in Wien in Vienna

Wolken Clouds, 1930–1938
Pastell auf Papier pastel on paper
25 x 32 cm

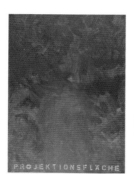

Wagner-Weger Sylvia, * 1960
in Linz / A, lebt in Wien lives in Vienna

Projektionsfläche
Projection Screen, 1997
Acryl auf Leinwand
acrylic on canvas
100 x 70 cm

Walch Martin, * 1960 in Vaduz / FL,
lebt in Wien lives in Vienna

Please don´t touch I, 1996-98
Farbstift und Graphit auf Papier
colour pencil and graphit on paper
130 x 150 cm

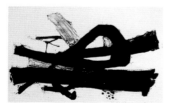

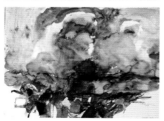

Wanke Johannes, * 1923 in Wien
in Vienna † 2005 in Neumarkt / A

Lafnitztal mit großer Wolke –
Burgenlandzyklus Lafnitz Valley with
Big Cloud – Cycle 'Burgenland', 1969
Holzschnitt auf Papier woodcut on
paper
65 x 85 cm

Große Wolke Big Cloud, 1975
Aquarell auf Papier watercolours on
paper
47,9 x 64,5 cm

Walde Martin, * 1957 in Innsbruck /
A, lebt in Wien lives in Vienna

Die Daten rufen nur vage
Vorstellungen hervor The Data just
Cause Vague Ideas, 1990
Filzstift auf Papier felt pen on paper
49 x 70 cm

Weigand Hans, * 1954 in Hall / A,
lebt in Wien lives in Vienna

Guanafelsen vor Catalina
Guana Rock off Catalina, 1999
Inkjet-Print, übermalt
inkjet print, overpainted
110 x 157 cm

Weissenbacher Sebastian, * 1959
in Eggenburg / A, lebt in Wien
lives in Vienna

Lämmchen Lambkins, 1993
Öl auf Leinwand oil on canvas
130 x 200 cm

Wenemoser Alfred, * 1957
in Graz / A, lebt in lives in Caracas

Heischelieder, undatiert undated
Mischtechnik auf Textil mixed
media on textile
125 x 95 cm

Wiesauer-Reiterer Heliane, * 1948
in Salzburg / A, lebt in lives in
Neulengbach / A

O.T. Untitled, 1990
Öl auf Leinwand oil on canvas
100 x 100 cm

O.T. Untitled, 1995–1996
Eitempera auf Leinwand
egg tempera on canvas
80 x 100 cm

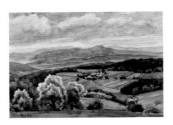

Wiesler Adolf, * 1878 in Graz / A
† 1958 in Wien in Vienna

Oberthalheim – Waldviertel, 1956
Aquarell auf Papier
watercolour on paper
27 x 37 cm

..

Wisniewski Jana, * 1941 Pan evo /
YU, lebt in Wien lives in Vienna

Fotomärchenbuch
Fairytale Photo Book, 1980
Schwarzweißfotos in Buchform
black and white photographs
in book size
24 x 30,5 cm

..

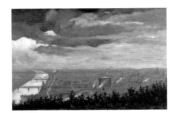

Witt Hans, * 1891 in Wien
in Vienna † 1966 in Tragöß / A

Blick auf Wien View of Vienna, 1955
Öl auf Hartfaserplatte
oil on wood fiber plate
77 x 103 cm

..

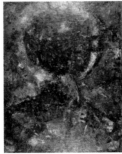

Wolf Karl Anton, * 1908 in Wien
in Vienna † 1989 in Wien in Vienna

Gestirn Luminary, 1960
Öl auf Hartfaserplatte
oil on wood fiber plate
175,5 x 135 cm

Himmelskörper Luminary, 1967
Öl auf Hartfaserplatte
oil on wood fiber plate
50 x 31,5 cm

..

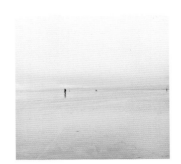

Würdinger Eva, * 1975 in Wien in
Vienna, lebt in Wien lives in Vienna

aus der Serie „Wien-Süd-Ost"
from the series "Vienna-South-
East", 2000
C-Print auf Aluminium
c-print on aluminum
44 x 44 cm

..

Zell Monika, * 1941 in Graz / A,
lebt in Wien lives in Vienna

Rote Wolke Red Cloud, 1974
Mischtechnik auf Papier
mixed media on paper
35,9 x 47,7 cm

Zeppel-Sperl Robert, * 1944 in
Leoben / A † 2005 in Wien in Vienna

Die Innenseite der Aussenseite
The Inside of the Outside, 1970
Farblithographie auf Papier
colour lithography on paper
50 x 65 cm

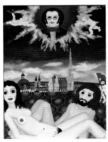

Schubert über Wien
Schubert above Vienna, 1972
Öl auf Leinwand oil on canvas
100 x 75 cm

..

**Ziegelman David
alias Philipp Preuss,** * 1974
in Tel Aviv / IL, lebt in lives in Berlin

Himmel über Berlin, Regie:
Philipp Preuss Sky above Berlin,
directed by Philipp Preuss, 2000
Danchlor auf Denim
Danchlor on denim
je each 130 x 190 cm

..

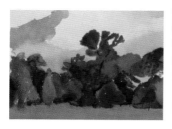

Zimmermann Wilfried, * 1939
in Hohenems / A, lebt in Wien
lives in Vienna

77 08 15 15 17 58, 1978
Aquarell auf Papier
watercolour on paper
25 x 32,3 cm

..

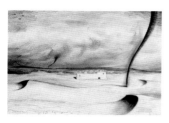

Zülow Franz-Joachim, * 1924 in
Wien in Vienna, **weitere Daten
unbekannt** further data unknown

Windhosen am Rand der Wüste/an
der Küste Landspouts at the Edge
of the Desert / at the Coast, **1955**
Bleistift, Kugelschreiber auf Papier
pencil, ballpen on paper
20,9 x 29,7 cm

..

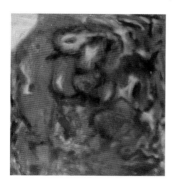

Unbekannte/r Künstler/in
unknown artist
O.T. Untitled, undatiert
Öl auf Leinwand oil on canvas
100 x 90 cm